JOURNEYS TO ABSTRACTION 2

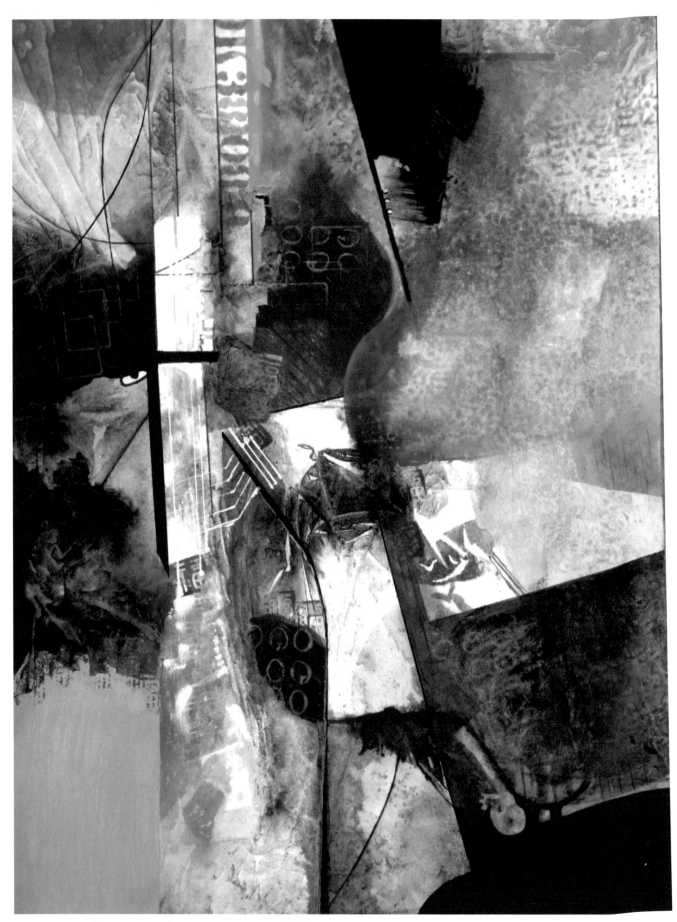

Treble • Sue St.John, AWS • AWS Award winner
Mixed media, 30"x 22"

JOURNEYS TO ABSTRACTION 2

**100 More Contemporary Paintings
and Their Secrets Revealed**

Sue St. John

CONTENTS

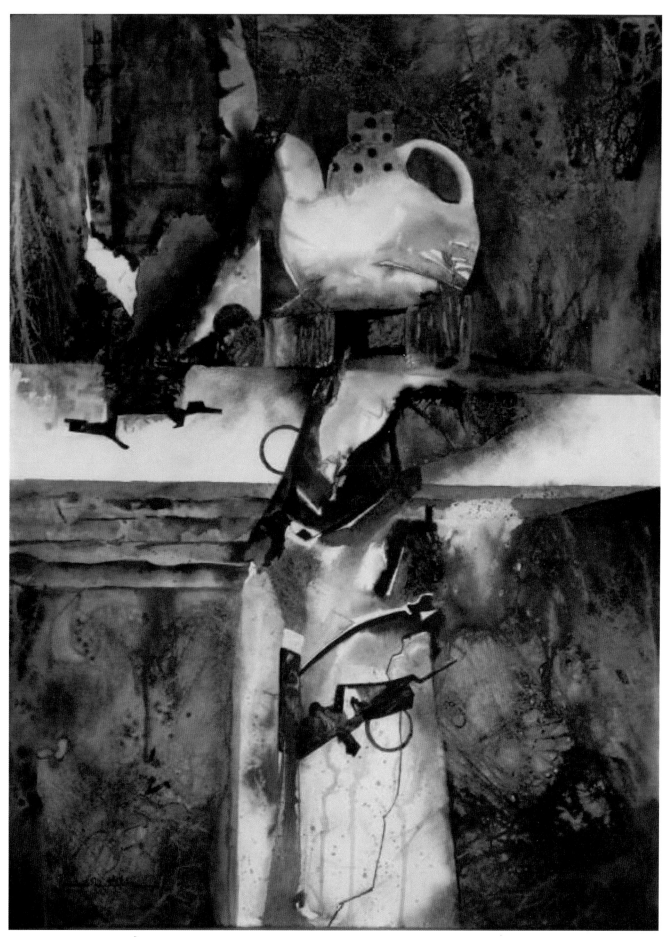

Breakthrough • Sue St.John, AWS
Mixed media, 30"x 22"

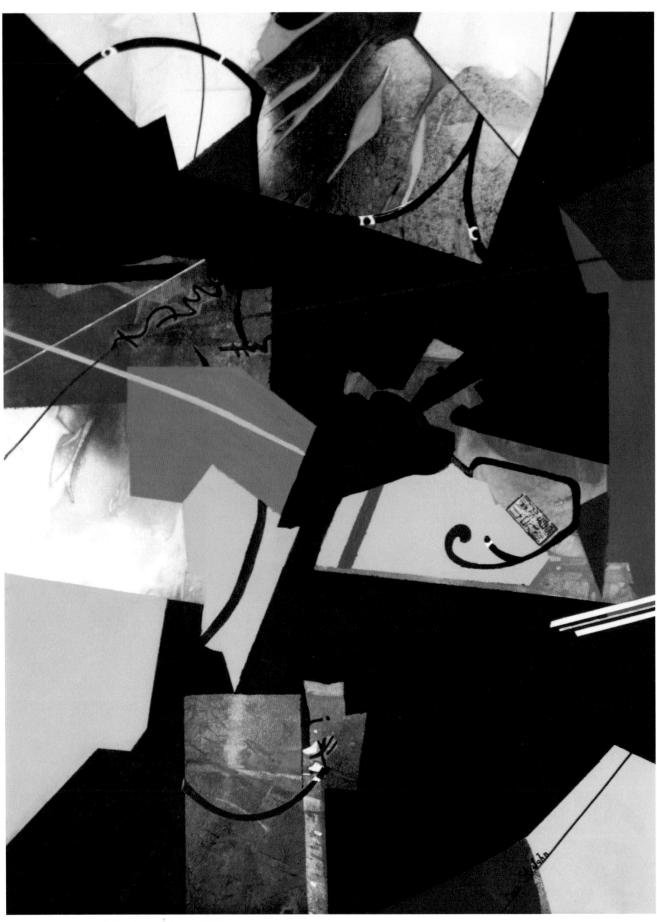

Fractured • Sue St.John, AWS
Mixed media, 30"x 22"

Thinking About Art

INTRODUCTION

Abstract painting is a complex and thought-provoking art form, but as such it can present many challenges to both artist and viewer. Unlike many forms of art, abstract art does not rely on recognizable images and forms in order to convey its meaning. Instead, it uses color and shape to convey the essence of emotion and human experience. If sadness were a color, which color would it be? Or which combination of colors? Would it be active or static? Would its shape be defined or would it flow into the colors and shapes around it?

The challenge of painting abstractly is to answer those questions, and many more. Sadness can be painted in many ways, and there are many sorts of sadness—but regardless of the techniques and materials used, unless a viewer is able to understand that sadness is what is meant to be conveyed, the painting is, at some level, a failure.

Abstract artists approach their painting in different ways, which is part of what makes abstract art such a rich field. Some artists aim to make their works more simple; others thrive in complexity. Some use vivid primary colors; others aim for calm neutrals; still others combine the two for stark juxtaposition. In abstract art, no choice is wrong.

Since abstract art does not rely heavily on recognizable images, it is not always easy to look at a painting and fully understand its unique visual language. In many cases, the best way to understand an artist and his or her art is to learn about the working process behind the art—the tools used, and the ideas, methods, and techniques that are unique to that artist.

This book is all about that: looking at a painting and then learning about the process that went into it in the artist's own words. Whether you are a total beginner or an award-winning expert—or even if you prefer painting realistic rather than abstract art—this book will provide the means to deepen your understanding of abstract art and help you develop your own style. And afterwards, if you are interested in learning more about a particular artist, feel free to consult the Directory of Artists for contact information!

So without further delay, let us dive right into the inspiring world of abstract art.

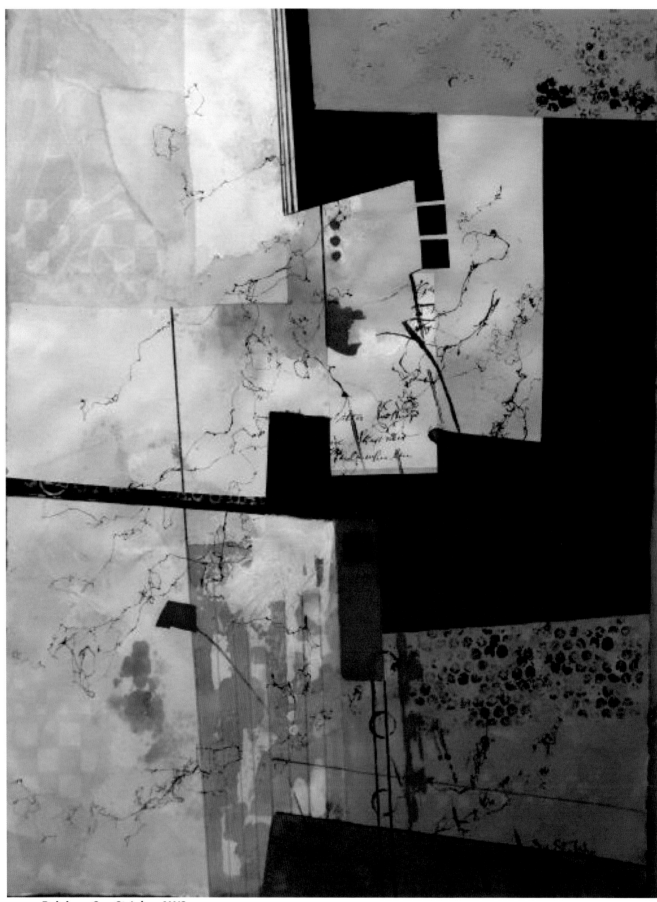

Rejoice • Sue St.John, AWS
Mixed media, 30"x 22"

THE PAINTINGS

Patricia Baldwin Seggebruch

I have always had an affinity for burning; yet it needs to be noted that I have not burned a single thing that wasn't done intentionally!

In this series I was experimenting with the new Encausticbord from Ampersand. I had used their Claybord for years, burning on it as well as experimenting with every other technique in encaustic. This new Encasuticbord was designed specifically for encaustic work, through collaborative efforts of R&F Paints and Ampersand. The results of the burn I so love were tremendously satisfying!

While working abstract lends one to think that there is perhaps no design direction, I do begin some series work with a rough sketch of where I want to go in terms of the composition. Now if I would just stick to it!

In Storyboard III the simple design of three circles, increasing slightly in size, is bisected by an incised carved line. The blush of burn around the circles adds unexpected yet necessary variation in tone.

To begin I took my propane torch in hand. This tool is one of my favorite-next to the crème brulee torch.

On full flame power I held the flame to the bare Encausticbord, about 2 inches from the surface. After 20 seconds or so the Encausticbord began to discolor, then toast and burn.

As the burn circle grew to the dimension I desired,

I pulled the torch away to quickly stop the burn. I moved on to the second and third circles in this same way.

Allowing it to cool completely before adding encaustic is imperative so that the wax will have an even-temperature surface over which to work. I chose to apply three coats of un-pigmented encaustic medium to this painting before scribing a straight incised line with a stylus through the circles, as well as loose circles carved around the burn spots. Once the encaustic cooled completely I was able to use a R&F Burnt Umber Pigment Stick, rubbing it over the surface before rubbing it into the in-

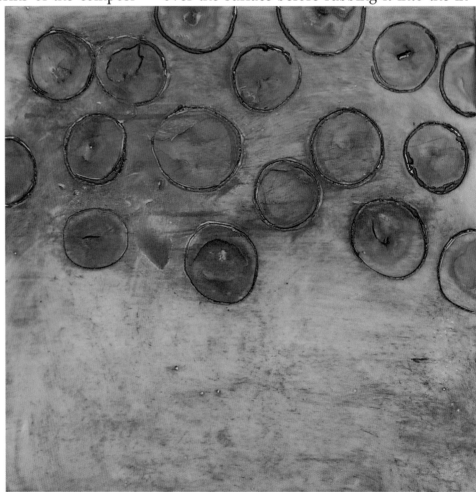

Storyboard • Patricia Baldwin Seggebruch
Abstract encaustic on Encausticbord

cised line with my gloved hands, and wiping back the excess with paper towel to highlight the incised line.

In Storyboard the same burn technique was employed, yet with less strategy and more randomness! Multiple circle burns fill the top half of the board before cooling for encaustic application. In the incising for this piece I used the stylus to carve loose circles around all of the burn marks. Once cool, the same burnt umber pigment stick was employed to fill the incised circles as well as leave behind a tint on the wax, causing this piece to have a more rich, deep overall col5or.

Variations of these same techniques can be viewed at www.gingerfetish.blogspot.com/sitkacollection.

I intend to go further with fire and encaustic; it means 'to burn into' after all! And the results of the two are just too delicious not to try!

Note: use caution with open flame. I always burn in open air so that fumes do not collect and cause potential harm.

Best to you in your exploration and as always, Happy Waxing!!!

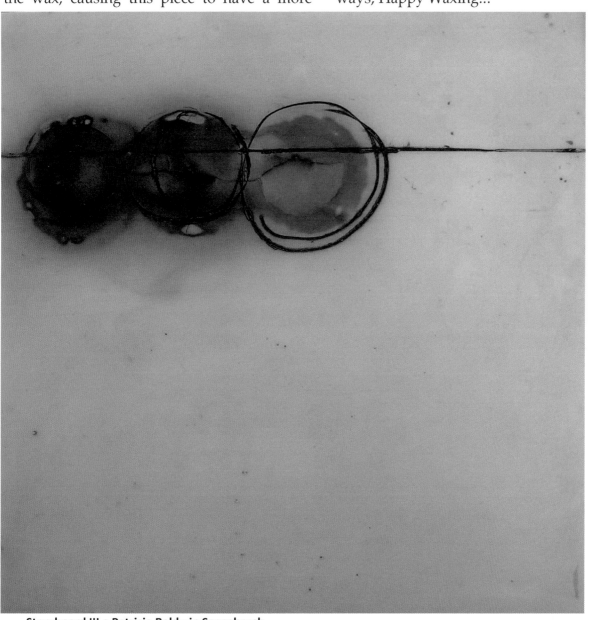

Storyboard III • Patricia Baldwin Seggebruch
Abstract encaustic on Encausticbord

Jane Bazinet

My abstract paintings begin with a concrete thought based on reality. I use paint and various materials to express my impression. My most recent work is based on my travels. While on a trip to Italy, the approach to the city of Siena brought a vision of a cityscape and the name Siena gave me the palette.

The first step was a watercolor interpretation, used for planning the composition and color choices, the primary colors being sienna and reds. I then proceeded to transfer the idea to a 48" x 36" canvas. Next came a sketch using a charcoal twig. Then I applied acrylic paint in ochre, sienna, reds and red-oranges, leaving the area on the bottom left and right for greens, blues, purples, and yellow. I also left a horizontal strip at the top for contrast. I added the purple compliments of yellow and yellow green at the left and right bottom, then added purple glaze.

In the next layer I used watercolor crayons and pencils to indicate architectural shapes in ovals, squares, rectangles, and arches. I used acrylic medium to dilute crayons and this also helped dry the color in place. At this stage gesso was used to define very light areas. After the gesso dried, I textured certain lines and shapes by applying acrylic paste using a plastic palette knife.

I then poured diluted acrylic color in ochre, then sienna and some orange down the middle of the canvas using paper towels to control shapes. Basically, it's a style of a watercolor pour. I again worked on the bottom left and right with yellows and purples using an angle brush and then introduced blue. I moved directly to the top and added the same colors to draw the eye of the viewer. Going back to create shapes and direction, I now used strong reds and siennas throughout the canvas.

From here I used oil paint mixed with Quicken for faster drying and a glossy look. I started painting glazes of red tones of different intensity. Small pours of oil paint are used during this layering process.

Defining my approach to Siena, I painted strong, bold red burgundy [vertical stripes] from the bottom up, pulling the eye up into the painting. Then I added glazes of orange and sienna. Next I poured paynes gray down the right side, controlling with tissue. I finalized by working in greens and blue, and brought it together with dark areas of paynes white highlights.

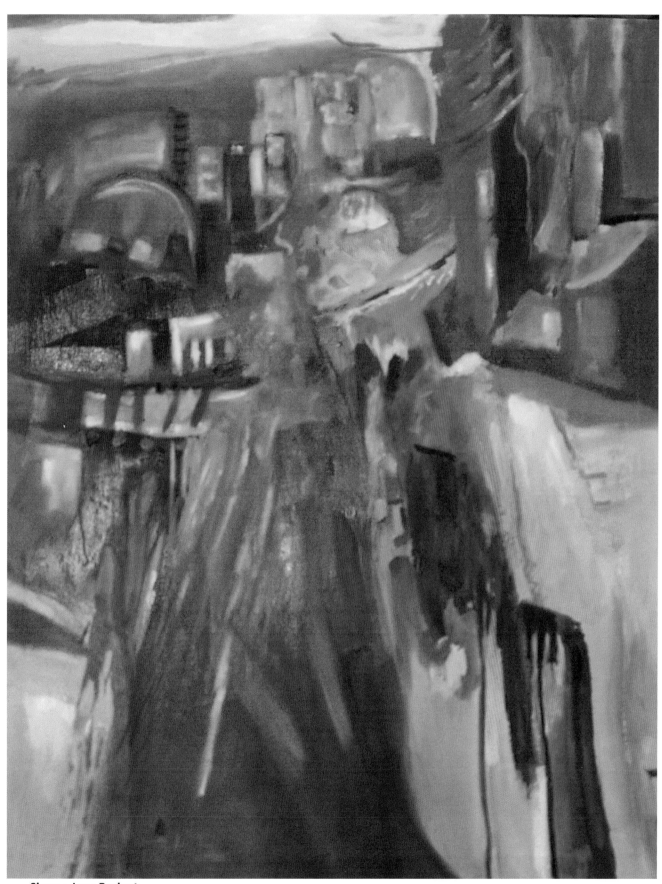

Siena • Jane Bazinet
Watercolor, Watercolor crayons and pencils, Acrylic and oil, 48" x 36"

Mary Ann Beckwith

Creating paintings with my techniques can be a very messy process. When I begin working, I start several paintings. Producing many paintings at once gives me a wealth of textured starts to develop into finished paintings. I often have dozens of paintings in various stages of completion. This allows me to experiment and take chances in my work that I might not try if I were working on one painting at a time. Having many paintings in progress keeps me free and they never become too "precious".

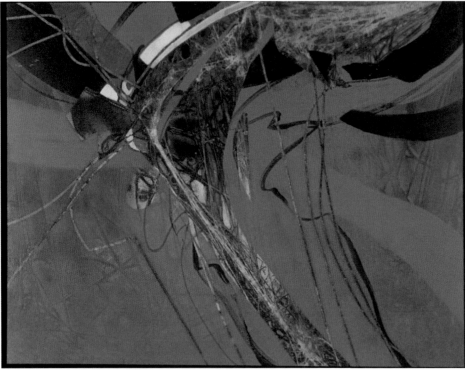

Ascension • Mary Ann Beckwith, AWS, NWS, ISEA
Watercolor Acrylic on Yupo, 22" x 30"

I begin by spreading a layer of decorative Halloween cobwebs on the surface of the paper. My papers of choice are Yupo and almost any hot pressed paper. The web technique will also work on cold pressed paper but will not leave as precise an image of the web pattern. I stretch the web as finely as I can across the surface and hold it in place with pushpins. Once it is in place I moisten the entire surface and the webs with water. The water tension holds the webs in place while the paint is being applied.

Inks and liquid acrylics were my early choices for pigments, but each had shortcomings. Inks were fugitive and acrylics bonded the webbing to the paper, creating results I did not want. I became aware of the liquid watercolors and tried them. The vibrant colors were exactly what I was searching for. These paints had an intensity that I had not experienced before in any medium. It was time to combine the webs and the liquid watercolors. The results were exciting. Lively color and pattern formed the foundation that I was ready to build my designs upon.

To apply the paint, I use spray bottles. The liquid watercolors are mixed with distilled water, a diluted solution but still strong enough to provide the intense color I love. I always shake the bottle well before spraying. Spray holding the bottle in an upright position, and rinse the spray top after using. I continue spraying until the color has the intensity I want. Color dries lighter than it appears when wet, so I must anticipate that loss of color. While the color is still wet I tilt the board to encourage the pigment to move along the webbing. The tilting also blends color on the surface of the painting. When the painting is completely dry, the webbing is removed.

Next I study the dried painting. I search for areas that intrigue me, and then consider how to design the next application of paint. I preserve the most interesting webbed areas by placing stencils or cut plastic shapes on the surface. Areas covered with these stencils are protected from the spray of white paint. I allow this layer of spray to dry and then lift the stencils. I check the composition and I may choose to add more layers of paint or spray. I study the painting for any adjustments that the composition might demand. Careful and thoughtful additions, changes, or embellishments are the last part of the process, the most important and the most time-consuming. Often I am enthralled and excited with the process. What must be remembered is that the real challenge is the final design and the compositional choices one makes. Is the design exciting? Does it have a successful combination of shapes, contrast, lines, color, texture and pattern?

Painting with my techniques can always produce surprises. I never begin my work with a preconceived image. I cannot always guarantee an effect in a painting and therefore I am always experimenting with textures and materials to see what visually stimulating effects I can create. I love the textured patterns and fluid washes of watercolor, juxtapositions of color, pattern, opaque areas, and the process of design. I enjoy the unanticipated effects and delight in the random happenings of painting. I am thrilled when confronted with the challenge to resolve these seemingly accidental starts.

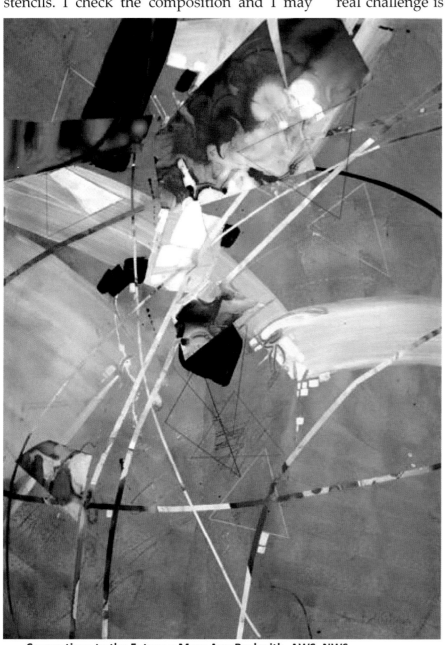

Connections to the Future • Mary Ann Beckwith, AWS, NWS, ISEA; Watercolor Acrylic on Yupo, 30" x 22"

Sue Bishop

I began with a small value study that acts as a road map for the placement of shapes and values in the painting. The goal was to produce a low-key painting with a full range of values and interlocking shapes and texture.

A 22" x 30" sheet of Strathmore Aquarius II was sealed with Golden fluid matte medium. This produces a very forgiving surface that you can lift, scrape into or rub. All of this is necessary to produce the surface texture.

Light gray acrylic was painted over the entire surface. Darker grays were added in some areas and lighter grays in other areas. I used a brush and a sponge roller to apply paint. While the paint was wet, I lifted out some areas with Kleenex and a brayer, or scraped out of or into areas with a square notched adhesive spreader.

Guided by my value study, I drew in the figure with a Stabilo pencil and sprayed it with a fixative so it would not smear. With a darker gray I started laying in the middle value grays, concentrating on interlocking the edges of each new shape to the existing shape with a variety of techniques.

Once this stage was dry, I began adding the white shapes and the black shapes. The edges of the shapes received my utmost attention. If a shape appeared too harsh and needed to be softened, I used a sponge roller with a lighter paint color and joined the surface of the shape with the other surrounding shapes. Another technique is to lift out wet paint with Kleenex and a brayer so the underneath color will peep through.

To create the shapes with hard edges, masking tape was used. I made sure the paint was dry before removing the tape from the paper.

At this point I studied the painting and reviewed my goals. They were interlocking shapes, full range of value with little color and texture. I kept adding to the surface with the techniques I had used throughout the painting. I kept pushing myself to create texture with variety. I continued to weave the values and the textures back and forth until a perfect balance was achieved. At the very end, I worked yellow ochre into the figure and wove it into several areas of the painting.

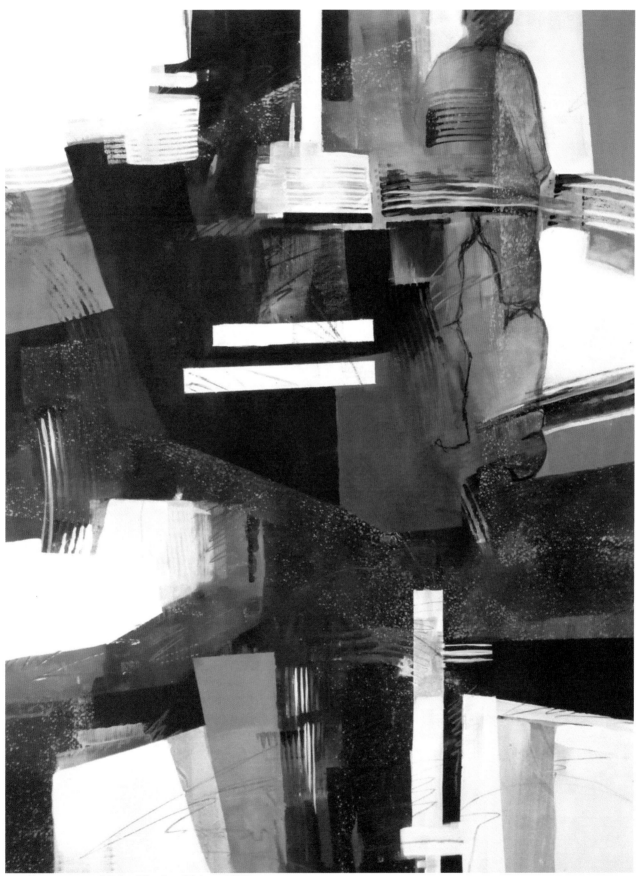

Entrances and Exits #9 • Sue Bishop, TWS
Mixed Media, 22" x 30"

First, three layers of gesso were applied to a 30" x 40" canvas and then sanded smooth. This smooth surface was needed for the transfer technique used in the painting. A small value study was drawn to designate the major value shapes and the placement of the transfers.

I use transfers on canvas to create arbitrary or abstract shapes and designs on the canvas. These transfers are painted around or painted on and then parts are lifted out. They provide variety and interest to the surface of the painting.

To create a transfer, I find lettering, designs, pictures, or anything of interest from magazines and make ink jet copies of them. These images will be transferred onto the surface of the canvas. I apply Golden soft gel (matte) with a brush to an area no larger than 5" x 7" and then place the ink jet copy face down on the area. Next I use a brayer to adhere the paper to the canvas. Do not let the area dry! While still wet, lift the copy off the surface of the canvas and an arbitrary transfer of the ink jet copy will be on the canvas surface.

Using my value study as a guide, I placed transfers across the middle of the canvas and carried some to the top and bottom of the canvas. I also added a few transfers to the area where the image of the house would be located.

Using blue, ochre, red, peach and white, I started painting on the transferred images. I was creating an abstract cohesive design. I would cut around the image with paint, apply and lift off paint with Kleenex and a brayer, or paint and then scratch through the painted area. I was weaving the arbitrary shapes together to create a unity of design.

Next I painted in the large areas of blue and off white. At this point, I began designing the edges of the large shapes and would totally eliminate some of the transfers. I also painted over some and then lifted them back out with Kleenex and a brayer.

I worked back and forth between the shapes until a good design was achieved. Turning my attention to the house, I began adding and taking away paint to produce the ghost-like effect.

Once the large areas were working, I went back to the smaller shapes. There I added darks and lights, added paint and lifted off paint, and added texture. I wove the large areas into the small areas and the small areas into the large areas.

Upon final inspection it still needed more unity. I took white sheets of tissue paper and collaged them onto the surface of the canvas with Golden fluid matte medium. I placed the tissue in selected areas. This is what was needed and the painting was complete.

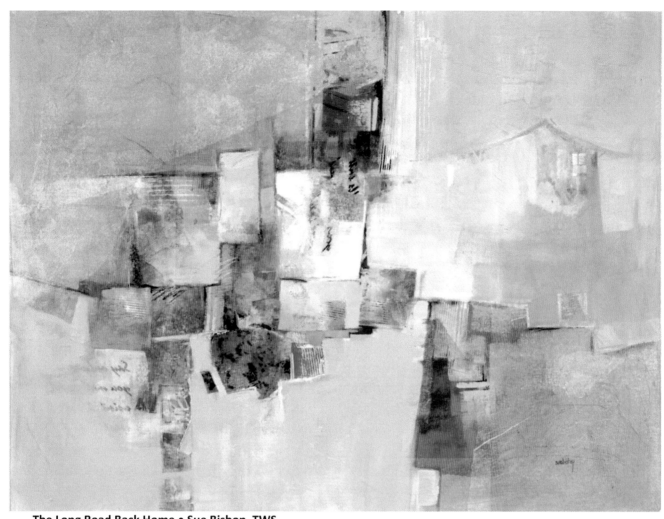

The Long Road Back Home • Sue Bishop, TWS
Mixed Media, 30" x 40"

Joan Blackburn

I began this painting over a previous painting start which was an old ink pouring gone awry. I had kept it because there were areas that I really liked and was waiting for my muse to speak to me, telling me what to do next.

This project was a demonstration in class: to save the parts we liked and to brush another layer of white gesso over portions we didn't like, plus painting each corner a different size, a different shape and a different color, softening edges over the "saved" areas.

I had textured the original ink pouring while the ink was still wet with netting and wax paper, both crumpled and pleated for different effects, so I continued the texturing into the wet gesso using bubble wrap and plain wax paper. Then I demonstrated using the mouth atomizer and inks over a stencil of the letter "A", a light value over darker for a negative shape and dark value over lighter for a positive shape. My demo ended because of time.

Sometimes I go in the studio and want to paint but can't seem to get motivated, so I go through my box of "starts" to see if my muse will speak to me about one of them. One by one I pull them out and consider the prospects and possibilities in resolving one of them.

When I pulled this one out, I thought about the politicians I had seen on TV the night before and how uncivil they were to each other. At first they get an "A" for deportment, then they get into the ugliness of bad manners, and then it's all down the tubes, so I used the others letters to state my opinion of their actions.

I painted the inside edges of the two dark corners at the top to make the shapes larger and to strengthen the cruciform design format. I placed it behind a mat on an easel and studied it from across the studio evaluating all design elements, especially color harmony, contrast, and content, and decided to quit before I ruined it.

Civility in Politics • Joan Blackburn, FWS, TWS, SWS
Acrylics, 22" x 30"

I like to paint abstracts in acrylics because of the fun process of layering and I can get wonderful textural effects with different materials, breaking up the surface of the paint, lifting some of it and transferring it elsewhere on the paper. This helps break up the frontal plane and gives depth to the painting.

I began this painting on Arches hot pressed 140 lb. watercolor paper covered with gloss medium. The medium makes a hard surface which accepts texturing very well, and when it was dry I applied the first layer of paint, using various texturing materials to make and break up shapes within each shape while the paint was still wet. The shapes were brushed on randomly but were dominantly red in color from the warm reds to the cool reds. I also painted some areas in greens randomly as the complement and added some blue-green to go with the red-orange.

After the first layer was dry I painted in some black shapes, all entering at one-third on each side of the paper, bringing the largest one in further as a foundation for possible location of a focal area. When this was dry I placed a stencil with numbers on a diagonal over this black background, and used a mouth atomizer to spray white ink over the stencil and out over some of the other black shapes and surrounding areas.

Now was the time for evaluation and using the right side of the brain. I put the canvas behind a mat on an easel and studied it from across the studio, turning it different ways so each side was at the top. I decided the balance was better in the vertical orientation with the numbers at the top, and also that I would use the grid design format for developing.

But what about color? Do I stay with the red dominance or do I change to cool blues and let some of the reds peek through? After much thought and deliberation I decided to change to blues with different shades of neutrals to hold the painting together.

I carried the blues, the light neutrals and the black out on each side, while making sure the reds escaped also.

During the next time of evaluation, I realized I had stopped the largest shape of blue almost in the middle of the paper. I enlarged it by stamping blue paint on the left edge with texturing material which also subdued some of the numbers.

The bottom was then broken up into various shapes in grids. By using various texturing materials I made overlays of color in several different places and transferred the wet paint on the materials elsewhere on the painting. Example: the blue color placed in the bottom right corner was stamped with a plastic gripper and transferred in the adjoining shapes. Also, for variety in the middle of the page on the left edge a warmer blue was placed over some of the red, textured with crumpled wax paper and brayer and transferred nearby, helping to subdue some of the red color.

Again after much thought and deliberation, I decided to stamp overlays of blue, red and the light neutrals randomly as needed to ensure all colors moved across the page. With the black squares stamped to break up the largest blue shape, some "scribble scrabble" in the right middle to join the blue shape with the light neutral and a little line work, I decided that all elements worked well together.

The Numbers Cruncher • Joan Blackburn, FWS, TWS, SWS
Acrylic, 30" X 22"

Pam Brekas

I am an intuitive painter, and prefer to allow my artist within create the work. Therefore, I have no preconceived notion of what the final result will be. Often, images appear at will and I incorporate what inspiration I am given. For some reason, I am drawn to feathers and they frequently show up in my work.

My main tools are a soft rubber linoleum brayer, a metal kitchen spatula (with a slightly slanted edge), spray water bottle, Strathmore Series 300 Bristol Paper (in a pad or individual sheets), Golden artist paints (both the pre-mixed acrylic glazes and fluid acrylics in various colors), Prismacolor colored pencils, and Jacquard Pearlescent powders.

For this piece, I started by dripping acrylic glazes (titan buff, indigo blue, metallic gold) in the style of Jackson Pollock on the paper. Using the brayer, I lightly roll the glazes using one color before adding another. This disperses the glaze, spreading it out to the edges and off the paper. I spray with water and turn the paper in different directions to get a loose flowing effect. I can also get interesting textures when I lightly spray the glaze with water, wait a few seconds and roll through it.

Using the side edge of the metal spatula I carve shapes into the wet paint. For this piece, I added a clear glaze in the upper left area, pouring a few drops of red fluid acrylic. While it was wet, I used the spatula as a drawing tool back and forth to give the petal feeling in the upper right. I also carved through the paint to get back to the lighter color glaze for the feathers in the center lower area. I also sprinkled on a small amount of fine gold pearlescent powder, which I sprayed with water to set.

When the paint was completely dry, I used Prismacolor pencils (black, indigo, white, crimson, lavender, gold) to alter the values and enhance the upper left area and feathers. The lavender pencil created a nice compliment to the gold.

By using the pencils to darken and lighten areas, I can change the values and move something that is not so special up to a piece that has real punch. The black and indigo pencils were used to define the feathers and leaves, as well as outlining and enhancing some bubble-like pod images. As I work I keep turning the piece, adding a line or shape where the art tells me it is needed.

I then added a piece of paper jewelry I had made. This seemed to complete the piece. I adhered it with a matte medium. When it was completely dry, I lightly sprayed it with a clear acrylic spray and had it framed.

Native Jewel has a Native American feel to it and could be hung in any direction. Because it is done with acrylic, colored pencil, and the addition of the paper jewelry, it truly is a mixed media piece of art.

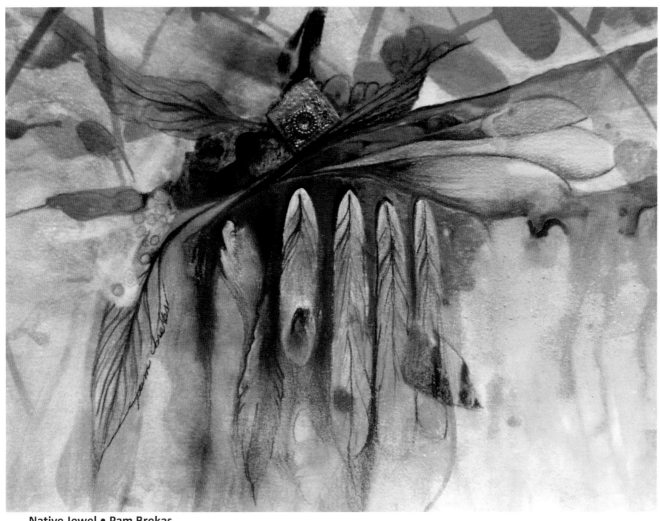

Native Jewel • Pam Brekas
Mixed media on paper (acrylic/colored pencils), 14" x 11"

Sally Clark

I had no idea in mind for the title of this painting when I began, as my paintings are sort of stream of consciousness paintings.

I began by putting shapes of white paint on to Arches 140# paper, followed by some random shapes of brown, sienna, and black. After looking at this for a while, I painted over the whole thing with white, collaged on some tissue paper for texture, and probably scratched into the paint for more texture. I am constantly striving for texture (one of the reasons I gave up transparent watercolor.)

I then added some blues to bring out the whites, some quin nickel azo gold to soften the blue and white. For more texture, I stamped with rubber-like padding for shelves (my son, a chairwright gave me a lot, as he uses it for packing his furniture for shipping). I also used stamps made from an eraser. Styrofoam containers for fish and meat also make good stamps when marked up with the end of a pen.

To move the viewer's eye through the painting I added some dark blue to pull out some shapes. Some aluminum foil was placed in spots for more interest. Finally, I scribbled some teal blue, gold and red paint through the finished painting for more "oomph".

The finished painting was varnished with two coats of gloss medium and varnish. Then glued to masonite and framed with strips of Oak wood, mitered at their corners.

I have broken the rule that says paintings on paper must be matted and framed under glass or plexi.

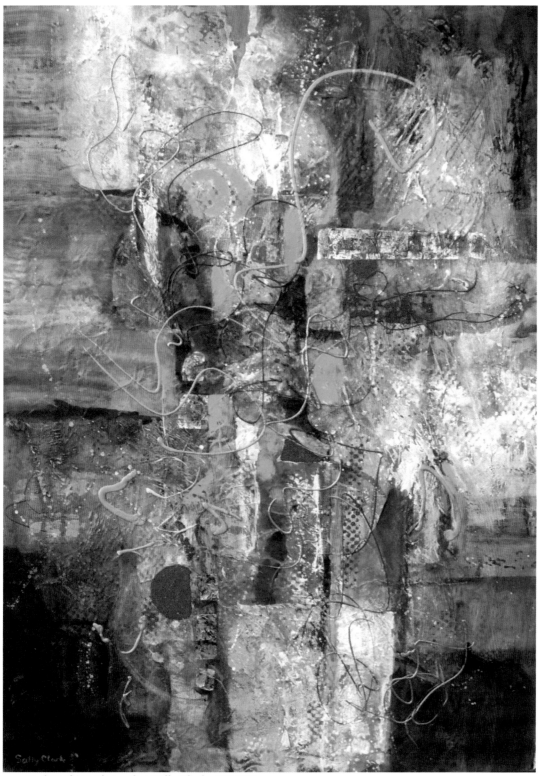

Red Peeking Through • Sally Clark, CNYWS
Acrylic/Collage, 30" x 22"

Patricia Cole-Ferullo

In all of my work the underlying goal is to present a peek at the beauty and magic of the network of life and our part in the mystery.

I usually begin with stretching heavy un-primed cotton canvas on gallery type 1 1/2" deep stretchers 3 at a time. In this series of works I approached the process with the idea of experimenting with pouring liquid dyes directly onto the stretched canvas in order to achieve a subtle but energetic mingling of colors on their own, with as little manipulation as possible. This technique allowed the liquids to form beautiful patterns as the slightly differing viscosities pushed each other around and

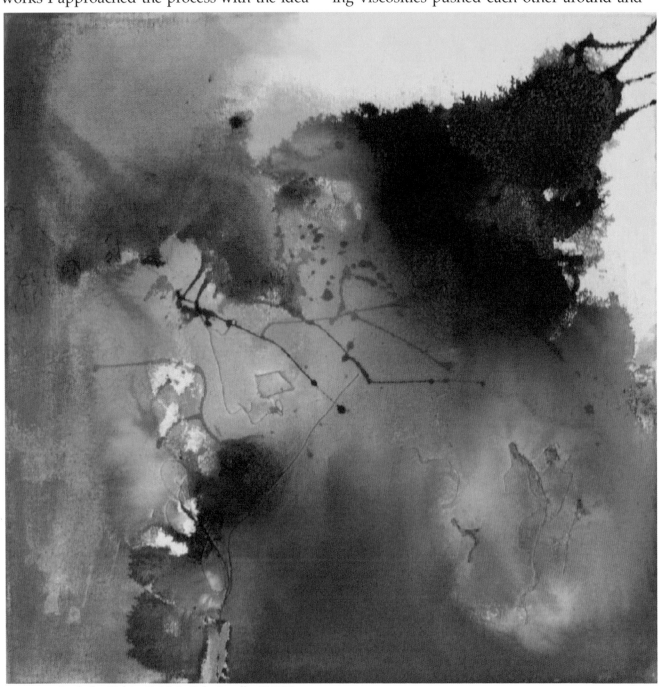

Seek the Light • Patricia Cole-Ferullo, SLMM
Mixed media, 36" x 36"

flowed together. The only manipulation at this point was lifting the canvas and tilting it to allow different configurations and blendings to occur. After pouring the first canvas, I proceeded to the next while the first was allowed to dry, repeating the process as I moved on to the third canvas.

My choice of colors was limited to 3 hues; 2 analogous with 1 complementary, resulting in a wide range of subtle shadings produced by the arbitrary mixing of the complimentaries balanced against pure color of different intensities.

This technique allowed the process to lead me into the content, then, following my intuition I introduced line, scribbles, fabric scraps, and layering with acrylic to bring out the depth and meaning I was seeking. In the process, some areas were painted out with white Gesso or water based KILZ, emphasizing composition, contrast, and direction, giving greater force to the remaining images. In the process I like to contrast hard edges with soft edges in order to keep the eye moving in an interesting trip through the picture plane.

Finally, I fine tune the paintings, pushing some areas back and emphasizing others, softening and heightening until it comes together as united whole.

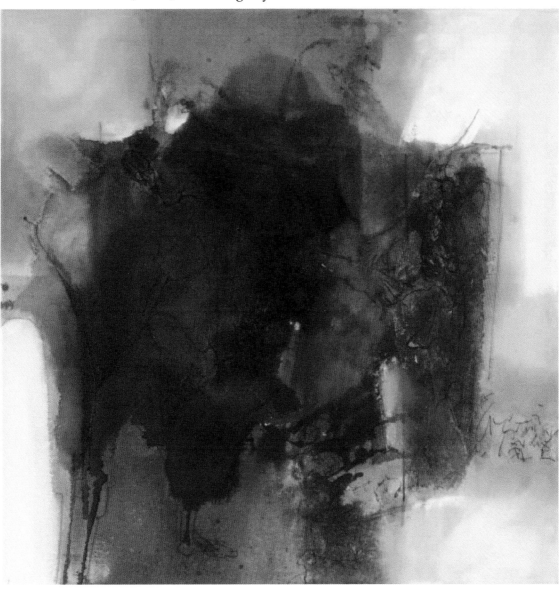

Touch
Patricia Cole-
Ferullo, SLMM
Mixed media
36"x36"

Phyllis Coniglio

It all began with a photo of an interior living room. I was attracted to the high ceilings and large decorative wood beams. It was my intention to find the large shapes and to minimize the details.

I lightly sketched the shapes on 140 Arches watercolor paper. After wetting the surface I painted sections using a 3″ Hake brush. I then started adding watercolor paints. I layered more than one color so that they mixed on the paper. I had to choose a dominate color scheme of either cool or warm colors and decided on cool. My palette consisted of ultramarine and manganese blue for the cool with burnt sienna and pyrole orange for the warm colors. I then added accents of turquoise.

While the paint was still wet I used several items to obtain texture. I used plastic wrap, wax paper, rubber stamps and bubble wrap. When this layer dried I painted in some smaller shapes. I overlaid white gesso in some areas then I sprayed with alcohol for more texture. I established my darks using acrylic paint.

I finished the paintings by adding a black line using my non dominate hand. That's when I take a deep breath and hope for a good outcome. I call that my surprise.

I chose a 4″ wide white mat and a black wood frame for Interior Design. When my husband hung it upside down by accident and after I got past my first reaction, I realized this was the better way for the work to be shown.

Interior Design • Phyllis Coniglio
Watercolor/Acrylic, 22" x 30"

Carol Cooper

I love creating small watercolors with a punch. My intent with Spiral was a nonrepresentational watercolor with a limited palette of colors, interesting shapes and textures.

Looking through art books and magazines and art show catalogs and attending art shows can be a great source of inspiration. Gleaning ideas from artists you admire is a great way to develop your own artistic voice.

Finding inspiration for a nonrepresentational watercolor can be a lot of fun. For Spiral, I used the old magazine excerpt trick which I love. Using a variety of small viewfinders (about 2 inches square), I moved the viewfinder across sections of images from travel and gardening magazines. I turned the magazine page all different directions seeking the "sweet spot" that inspired me. I was seeking what I consider a good nonobjective composition: interesting lines, shapes, contrast and direction.

For color choices, I could have used the palette of colors suggested by the magazine excerpt, but I chose my own for Spiral. For value, I allowed the excerpt to guide me as to where to place lights and darks.

The magazine excerpt was used as my starting point. I loosely penciled in the lines and shapes on my watercolor paper which were suggested by the excerpt-- not feeling compelled in the least to copy it exactly. Next, I took an 11" x 7.5" piece of 140 lb. Kilimanjaro watercolor paper and taped off a small rectangle that was 5" x 4.5".

On dry paper using my 1 inch flat brush, I painted my lightest colors first-- Quinacridone Gold, Quinacridone Burnt Orange, and Skips Green (a lime green). I allowed some of the edges of each color to blend, placing section next to section. (Try to leave some white paper in spots.) I immediately placed some Quinacridone Violet mixed with Ultramarine Blue and a bit of Prussian Blue in the dark areas. (Remember, when trying to go darker, have more pigment than water in your brush.) I cleaned my brush and discharged most of the water onto my sponge, then blended more of the edges. Cleaning my brush again, I dragged a fairly thirsty brush over certain areas to blend the colors even more. This was allowed to dry.

Painting a portion of the hand-carved stamp that contained the spiral shape, I stamped the large purple spiral in the lower left section. Using an open film canister as a painting tool, I rubbed it around my palette to get the edges of the canister "inked" with the Quinacridone Violet and Ultramarine Blue mixture. I judiciously placed this circular mark near the spiral.

The lines in the painting were actually stamped using the brush tip end of the 1 inch flat that was mostly pigment (the purple combination). I like the expressive look of this type of line. Lastly, bits of Quinacridone Burnt Orange were added in places. A few splatters of violet and orange were added for one more texture.

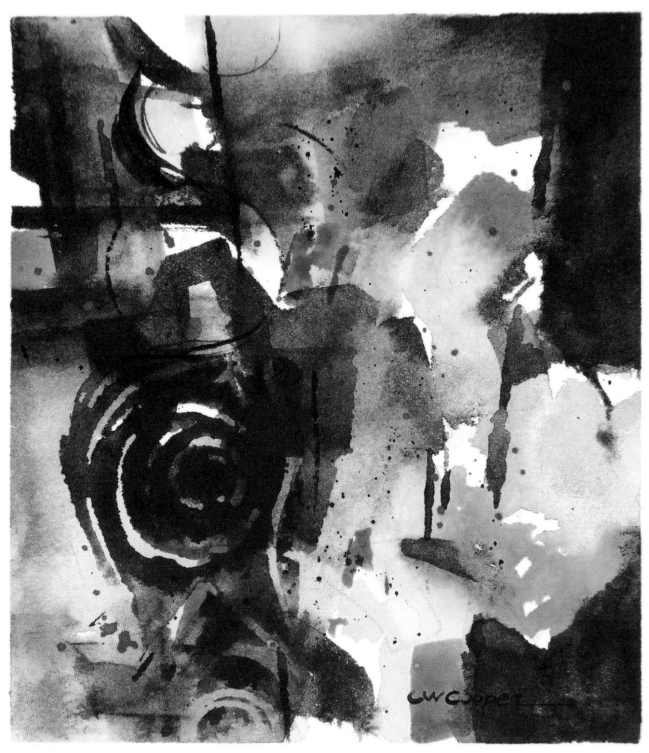

Spiral • Carol Cooper
Watercolor, 5" x 4.5"

My intent for The Secret Garden was to create a fairly large abstract floral with a strong cruciform composition, brilliant color, and a hint of mystery.

One spring, my friend Mary Lynn had a bumper crop of riotous peonies—white and pale pink. I was invited to cut a large basketful early one morning. Holding as many as I could in one hand, I took a photo of the impromptu bouquet. I knew then I would have to paint them!

Inspired by my close-up photo of the peonies, I lightly drew a simplified and somewhat abstract interpretation of the flowers on my 300 lb. cold pressed watercolor paper. I placed a somewhat strong cruciform behind the flowers as compositional "glue" for the painting. The cruciform was placed at a fairly strong angle to create more energy.

I wet a large part of the paper with my 2 inch flat brush, remembering that 300 lb. cold pressed paper needs more water and pigment than 140 lb. paper. I left a few small areas of dry paper. While the paper was still wet, I charged in with my lightest colors. I placed Wild Fuchsia, Quinacridone Pink, and Quinacridone Gold over a large part of the background and portions of the flowers. I allowed some colors to mix and some to stand alone. Next, using a #8 round, I placed Skip's Green (lime green) on the buds and in the background. I allowed the painting to dry.

Next, it was time to establish some value contrasts with the rich darks. I mixed Ultramarine Blue and Quinacridone Violet to create a deep blue violet. I mixed in a bit of Prussian Blue to help darken the mixture in places. Using my 1 inch flat, I placed both of these purple mixtures on top of the dried pink/gold/lime green layer. This glaze created some lovely color combinations. I used my 1 inch flat brush to blend some of the edges where dark violet met pink. I left a small rectangle of pink peeking out of the left lower left corner. Notice how the darks move around and through the flowers. I let this layer dry.

I lifted out color to create some leaf shapes and painted negatively to create leaves in the middle of the flowers and in the background. I also was able to leave some white paper showing around the flowers that had color on them, to create a little glow around them. I felt like some of the painting needed toning down at this point. Using my white gouache and 1inch flat brush, I placed streaks of opaque white over the pink at the top left. I used very little water so that the stroke would have a drybrush look. More gouache was added to some of the flowers.

Lastly, I used a small bit of needlepoint backing material as a stencil and applied the resulting texture in a few spots. Then, using my #8 pointed round brush, I painted in the small mysterious window just to the left of one of the flowers. I kept the contrast low to keep the window as subtle as possible. I then gave some depth to the small flower buds by creating a shadow on the underside of them and maintaining a highlight on top. The entire painting was treated to a few splatters of white gouache.

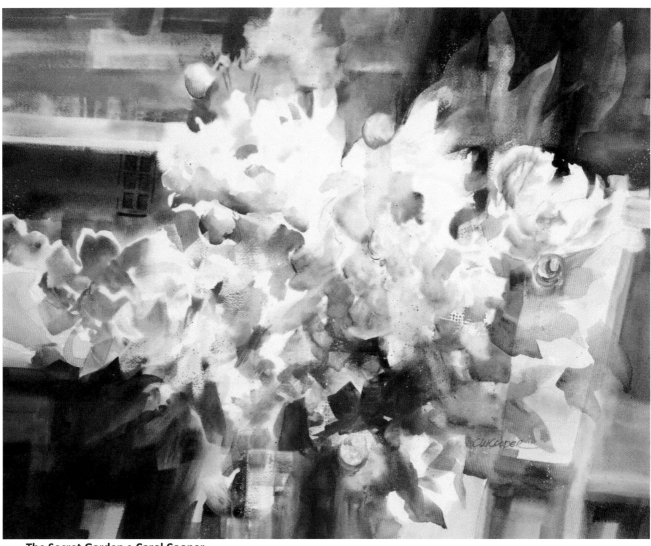

The Secret Garden • Carol Cooper
Watercolor and Gouache, 18.5" x 23.5"

Lauren Daddona

I began this painting on Bainbridge 1000 hot pressed illustration board. My original intent was to work with a neutral palette of acrylics and watercolors. I had no specific subject in mind.

My color choices were black, burnt sienna and gray. The acrylics used were burnt sienna, gray and black. I also used white gesso in a few places, and burnt sienna and black watercolor inks were applied with the ink applicator. As I applied paint to board I worked very spontaneously. I always use a large brush to start and work to a smaller one if necessary. I let the acrylic flow and run together. I want the experience to be fun so I approach it in a very playful way. My motto is "What if?" so anything that comes to mind, I try. I crinkled wax paper and imprinted it into the wet paint creating texture. Then I took the used wax paper and pressed it down somewhere else on the painting surface, creating a similar texture with the wet paint from the first imprint.

I also used watercolor ink to create lines and movement. Sometimes I will put paint down and press wax paper over top, using a foam roller to create interesting shapes. That is what happened in this piece. The crow seemed to appear on his own. Even though I had no subject in mind when I started the painting, if a subject presents itself and I like it I will let the painting guide me. I go with the flow. I really enjoy the spontaneous, exciting application of paint and texture. In this particular piece the values are strong, the crow demands attention, and the textures create added interest. The word "CAW" on the upper right side was put down with letter stencils at the very end.

The support for this mixed media piece was Arches 300 lb. cold pressed paper. I like the 300 lb. because it is a great weight and takes a lot of abuse.

My challenge for this painting was to work with rectangular shapes, creating a strong composition with the rela-

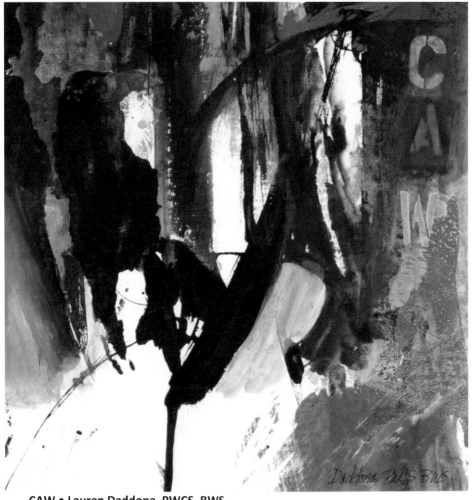

CAW • Lauren Daddona, PWCS, BWS
Acrylic, gesso, watercolor inks, 14" x 14"

tionship of these shapes. Having larger shapes and smaller shapes work together with value contrast was also important.

Selecting a neutral palette of browns, black and gray, I began hunting for collage pieces. I love this part of the process! Assembling stained tissue paper, beautiful Japanese papers, old torn up paintings, scrapbook papers, sandpaper, wax paper, etc., I was ready to begin.

I began painting shapes with watercolor, establishing light and mid tone areas. The white area of the piece was covered with a thin coat of matte gel medium. While it was still wet, tissue paper was laid into it to create texture. When that was dry I coated it with more gel medium. When that gel medium was dry I then painted the lower left side with a gray watercolor to create a more interesting shape.

The collage materials were laid out and moved around until I was pleased with their relationship to each other and the overall design.

I applied the collage pieces with matte gel medium, first putting a coat of gel medium down, placing the collage piece on top and then collaging over to sandwich the material between the gel medium. I also applied a wax paper overlay in a few areas to give a more opaque quality.

I did some stenciling at the end and applied the numbers and question marks with letter stencils. I drew with watercolor ink using the applicator at the very end to establish a nice shape into the white. I also rubbed a little Conte crayon in the top right corner to add some texture. I was pleased with the overall design and the neutral palette. This piece became part of an ongoing series of the different aspects of aging. The thought-provoking words "Time Discovers Truth" were stenciled on paper and then collaged onto the piece.

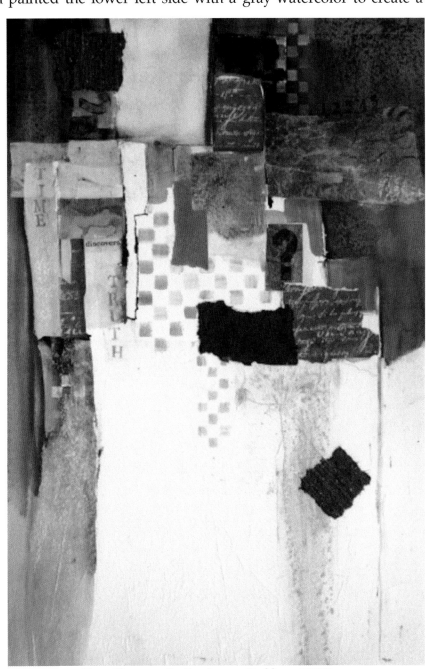

Time Discovers Truth • Lauren Daddona, PWCS, BWS; Mixed Media & Collage, 17" x 13"

Martha Deming

I got the idea for this method of starting an abstract a few years ago during a design workshop with artist John Salminen. As a long-time flower painter, I had accumulated many drawings for past paintings. I decided to try combining these drawings in groups of three, superimposing them on the same sheet of scrap paper, as a means for creating some "raw material" from which an abstract painting might be developed.

I chose the three drawings to combine for this painting with an eye for the shapes and patterns the combination created. The drawing which resulted for Garden Chimes looked like total chaos at first. It was transferred in that state by tracing it onto a piece of Arches 140 lb. cold pressed paper. The job before me was to find design and order within apparent chaos. To do this, I first studied the drawing for directional movement, shape groupings and possible placement of a focal area.

When I had decided to place the focal area in the upper right, I reserved a large white shape in that area a la Edgar Whitney via John Salminen, irregular, oblique and unpredictable. Light value washes of colors suggested by the original flowers were then laid in over large areas around the white shape using a 2 inch flat brush. A few small darks were placed in and near the white shape to establish the area of maximum contrast. Mid tones were glazed in and then transitions were developed by glazing and lifting, starting with groups of shapes, gradually working with smaller individual shapes and brushes as the painting progressed.

Value was controlled by ratio of water to pigment, number of glazed layers and by hue. No black or white paint was used.

Every decision was design-driven with each addition depending on everything that had preceded it. Each addition would affect the whole and give direction to what needed to be done next.

The painting gave me direction every step of the way. There was no preconceived idea or subject. The process was completely intuitive and emotional. Every change was evaluated by asking, "How does it feel within the composition? How does this affect the whole?" And then, "What needs to be done next?" There were frequent "study breaks" to step back and contemplate the progress or lack thereof. Careful attention was given to value, color and temperature changes, the fabled "push-pull effect, step by step, shape by shape, by themselves and within the composition.

Glazing and a little lifting were the main painting techniques I used. This allowed for a richness of color that might not have been achievable any other way. There is no recognizable or traditionally realistic subject matter in evidence. The viewer is free to find or imagine whatever subject the image may suggest. Or the viewer can simply enjoy design elements as being the subject matter like shape, color, value transitions. The joy of abstracts is that they don't have to be seen as something else, something recognizable, to be of value; their beauty lies in their being free to simply be themselves: beautiful shapes, colors, etc.

The painting was done when it felt done, a balanced whole that felt complete within itself. I asked the painting for a title and it suggested the delicacy of musical chimes to me. I imposed almost nothing on the painting; I listened and paid attention, and it led me through the process from start to finish.

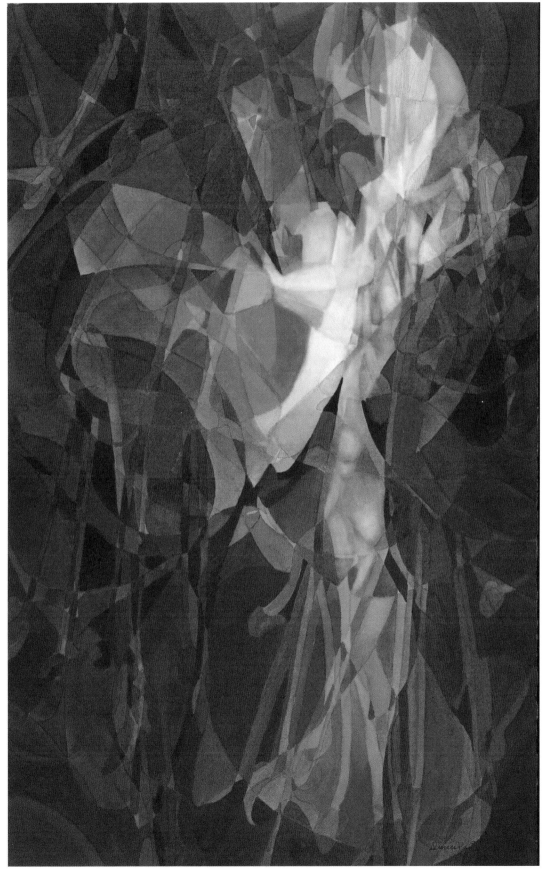

**Garden Chimes
Martha Deming,
TWSA
Transparent Watercolor
20" x 13"**

This painting began with the fuschia plants that I hang out for the hummingbirds each summer. I photographed the blossoms and made three 20" x 25.5" drawings based on my photos. The three drawings were then traced onto one 20" x 25.5" page of scrap paper. This gave me an almost indecipherable and rather chaotic collection of shapes, the "raw material" from which I could then create an abstract painting. The combination drawing was then traced onto a 20" x 25.5" sheet of Arches 140 lb. cold pressed watercolor paper. It was time to study the raw material and decide how to bring order out of chaos in a beautiful way.

I looked first for directional movement and second for possible center of interest placement. My color palette was based on the natural colors found in the fuschias, mostly pinks, reds and greens. I then started applying very light washes over large areas covering groups of shapes, reserving a big white area at the center of interest. In designing the white shape, I kept in mind the advice of Edgar Whitney to make it "irregular, oblique, and unpredictable". Initial washes were followed by glazes of light to medium values. Darks were added as the painting progressed so value relationships could be evaluated throughout the piece as it progressed. Slowly I began to work from large multiple-shaped areas to smaller individual shapes, turning the paper and working from all four sides, always focusing on directional movement, value structure and color pattern rather than the actual subject matter. Every decision was design-driven. The blossom shapes became a vehicle to abstraction, not an end in themselves.

Through many steps of glazing and lifting, colors and values were developed and modified. The red-green complementary color scheme emerged on its own. Red was dominant with green as the counterpoint. Each was echoed throughout the partner color to achieve balance and unity. This was done mainly by layering glazes. Verticals and diagonals and curvilinear shapes were selected by value and color contrasts, and repeated to contribute to the sense of unity. There were frequent "study breaks" to judge the progress of the design and to decide what was needed next. Eventually the painting felt finished, felt complete, unified and in balance, a very intuitive and subjective moment to be sure. Nothing jumped out at me as not belonging, nothing seemed to be lacking. The subject matter is only hinted at in the final design. The hints may invite the viewer to consider the image further, to explore and imagine according to his or her own ideas and feelings.

This design-driven process, inspired by the teachings of artist John Salminen and others, is very intuitive, emotional, and unpredictable. At the start of each painting, I never know how the piece will develop. Each thing I do influences what the next thing will be. The paintings really do speak to me as they progress, telling me what works and what doesn't. They have taught me to pay attention and listen carefully. Over the years I have heard and read that one should paint one's feelings about the subject, not the subject itself. Easier said than done, but I think this piece moves in that direction. It captures the feeling or essence of the fuschias and the awe I feel at their complexity and beauty, rather than the surface appearance of the blossoms themselves.

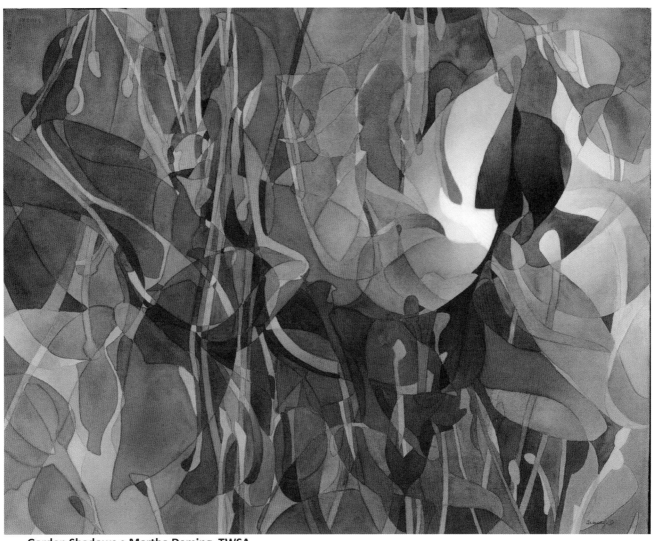

Garden Shadows • Martha Deming, TWSA
Transparent Watercolor, 20" x 25.5"

Marilynn Derwenskus

To me, the word "experimental", as it relates to the visual arts, implies exploring new strategies with one or more of the four parts of Art - technique, form, subject, or content. Those who clearly seek differences, newness, the novel, the unique or avant garde are experimental artists. This painting is experimental because I focused on different strategies toward the four parts of Art.

In Nashville, Tennessee, I enjoyed a day of different activities: laser tag, line dancing, and burgers at the White Horse Saloon. These experiences contributed to the development of my painted image although, at the time, I did not realize or expect this would happen. I gathered information in my sketch book from these life experiences. I sketched the people coming and going to play laser tag. I made

into my painting.

Except for the ongoing use of a long, narrow horizontal paper, I began the painting without a specific plan. I merely applied a randomly selected pale pink fluid wash in a loose, painterly manner. Backwashes developed. I liked that. Gradually my image emerged from the painting process itself, in tandem with life experiences. Those Nashville sketchbook notations translated when my favorite strategy - difference - paved the way.

The most important strategy in creativity for me is "difference", as many and as vast the differences as are possible within a painting - different materials, different techniques, different compositional strategies, different colors, different subjects painted in different ways to convey different ideas. Concern for

gesture drawings of line dancers. I wrote a verbal description of my observations and reactions. I glued bits and pieces of Western-themed images from the children's menu into my sketch book. I liked the juxtaposition of different marks and different stylistic strategies to present information. Little did I know that these juxtapositions would find their way

unity strategies did not exist because my artistic execution and thought automatically unified the painting. While my artistic training included learning the elements and principles of art, I now know I do not have to adhere to such rules in order to create Art. Strong, potent Art, developed with emphasis on the difference strategy is most significant though.

Perhaps because I loved the challenge of re-solving problems and deemed this as the pin-nacle of artistic success, I eagerly engaged differences without fear.

As I developed Laser Tag and More, I used different materials - watercolor pencils and Sharpie marker combined with transparent and opaque pigments. Different techniques - washes, backwashes, fluid painting, flat paint-ing, scribbly lines - were combined to present different subjects - horse, cowboy boots, corral fence, stairs, and Welsh patterned bookmark. Compositionally, I avoided placing any shapes in the center of the painting. Instead, I used a vertical location strategy at the paint-ing's right side to force spatial development while the left side employed a narrative bor-der. The left top edge shapes refer to the laser tag experience with tiny black spots shot across the painting. In general, most signifi-cant imagery is placed at the edges instead of a central location - a favorite device of mine.

This painting presents a collection of differ-ent subjects as a visual treat addressing a day in the artist's life: horse containing a maze, cowboy head, pen or brush, and more. The relationship of these subjects is unclear except to reference the unplanned appearance and disappearance of things seen and experienced. I liked altering the viewer's expectations of painting by employing unexpected devices - juxtaposing differences was how I achieved this. Seeking visual differences linked Laser Tag and More with experimental art.

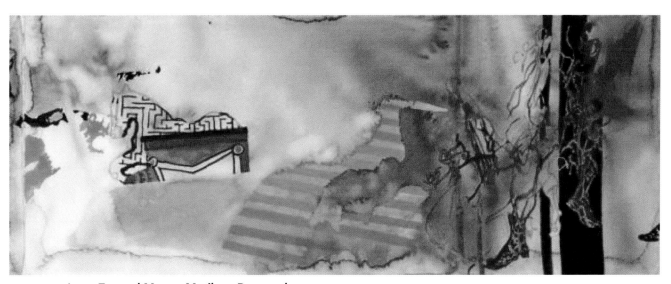

Laser Tag and More • Marilynn Derwenskus
Transparent watercolor, gouache, watercolor pencils, Sharpie pen, 8" x 38"

For me, painting is a creative process that proceeds from the unknown to the known, that begins without a precise painting plan or expected outcome. This process of development includes four stages: exploration, discovery, transformation and communication. In each stage the four parts of art are addressed: technique, composition, subject, and concept.

The exploratory stage of this painting began by positioning various porous papers, such as paper towels and Kleenex, over watercolor paper. Then I mixed a small quantity of tube pigment with water and poured the paint onto my paper. This was repeated several times with different colors in different areas.

pers and seeing the outcome. I must admit that this was the most joyful part of the process for me. To perceive what occurred without a precise plan was an exciting discovery!

What to do with the colors, shapes and textures that appeared on my paper from pouring? How would I organize these fragments into a unified whole to communicate an idea? These questions were answered as I discovered intricacies of the painting.

Considerable time was spent studying the poured paint outcome, turning the paper upside down to see compositional possibilities, even to determine the top of the painting.

I preferred to continue along a path of un-

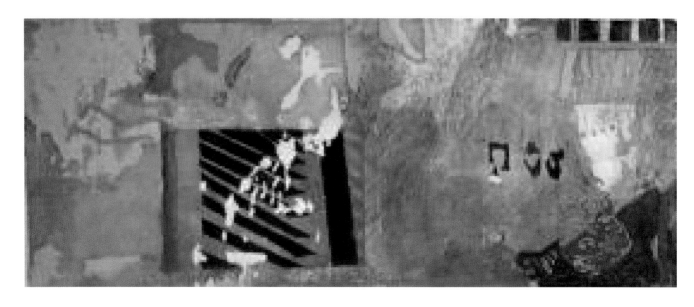

Though initial thought was given to the compositional arrangement of the porous papers, the unpredictable nature of fluid paint often resulted in unanticipated textures, shapes, or colors. I considered that to be a special bonus to achieve new and fresh results. Sometimes, no color penetrated through to the watercolor paper. It was important to not disturb the textural patterns forming as the pigment dried by peeking beneath the porous paper overlay. Patiently I waited for the pigment to set until it was nearly dry before removing porous pa-

predictability, seeking the unusual and unfamiliar by identifying what should be done and then doing the opposite. Without a doubt, ignoring the beautifully textured surface and adding paint was the most difficult decision to be made.

After pouring outcome admiration subsided, I evaluated the quantity of color versus the white paper where no poured pigment adhered. I preferred a dominance of either color or white paper, but definitely not equal amounts. I noted small white spots and decid-

ed to fill some with a hue that matched surrounding areas so that spottiness was reduced. My personal preference for some white paper remaining unpainted caused me to proceed cautiously since once the whiteness was eliminated, it was impossible to regain it. White paint could be applied, but I preferred white unpainted paper. These and other discoveries initiated the translation process.

I noticed that the textural shapes imprinted from the pours were both organic and geometric. A recent interest in the bridges and architecture of Chicago prompted me to examine some photos from a boat tour along the Chicago River. Sections of these images lead to abstract forms, a combination of the textural

even liked the rectangular edges of the photo so I immediately defined and developed this area as a painting within a painting. Almost at the same moment, I recognized architectural stripes created by vertical rows of windows and painted the black stripes. They provided strong visual impact in the composition and that pleased me.

Artists, similar to writers, musicians, playwrights, choreographers, and others who created Art, spent time creating new and beautiful forms that communicated their ideas. Why would these creative people make Art if they had nothing to say? While I absolutely believe artists should communicate ideas visually during times of artistic and personal transi-

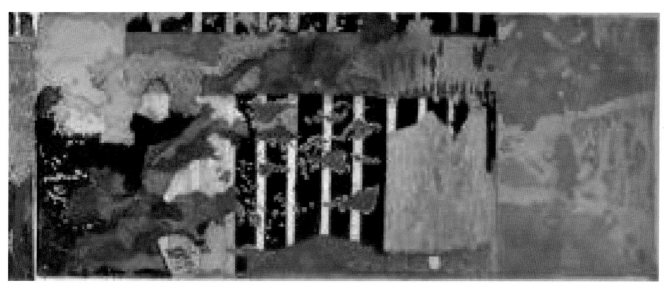

Launch • Marilynn Derwenskus
Transparent watercolor, gouache, 8" x 39"

mark/shapes and a translation of building/bridge details. Finally, the time spent exploring poured pigments and the discovery of beautiful, yet unplanned and unexpected outcomes, suggested a painting subject and content - the serious work of an artist was launched.

I noticed a photo that I had dropped on the painting. A close-up view of some skyscrapers seemed an unexpectedly good image to weave over and under the poured color/shapes. I

tion, ideas communicated may lack universal impact. This painting has this title because it launched the beginning of a painting series focusing on changes in my life - my Chicago relocation and new artistic directions. It is the union of technique, form, and subject that permitted me to develop Launch which communicated my ideas. My developmental process began with exploration and discovery and concluded with translation and communication.

Joan Dorrill

Falling Leaves was part of a series of eight paintings. The paintings were all painted with Liquitex and Golden acrylic tube paints on vertical Fredrix shallow wrapped canvases. I used the shallow wrap so that any one of them could be framed easily if someone wanted to do so. I also had in mind that each painting would be designed in three vertical columns. At the time, I was also experimenting with acrylic metallic paints and each painting was to have a small ratio of metallic paint to flat paint.

In the beginning I did not know this painting would contain leaves. To begin Falling Leaves I first painted the canvas in an overall pattern of bright colors using them straight from the tube. I brushed each of these onto the canvas separately with my 1½ inch synthetic Loew-Cornell brush # 7550. Once this was dry I began painting on top of this paint layer. I mixed very bright colors and painted with the brush to get my middle column. I then mixed the darker colors for the outer columns and painted those with very loose edges. During this second layer of paint I allowed some of the underpainting to show through.

While applying the third layer of paint I begin deciding how I want to use collage elements and how to refine the colors in the columns. From my closet I found just the fabric to use in this piece. I loved the colors and metallic threads in a vest that no longer fit. I cut out leaf shapes in different sizes and then glued the leaves down with undiluted Liquitex matte medium.

The colors in the fabric helped me to intuitively decide on the final refinement of the background colors. I continued to look at the leaf shapes while I painted in the final layer.

The gold threads in the fabric led me to add a bit of gold glitter for a finishing touch. To do this I painted matte medium on the areas where I wanted the gold dust to show and then sprinkled gold glitter into those areas. After it dried completely I carried the canvas outside and shook off all the loose glitter . I now had a completed and glitzy painting to hang in my upcoming art show. I used a small round brush to sign the painting and let it dry. The next day I attached the wire for hanging and it was ready to go. This painting was one of those rare ones that flowed easily from start to finish.

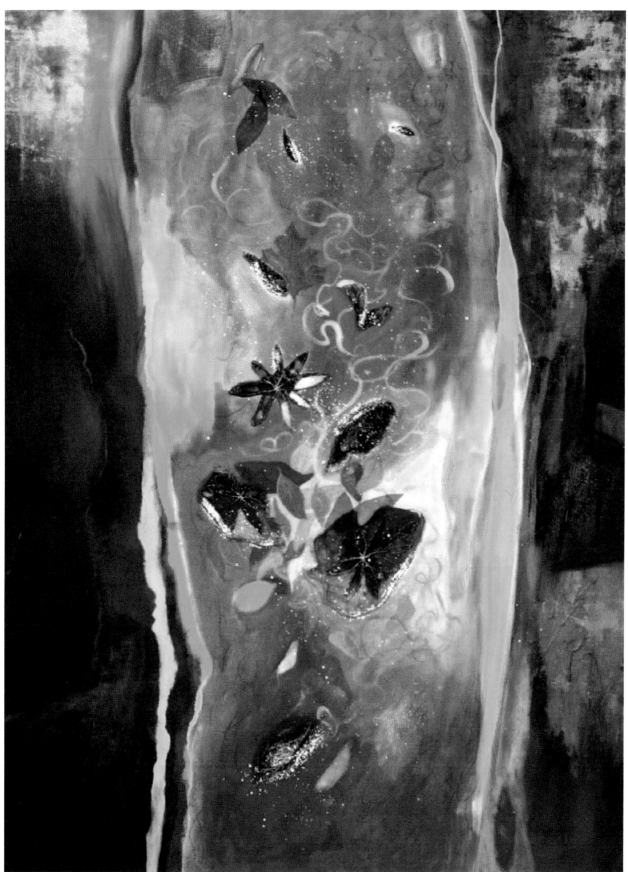

Falling Leaves • Joan Dorrill, ISAP
Acrylic/fabric collage on 5/8 inch wrapped canvas, 40" x 30"

For my first layer of paint I began with a large Fredrix Gallery Wrap canvas and my brightest Blickrylic Student liquid acrylic paints. These work quite well for an underpainting. I brushed on a large unplanned abstract pattern covering the entire canvas, including the outside edges, with different colors. I used a 1½ inch flat synthetic Loew-Cornell brush #7550. I let this brightly colored but unfinished abstract design dry overnight. While I love bright colors I was prepared to cover most of this with my second layer of paint. Using the same paints I mixed different shades of blue and painted blue squares all over the canvas in a grid pattern, letting some of the bright colors show through. I did not measure and draw straight lines as I wanted them to be loose and imperfect. The painting dried while I made a stamp to print a pattern on top the blue squares.

The printmaking stamp was constructed out of a foam meat carton. I first cut a flat shape from the bottom and drew a spiral design with a ballpoint pen pushing down into the foam. I mixed silver, gray and blue Golden tube paint which was then painted onto the foam design with a 1 inch flat synthetic brush. Each square was hand-printed and I repainted the foam stamp after each printing. It was time to let it rest for a while and take time to figure out the next layer of paint. I always put at least three layers of paint on a canvas painting.

At this point I liked the colors of the silver gray spirals so much that I wanted to have the whole painting in different shades of silvery gray.

Changing my paint to Golden and Liquitex professional artist's quality, I began mixing lots of white with black and small amounts of greens and blues that were previously used in the painted squares. I started blocking in these cool shades of grays using my 1½ inch flat brush, covering most of my blue squares but allowing some of the underpainting to show through and added some warmer shades of tan. Allowing some of the underpainting to show through lets the viewer see some of the history. I then blocked in darker shapes of grays and browns to divide up some of the space and darkened the top. This was a design decision so that I could have about two-thirds light and one-third dark. All the while I was also printing some pattern into the painting with my handmade print stamps, bubble wrap and corrugated cardboard. This placed repeated patterns onto the design and helped add more interesting texture.

By this time I knew I would put a circle shape in for a focal point and I wanted it to be very light in value. This would be a collage element made from brown textured packing paper. I cut it into a circle and painted it with white gesso, then tore some of the circle away and glued down what was left with Liquitex acrylic gloss medium and some heavier gel medium made by Golden. I made the darker ring around the circle by holding a string in the middle and tying the outer end around my small round paint brush and painted it on. To do this you hold the brush straight up and down.

The circle had now become a moon in my mind so I stamped on fantasy musical note symbols to make it look like the moon was singing. These are printed in light, medium and dark tones to represent soft, medium and loud sounds. Thus, my fanciful trip to the moon is concluded.

Singing Moon
Joan Dorrill, ISAP
Acrylic/paper collage on deep-wrapped canvas
60" x 36"

Glenda Drennen

Doors have featured prominently as a personal symbol in my recent work. In fact I have painted a whole series of doors, all found on a fictional street somewhere in France. I call my street "Rue Rutabaga" simply because the fanciful name seems a good fit for these light-hearted paintings.

Although I love serendipitous starts for paintings, with no predetermined subjects and plenty of room for happy accidents, from the start "Maisons de Rue Rutabaga" was a painting of three doors. However, I knew nothing else about where this painting would take me.

Working on Arches 140 lb. cold pressed paper, I first created three unique doors composed of irregular geometric shapes and patterns. I drew each with a brush dipped only in clean water before dropping in Anthraquinone Red, Viridian Green, and Quinacridone Burnt Orange watercolor pigments, using some of each color in every door. I tipped the paper so the colors mingled and ran to fill each wet shape. With a stick, I coaxed some of the drips at the top of the red door into a rectangular outline that later became a frame for a house number. Since the painting begged for some texture, I mixed a neutral gray from the same pigments and sponged that through a scrap of coarse metal screen discarded when my roof was reshingled. Then, unable to decide what to do next, I set the painting aside.

Months later, still undecided about how to proceed, I used the computer to manipulate a photograph of this work in progress with Adobe Photoshop Elements.

This sparked creative ideas and solutions to design issues rather than creating an image to be precisely replicated on my paper. Using the computer, I planned an effective, irregular line for the bottom edge of the wall. My computer sketches told me that dark, neutral texture would suggest an aged building of stucco or stone. Semicircular shapes in the foreground walkways, as a repetition of previous semicircles, also emerged during my experiments in the computer.

With these choices in mind, I was ready to proceed. I applied several uneven, neutralized glazes of transparent watercolor around the doors to add depth and value. Then I outlined stones with watercolor pencils and added a watercolor glaze to make them stand out. The wall still needed to be darker and rougher, so I weighted pieces of crinkled plastic wrap in diluted glazes of black and brown acrylic inks. Anthraquinone Red watercolor, sponged through the same metal screen, repeated that grid texture both on the building and in the foreground.

I taped torn and cut pieces of junk mail postcards to mask the edges of the sidewalk shapes, then splattered neutral mixtures of watercolor pigments to darken the walkways in stages.

The painting was nearly finished, but an uncomfortable dichotomy existed between the rugged walls of the building and the relatively pristine doors. Judicious splattering of some watercolor related them nicely.

The three doors in this painting suggested to me that inside were shops. My imagination soon made the leap to a trio of small businesses here on Rue Rutabaga - "The Butcher, The Baker, The Candlestick Maker." I speak not a word of French, but with a little help, the shop identities were translated and posted on the signs.

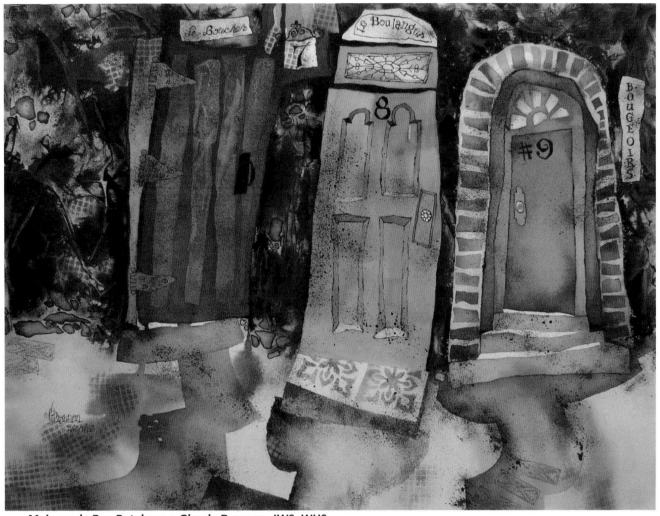

Maisons de Rue Rutabaga • Glenda Drennen, IWS, WHS
Aquamedia, 22" x 30"

This painting might well be considered a metaphor for the proverbial tiger who changed his stripes. Initially finished in 2000, it was a conventional transparent watercolor on Arches 300 lb. cold pressed paper. But by 2010 the painting style no longer fit with my current work, so I set it aside to be destroyed. Reconsidering, I asked – why not radically change the personality of this "tiger" by adding texture, and by changing the value plan, color scheme and edge qualities?

Several issues about the original painting bothered me: 1) The analogous colors seemed too bland to depict the riotous colors of fall leaves, 2) A dark background behind lighter-value leaves seemed oppressive, and 3) Hard edges and smooth washes dominated.

I plunged in to find solutions. First I used a firm foam brush to scumble opaque aqua-blue acrylic roughly over the background. The initial brush strokes seemed terribly out of place, but I soon started to see the benefits of this dramatic change. The complementary color definitely gave the orange and yellow leaves more zing, plus the new, lighter-value background was no longer ponderous. Since the aqua-blue acrylic didn't entirely cover the slightly rough cold pressed paper, bits of the initial background showed through, providing visual texture and relating the colors of the background to the subject. Conventional wisdom holds that transparent recedes and opaque advances, but I found it visually exciting to paint an opaque background behind the transparent leaves.

The next step in the transformation was to collage torn paper from my considerable collection of dyed artist tissue to darken and add texture to some of the leaf shapes. This is Spectra artist tissue paper that I paint and dye with acrylic inks, paints, and mediums, so I have a full range of colors and values from which to choose at all times.

I then altered most of the hard edges by scribbling lines on the edges of the leaves with the droppers from bottles of black FW acrylic and Dr. Ph. Martin's antelope hydrus watercolor inks. Spritzing the wet inks with water made them run slightly, forming rough, web-like edges.

I used a purchased plastic stencil cut in a scroll pattern to add texture to some leaf shapes, alternately removing pigment by scrubbing through the stencil with a toothbrush and adding color by daubing casein pigment through the stencil. Tracing around the stencil with a fine brush and black acrylic in the background further integrated the elements in this painting.

This transformation of an older painting was so complete that it warranted a new, descriptive title, "Tattered Veils of Fall." The first painting was matted and framed under glass. I chose to mount the new version on a 2" deep cradled Aquabord for a no-glass presentation, and protected the painted surface with several thin coats of Liquitex acrylic Gloss Varnish.

When I first grabbed this tiger by the tail I wondered if was possible to change a controlled painting with hard edges and smooth washes into something bolder with texture, freedom and surprises. Happily the answer was "yes," and I can report that the painting was the first to sell in a recent show.

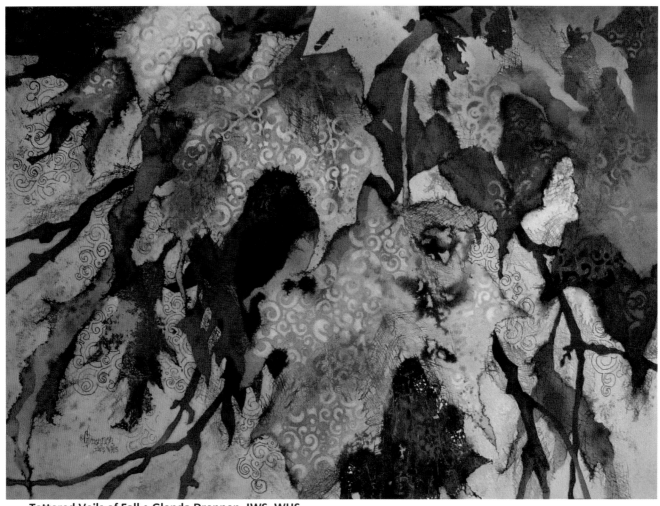

Tattered Veils of Fall • Glenda Drennen, IWS, WHS
Aquamedia, 22" x 30"

JoAnn Durham

The mysteries of the cosmos intrigue and inspire as these forms of energy dance across the universe light years away. Moving patterns in the galactic darkness are expressed with shape, form, line and dimension. In the making of abstractions I disregard the brush and allow the gesture drawing with wax to metallic powders enhance the vibrancy and the wealth of counterpointed cadences. A dance of sweeping and curvilinear white lines compels the viewer back to the cleanliness of white paper as they describe open and closed forms.

Arches 300 lb. hot pressed watercolor paper, liquid acrylics, metallics and encaustic are the media used.

A double boiler on the stove is used to heat the wax mixture. Dip the Tjanting tool into the boiling water to clean out the wax in the tool. Fill the tool with hot wax.

Begin drawing on paper which is completely dry. Listening to Strauss waltzes performed by Andre' Rieu, I draw expressive lines. Shake out a few drapes of wax to make interesting shapes. When the drawing is finished, dip the water outside. Let the pan cool off with the wax which can be saved for another drawing.

Pick out three liquid acrylic paints to pour. Use a large brush with clear or distilled water and saturate the paper. When the water begins to roll, pour on the paint and also a powdered metallic. The paint will blend, move and make other colors.

At this point, let the painting stay flat for approximately 24 hours. It will be dry. Take an encaustic iron (Proctor Silex) and place the painting between two sheets of newsprint. Iron on top of one piece of newsprint and the wax will come off. Go over this several times until all the wax is removed.

Draw your shapes. Using several different glazes of blue pigment, paint until the background is finished. Dry between each layer.

The final process is the encaustic. A special electric drawing tool is used to place on the dots of color. Several colors of encaustic are used. Placing the dots takes many hours and this pointillist approach adds dimension the work.

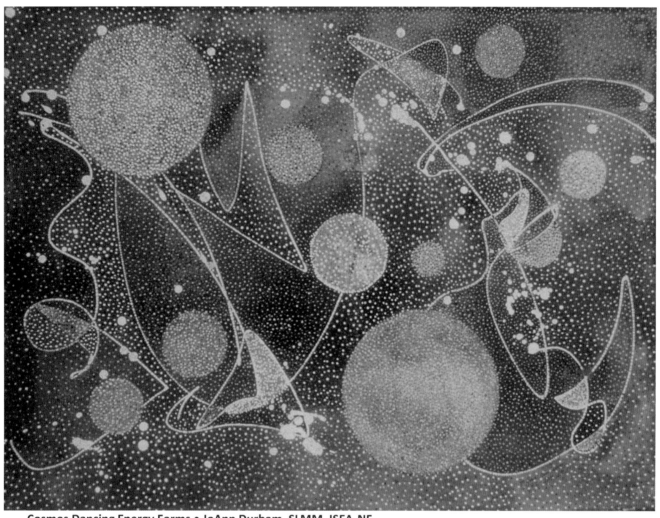

Cosmos Dancing Energy Forms • JoAnn Durham, SLMM, ISEA-NF
Mixed Media

Michael Edman

I try to communicate my passion, concepts of the mind and emotions of the heart. My design concepts are often rooted in patterns and imagery from many cultural beliefs and motifs that have shown up in history. There is purpose in my art. I hope the observer sees and feels this depth and meaning in their own heart and mind.

I used a Fredrix Gallery Wrap Canvas. I applied and lightly sanded 2 coats of white gesso to create a smoother surface. Using some historical motifs as inspiration. I used a compass, a straight edge, and pencil to create the overall design. Accurate measurements in this painting were important for symmetry in the design.

My choice of paint was Golden's fluid acrylic paint. Using primarily ½" and ¾" Silverwhite angular brushes, I used primary and secondary colors to create the base shapes. Let each layer dry before continuing. As I applied additional coats I added a small amount of Liquitex matte medium to my paints to create more transparency to each layer. I applied some outlines throughout the layers, using transparent fluid paint and various sizes of script brushes.

The textures were created in two different ways. The primary textures were created by painting a section or shape with an overall semi-transparent color. Laying standard

Bird and Fish • Michael Edman
Acrylic, 1½"x24"x36"

56

sheets of kitchen plastic wrap on these areas and moving the wrap in various ways created interesting patterns. Again, let each area dry before continuing.

The other texturing method was using two or three types of sponges. The material used varied, from a sponge, to a rag, and sometimes with balled up plastic wrap.

The last layer of paint I applied outlines using opaque fluid paint and various sizes of script brushes.

After achieving my desired overall look, I used Liquitex gloss medium and varnish, applying two coats, letting it dry about 4 hours before applying the second coat.

Michael Edman
Flowers and Fish
Acrylic
1½" x 24" x 36"

Sharon Eley

I enjoy the beauty of nature and the organic shapes nature creates so I include nature in most of my artwork (trees, leaves, shells, dragonflies, etc). I called this painting "Eternal Serenade" because it reminded me of how all of God's creation is an eternal serenade of sounds and colors throughout each season of the year. I wanted this work to feel peaceful and create a sense of well-being through the use of color and shapes.

I chose the Golden fluid acrylic triad of Quinacridone Nickel Azo Gold, Quinacridone Crimson and Phthalo Turquoise because of the intensity of Golden's colors. Any triad of three primary colors can be used depending on your personal preference. Black gesso or paint was added to different colors to create darker values. White fluid acrylic or white gesso was added to create opaque colors. Sometimes both black and white were added to a color to create a deeper opaque color.

I work with a lot of my own painted papers as I have found that many purchased papers fade in the sunlight or over time. I also work with black and white images of trees or plants I have photographed and saved as JPEGS on my computer, and pen and ink line drawings I have created in my sketch book.

Before getting started, I painted a number of tissue papers in each color that I planned to include in my artwork, using a dilute solution of 1:1 or 1:3 fluid acrylic and water. More water can be added if a more transparent color is needed.

By the time I am ready to start a project I have a stack of approximately 50 to100 painted tissues in different hues and shades of each triad color, including opaques. I especially enjoy the neutral colors, creating different shades of "tan" or khaki. All painted papers can be either used as part of the underpainting or stamped and used as texture pieces on top of the underpainting.

In creating the painted tissue papers, I laid the desired size of tissue papers (approximately 15" x 20") down on a sheet of plastic which had been cut from a white plastic garbage bag (with no print). I can usually place 3 sheets of tissue on each plastic bag. I mixed my paint with water in a plastic cup and spritzed the tissue lightly with water before applying the paint with a 1 inch watercolor brush. The tissue is allowed to lie flat and dry completely and then is pulled off the plastic. This procedure is repeated over and over until all the desired number of colors, shades, and opaques of each color is acquired.

I used a brayer to apply contrasting paint on top of some of my painted tissues to create texture with the brayer itself. On top of this texture I also stamped images using my handmade stamps. Black was applied to tan tissue and tan was applied to black tissue to create a "push and pull". On some pieces I used the stamp twice, once in black and then in tan or visa versa.

Making my own stamps for texture makes my artwork more unique and individual.

Stamps can be made with magic foam, string glued to mat board, cut foam glued to mat board, dried fruit, mat board shapes glued to mat board, hardware cloth, bubble wrap, carved erasers, etc.

I coat selected handmade stamps with gloss medium on both sides to make it waterproof and easier to clean when finished.

I use some purchased stamps if the design works into my composition. I generally use black gesso or Golden carbon black for my stamping "ink", brayering it onto freezer wrap paper to even out the thickness before stamping with it. I found that working in an assem-

bly-line style was helpful in creating an adequate number of both my colored tissues and my textured, stamped tissues.

Before I started I placed a foam core support under the center of the canvas so the center wouldn't sag while I worked on the surface.

In putting my collage together, I started with attaching black and white papers to the stretched canvas first, as part of the underpainting. Placing the blacks and whites helped me to decide where to place the colors as I worked. This included my black and white digital images, the black and white painted tissues, and copies of my black and white sketches, torn or cut and varying the shape and size. I glued these down on my canvas using a mixture of two-thirds gloss medium to one-third water. I kept the elements and principles of art in mind, changing the shape and size of my pieces and repeating the color on each of three or four sides of the canvas as I worked. Paper toweling was placed on top of each piece of paper as it was applied and a brayer was rolled over to secure the paper or tissue in place.

Next, I placed colored tissues on the canvas. I was aware as I placed my different colors that I was covering up much of the previous layer of color.

So, with each layer of color came new decisions in following the elements and principles of design. Some of the images showed through the tissue, while others didn't.

After all layers of color were glued down and dry, I started introducing the solid neutral colors and the printed or stamped neutrals. These were laid onto the surface temporarily and adjusted in location or size several times until I found the "balance. Some of these "arrangements" were photographed before I settled on a final conformation. The neutrals were then glued down. For heavier papers I used soft matte gel.

At this point I had to decide where my focal point was going to be (near the center) and how I was going to present it. I wanted the painting to feel "ethereal" and have a "flow". I introduced a piece of tissue that I had sandwiched string between and left the strings hanging. I then added a neutral in the center from a handmade string stamp. A painted piece of cheesecloth was glued down under the focal point and attached to two edges of the canvas. The ginkgo at the top had been pressed and dried, then painted with Golden Iridescent Bronze for the finishing touch. In this piece, I used the grid format and varied it.

The edges of my canvas were painted black and two coats of varnish were added to the surface to seal it, drying between each coat. Each coat consisted of one part gloss medium varnish, one part matte medium and one part water.

I hope you enjoy viewing my art as much as I enjoyed creating it.

Eternal Serenade • Sharon Eley
Acrylic, mixed media, 20" x 20"

Cheryl Fausel

This painting was done on Arches 140 lb. watercolor paper with a rough surface. Before I start work, I plan my color scheme and subject matter. I wanted to do a piece of work with a warm color sense, which was not my norm. I live in Europe part of the time, so I was interested in using photos in my collection from my time there. My goal was to have a "classic" feeling to this piece. I chose a photo of a door that I had taken in the town of Aix en Provence, France. I proceeded to manipulate the image and save it in various sizes, directions and coloration.

I then printed these images on transfer paper used to iron images onto T-shirts. I used the papers for white T-shirts. With an arrangement of various sizes of this image, I cut out what I wanted to use in my painting. Keep in mind that the transfer paper is waxy and does not take paint easily, so it was important to be very selective as to what parts I would iron on the paper. At the same time it was also important to think in reverse. I then ironed them onto my paper, according to directions. This might mean flipping the image before printing it.

I am attracted to the geometric in conjunction with the loose and flowing. I then proceeded to lay in the background colors with a combination of watercolor and white acrylic paint. I had complimentary colors working for me, oranges and blues and tones in between, as well as repetition of form and contrast, nature to manmade architecture.

I did a lot of painting around the images to diffuse the lines, to create a flow from the painting to the added images. I added the posts with negative painting to give the painting an added dimension. To create a bit more looseness within the work, I added bits of rice paper glued with matte medium to the surface, and used brush and paint to integrate them into the surface.

Looking at the overall painting, I felt the need to increase interest in the background colors and at the same time add more structure. I then cut out from the local magazine the letter "n" and used that as a stencil floating through the painting to give it an added sense of interest. Sometimes I laid the stencil in and painted around it and sometimes I drew it in and painted just that surface. In areas where I felt that the painting was too tight, I used a loose definite brushstroke going in a consistent direction to loosen up various areas.

Just as I thought I might be finished, I saw there was nothing happening in the major door, which was the point of interest. I photographed an old lithograph hanging on my wall, decided on the size and printed it out in a sepia tone. I glued it down with matte medium within the door. I then tried to integrate the image into the door, without having definite edges. I tried to make sure there was a light area and some very dark areas framing my area of interest. My final step was the calligraphy of the loose white lines. I first drew them in with chalk, so I could control what was happening and see if they worked where I put them. I then used a fine brush loaded with white acrylic paint to add the lines.

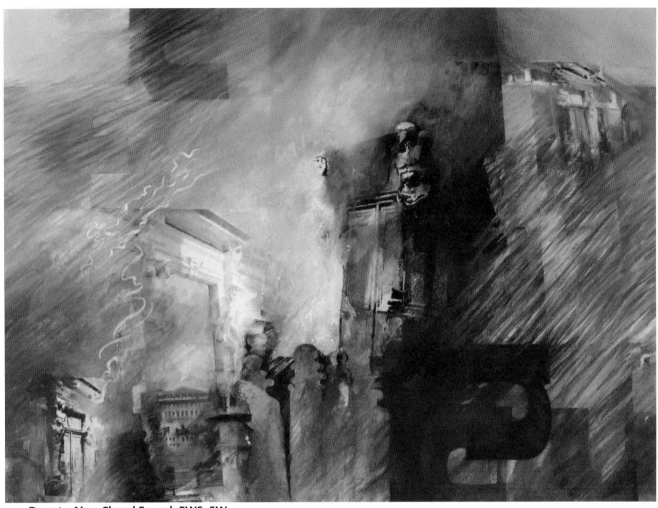

Door to Aix • Cheryl Fausel, FWS, SW
Mixed Media, 21" x 28.5"

This work is one in a series of pieces with images of doors. The door image was taken from a photo of a town, Le Beau, in the south of France. I took just the door image out of the photo, determined the size needed and printed the image in black on a piece of 3M acetate transparency (in my case for an inkjet printer). Laser printing or Xerox won't work. One must be careful that the image prints on the rough side.

I then applied the gel to transfer the image to be pasted into my painting. My paper is Arches 140 lb. watercolor, cold pressed. To adhere the image to the paper, I used an acrylic clear tar gel for my transfer. When printing the image, think in reverse, especially if you have lettering in the image and want it to read correctly. I put the gel on the image and over the area I wanted it to be pasted onto, waited a bit and then pressed onto the paper. It helps to use a brayer. Once I had the image on the paper, I carefully wiped away all the oozing gel around the images. The transfer is very fragile. It took a while for the gel to dry so one must plan for this. The flower pot images were also worked in the same manner. The palm tree was a transfer using an ironed-on image printed on the papers used to put pictures onto T-shirts. Because of the glossy surface it is difficult to paint over but persistence and acrylic help. With this difficult surface to paint over, make sure you cut away anything you do not want in your painting.

Adding the background colors was a way to integrate the transfer images with the paint to create a whole. I used watercolor paints, acrylics and water soluble inks to enhance the surface. In order to maintain a sense of unity to the piece, I used the color blue to give the whole piece a feeling of color dominance.

I broke my surface into a geometric design. In pulling the various areas together I used grids such as the form used in hook rugs and the base with square format used in embroidery, to add texture and tension to the surface. I used a toothbrush to spatter paint using these grids as stencils. All images added to the surface are integrated into the painting with paint, including the flowers in the flower boxes. In the upper right corner I used a doily as a stencil, painting over it. When it was dry I lifted the doily and then laid in an arrangement of dried flowers and natural shapes. Using Pat Dews mouth atomizer, I blew paint into that area of the painting and acquired the floral forms. When working with a mouth atomizer, it's important to have an area where it doesn't matter where the paint goes. I build myself a 3-panel enclosure out of foam core board and hinge it with masking tape. I then use a plastic tablecloth to protect the table that I set my enclosure on and drape it onto the floor. I start high up with the atomizer. I do a sample blowing on newspaper to get the color and intensity of the spatters correct. I block all areas of the painting that are not to be blown into with newspaper and masking tape. Make sure there are no holes anywhere so the paint doesn't creep in where you don't wish it to be.

I then layered with a few more coats of blown paint, and used the square grid as a stencil to add more interest and carry through the geometric design into the lower corner. I also repeated the same floral forms in the lower corner but not as strong in color. I love the results of spraying!

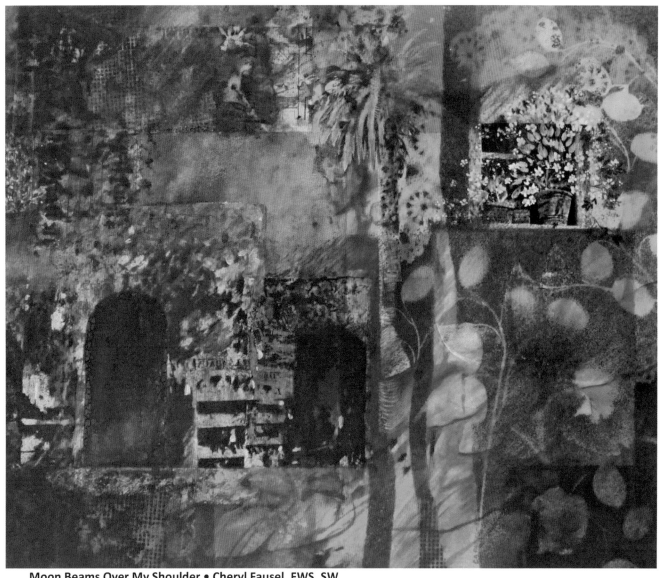

Moon Beams Over My Shoulder • Cheryl Fausel, FWS, SW
Mixed Media, 20.5" x 24.5"

Elizabeth Fluehr

As my husband and I drove through rural France, I snapped quick photos including a flock of chickens posed at the roadside. The most prim and proper of the group, whom I later determined was the mother superior, stood erect and alert monitoring her charges, and she became the subject of this painting.

Although Mother Superior was appropriately dressed in a black and white habit, I decided to invigorate her with playful use of color and to ruffle her feathers a bit for the sake of liveliness. This ruffling started with a quick paint-sketch done with the oldest, ugliest, splayed-bristle brush I own. With acrylic paint on this ugly brush, my paint-sketch was composed of crude clumps and strokes. Then, on tracing paper I drew around the most appealing brush marks of the paint-sketch, and reduced them to enclosed shapes. Mother Superior was still recognizable as a chicken, but a new flamboyance was emerging.

Now, if the truth be known, I originally selected not only Mother Superior to be in my painting, but one other chicken, presumably a novice. I also invented a swirly background, done as a separate paint-sketch with the ugly brush. I traced the best brush mark shapes from each of these three elements onto separate pieces of tracing paper. Then I scanned them into the computer, and used a paint program to resize each and to overlay them into a satisfactory composition. After enlarging that composite drawing, I transferred it onto Rives BFK printmaking paper, and painted the shapes with a dynamic selection of watercolor pigments.

After many hours of effort, I decided that the colors were just too gaudy and the scale too small for so much complexity. So I rejected that painting without completing it and started fresh.

At this point Mother Superior became the solo character in my design. I studied the original shape-drawing of her in the computer, and used a distortion tool to plump up her plumage to better fill the painting format. I then projected this new version onto Rives BFK paper, which I love because of its ready acceptance of visual textures.

Since I wanted to return Mother Superior to a level of dignity that had been lost during the previous attempt at bright colors, I limited this second painting to only two tubes of watercolor, Indigo and Quinacridone Burnt Orange, complimentary semineutrals. As the painting progressed, I was thrilled with the beautiful range of neutral colors achieved by mixing just these two, and also with the appealing textures wax paper created in the wet paint.

Shape by careful shape, Mother Superior came to life. From the very beginning, I knew I didn't want her floating in a sea of white paper. So, once she was completely painted, I tore shapes from magazines to invent a connection from her to the edges of the paper, and also tore magazine strips to test the idea of border lines. After painting these final design elements, I permanently adhered the finished painting to Cradled Aquabord, sprayed it with a fixative and sealed it for a glassless presentation.

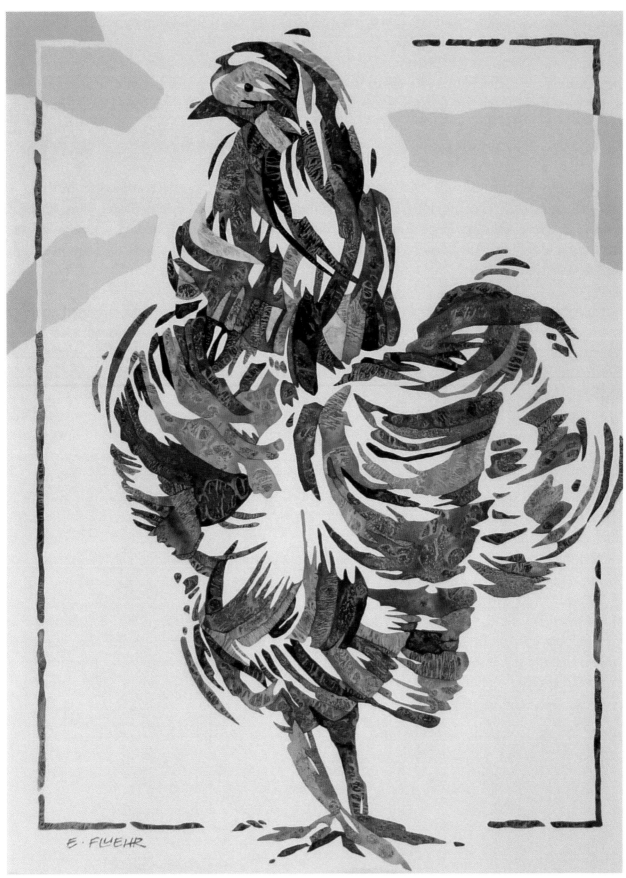

Mother Superior •Elizabeth Fluehr.
Transparent watercolor on Rives BFK printmaking paper, 30" x 22"

"Under a Country Sky" has been evolving now for perhaps 15 years, from the day I took a late afternoon photo looking from a high vantage point across fields of Iowa corn. Beyond the corn rows were trees, lanes, country houses and barns. The scene could have made a wonderful, realistic painting, but I have instead created a sequence of abstracts, with years passing in between the efforts. Each new version has used only the previous one as a reference. "Under a Country Sky" is the most recent "descendant" in this family, and any obvious connection between photo and painting has been lost.

What has been essential to all the versions, however, is an emphasis on shapes and values. In my first attempt, I spattered watercolor from a toothbrush through stencil shapes of sheet frisket. I dyed sheets of artist tissue and collaged them to make Version 2. For Version 3, I painted negatively in watercolor, applying thick pigment on damp paper for pleasingly soft edges. With each subsequent painting, fewer elements remained from the original photograph. By Version 3, day became night and the cheerful scene turned moody, perhaps even sinister.

Although Version 3 was a horizontal painting, I decided that "Under a Country Sky" should instead be vertical, and that I would invent a moon and night sky to accomplish this format change. I intended to repeat the dark moodiness of Version 3, but that plan dissolved as the painting progressed, and day-light and cheerfulness demanded their return.

Early on, I decided to create a pathway of light values in a "C" shape, curving from the upper right to the lower right of the painting. This compositional tool was more important to me than precisely interpretable subject matter. And because I was using just two tubes of paint—ultramarine blue and transparent red oxide, and many neutrals mixed from them—my subject matter was definitely ambiguous, especially in the areas of dark value. With realistic color cues eliminated, not even I needed to know just what might be rocks, trees, ground, sky, clouds, mountains or snow.

I chose to paint hard-edged, textured shapes, almost as if the picture were a quilt of appliquéd, patterned fabrics. The textures were created by pressing wax paper into the paint. Results varied with the size and direction of the scraps, the wetness of the paint, whether the scraps were weighted down or not, and whether I removed the scraps while the paint was still wet or waited until it dried.

Loose interpretations of visible brush strokes from Version 3 inspired the shapes for the bottom half of "Under a Country Sky." Then, using Version 3's technique of thick paint on damp paper, I painted a sky sample with a moon or sun, to provide myself additional brush strokes to imitate. Because I painted the sample with a flat brush, blocky shapes resulted, pleasantly consistent with the quilt-like personality I sought for the finished painting.

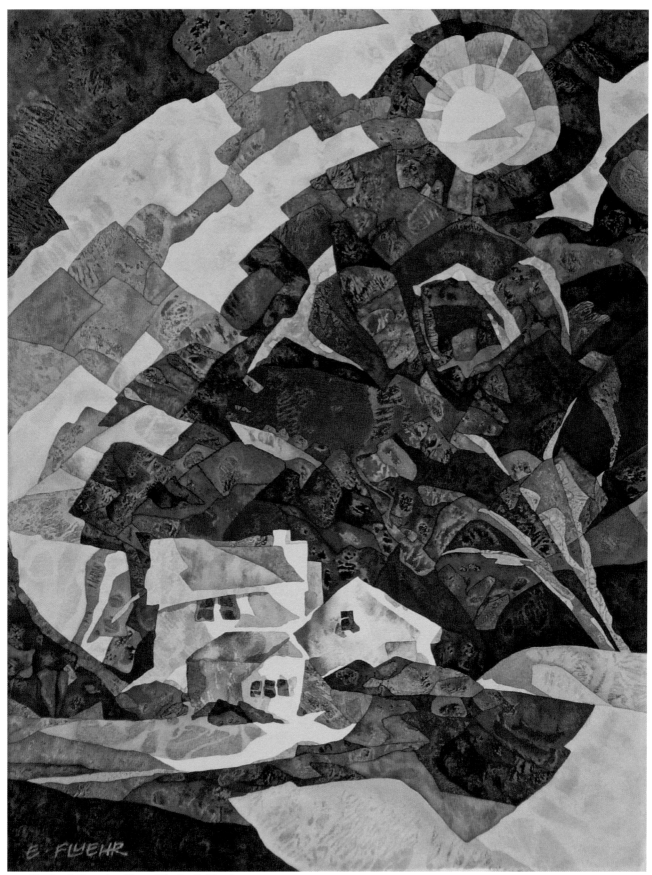

Under A Country Sky • Elizabeth Fluehr
Transparent watercolor on Rives BFK printmaking paper, 24" x 18"

Carol Frye

Following a workshop, I noticed someone had thrown away a gatorboard palette still loaded with Holbein watercolors in a rich assortment of both transparent ant opaque colors. Never one to let anything go to waste, I was immediately challenged to see just what I might create from someone else's dried up leftovers. I selected a half sheet of Strathmore's new Wet Media Board, a new support I have been experimenting with. This heavy cold press 300lb. surface takes a lot of abuse, and I love that it stays flat while I work on it. A group of my favorite Loew-Cornell wash brushes, (1 ½ in. flat, 1 in. flat ½ in. flat and a # 8 Ultra- round), were all I needed.

I prefer not to actually plan a painting, so just putting down some paint is my only immediate goal. I figured that a fairly dark but colorful surface would give me a good start. I sprayed the dried paint on my palette with water and began swishing my largest brush around several colors, mixing and applying a rich layer of paint over the entire board. A deep dark teal color seemed to dominate, but I made sure that that areas went from cool blues to warm brownish greens. I continued to add paint until I had a fairly heavy, solid layer of paint with few obvious brush strokes. At that point it was time to let everything dry completely!

Breaking up the solid rectangular surface of paint was my next step. I firmly drew some freehand vertical and horizontal lines with a red Albert Durer watercolor pencil. A couple of circular shapes were added to some of the lines.

I then selected a corner and began brushing on Holbein white gesso, allowing the gesso to blend with the dried watercolor paint; sometimes I used the back of my brush to make loose spontaneous lines into the wet gesso sections. I randomly chose areas defined by the pencil lines, and continued the process. Where the gesso touched occasionally into the pencil line and picked up color just added an unexpected surprise. As areas dried, if I wanted to make a section lighter, I layered on white gesso. I wanted to keep some areas large, with a few middle sized areas. Watching my values, the process continued until I was pleased with the overall composition. The overall painting felt too cool, so I mixed some raw sienna with gesso and lightly applied it to part of a couple of the whitest sections. Turquoise blue watercolor paint, using very little water, was added to several sections including the ladder-like patterns and part of the oval.

Black, turquoise, and lt. yellow, "Cran D'Ache Neocolor II" watercolor crayons were used in the final stages to re-define areas and add visual texture. Because they are water soluble, I could remove all or part of some of the lines if they were used over gesso. Finally I again used red and orange colored pencil to strengthen parts of my original red lines.

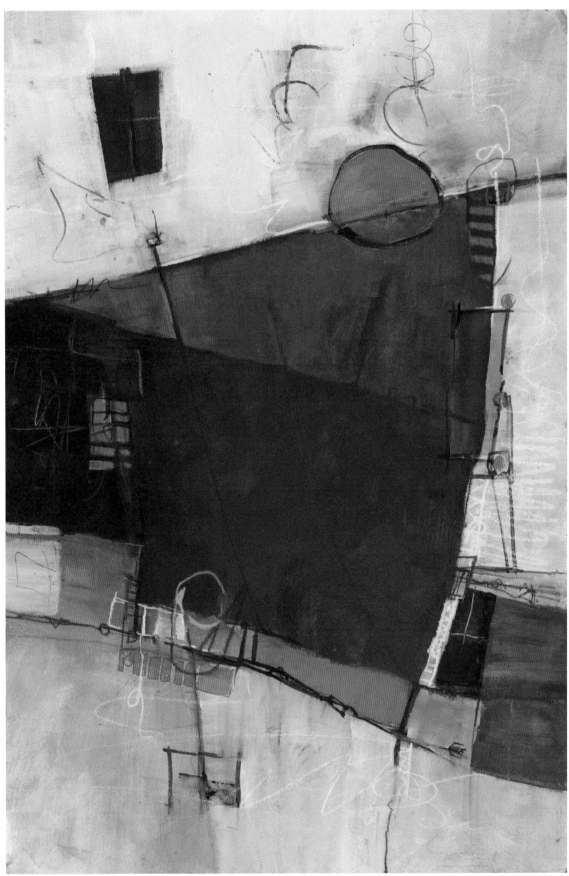

Ask Alice • Carol Frye, NWS, ISEA-NF, ISAP, SWS
Watercolor and Gesso on Board, 22" x 15"

This painting was begun and finished as a workshop demonstration, in about an hour. While there are hundreds of rice papers available, I selected three papers that were highly textured and neutral in color to use in the first layer of my painting. You can still clearly see the round holes of the paper I used in the lower left side. I tore, rather than cut pieces of rice papers, into smaller pieces, about 4x6 inches, I only needed a few. For my surface, I chose a 16x16 scrap piece of 100% rag mat board.

Using an inexpensive 1 ½ inch brush from a hardware store, I placed Holbein gel medium (mixed with 25% water) where I planned to adhere the papers, then put the torn papers onto the wet medium, following up with another layer of medium on top of the papers. Since texture in the lower layers was my starting goal, I also took a credit card and applied some gesso to some of the areas not covered by papers, making sure not to create sharp peaks. Now I dried the whole thing with a hair drier.

Some of the newer paints are made from natural mineral pigments that granulate beautifully adding additional visual texture. I washed some (Hematite Burnt Scarlet) over most of the surface, keeping strokes free and loose, occasionally scratching back into the still damp watercolor with the back of my brush. I also dropped in a few touches of Azurite blue.

Hand cut rubber stamps are fun to make and use. All it took was a 4x6 piece of the new soft Safety-Kut printmaking block and a Speedball cutting tool with a medium V-Point.

I choose a simple geometric diamond pattern for half the block and squiggled vertical lines for the rest. The block was painted with darker brown watercolor paint (Hematite)"and then stamped around the edges, adding more paint to the stamp, as needed.

Simple handwritten script was written with a burnt sienna watercolor pencil. You can send write a message or just use random text. Because the lines are water-soluble, some of the line can be softened by blotting with a damp paper towel. A couple loose vertical lines added to the left and right sides were a nice touch. I added a variety of shapes and patterns to some of the line work.

Highly pigmented watercolor crayons (Cran D'Ache) of turquoise, prussian blue and red added color and shape. I used simple lines and circles then noticed figure shapes and played to the idea. Why not have some fun!?!

I love my alphabet vintage rubber stamps. (These can sometimes be found on E-Bay.) Painted with more watercolor paint and stamped onto the upper section of the painting, these strengthen the simple script, and add additional variety and interest.

The application of E600 glue (used in a well ventilated area) to flat, rusted bottle caps (found in parking lots and gutters), then more glue for the turquoise beads on top of the bottle caps gave the piece d'resistance. Remember that with collage, the theory is…." Less is more!"

Multi-Facetted • Carol Frye, NWS, ISEA-NF, ISAP, SWS
Mixed Media on Board, 18" x 18"

Joyce Gabiou

The inspiration for this painting began while in a meditative or dreamlike state. With my eyes closed, I visualized oriental letters on the ceiling and knew I had to do a painting of my "dream".

This is an acrylic painting done in layers on a full sheet of arches cold press 140 lb paper.

I chose a limited palette of very neutral colors to express the dreamlike feeling.

This is a high horizon composition incorporating stencils and bubble wrap over painted surface. Colors used are primarily paynes gray and raw sienna. I finished the painting with gestural strokes of paint and chalk.

Memories, Dreams and Reflections
Joyce Gabiou
Acrylic
30" x 22"

"Solar Return" was first inspired by a small abstract I collaged from my hand-painted Yupo synthetic paper.

This award-winning piece is an acrylic/mixed media painting on a 60' x 48" gallery wrap stretched canvas. It was a challenge because I hadn't tackled anything so large in the past. For starters, it just fit on my dining room table, where I could do the first pours. I thinned down acrylic paints, in primary colors, with water, pouring and guiding areas with a brush. I allowed the paint to flow spontaneously and intuitively. I then used plastic wrap in areas, so it would dry with some texture. Some of the areas were poured or painted in layers.

The center of attention was also a pour of color mixed with gloss medium. I gave it some highlights with a brush later on. There is also dried acrylic paint collaged in some areas.

I later finished off some areas with bold brushstrokes.

I'm thrilled to say "Solar Return" was chosen as Finalist - Outstanding Abstract by Informed Collector, a monthly national/ international competition by Fine Arts Studio Online.

Solar Return
Joyce Gabiou
Acrylic/mixed media
60" x 48"

Susan Greenbaum

Typically I begin my abstracts with no preconceived idea but often try to give an impression of something, or just allow the painting to start speaking to me in its later stages. However, in this painting I did want to have a feeling of Autumn and harvest time.

This painting was begun on a 36" x 36" pre-gessoed canvas. I first created raised texture on this surface using acrylic texture paste. To create the squarish places, I squeegeed the texture paste through a rubber sink mat making the texture more pronounced in that "golden mean" area, making sure I repeated it to a lesser degree elsewhere on the canvas. I then slapped the mat in other parts of the canvas creating a sort of negative texture. Using a scrap piece of mat board, I smoothed out some areas to make them less textured. I also smoothed down some of the points and gradated the texture so the sink mat shape was not evident. After this completely dried, I then sanded the texture to smooth the surface of any really rough points.

My next step was to gesso the entire surface with an orange-tinted gesso to liven up the surface color. I set it aside to dry.

Now the fun began (not that those first steps weren't a lot of fun!) using the color palette I had chosen (warm analogous with a complement of blue). Since I work mostly intuitively, I just allow myself to take those colors and dive in. I typically lean naturally toward a cruciform design but I don't think about the design at this point in the process.

Semiconsciously, I begin creating light and dark areas, watching as I go to find shapes that feel interesting and varied in shape, texture and color. I usually put on some energetic music and my nitrile gloves, and literally put my whole self into this first round of painting-ultimately covering the whole canvas. I love this part. I am not judging the process, just enjoying the freedom of it. I may lay on thick paint or fluid acrylic. I may mix right on the canvas. I may smooth it out and squirt with water to let it drip, or squirt with rubbing alcohol to make the liquid paint surface open up to the color beneath. Some effects of the dripping are in the markings in the middle of the painting. First they were drips that later gave me the idea to paint them firmly and create the fence-like look in dark paint, which I repeated in the negative in the upper left. I also found that I liked wiping paint off the crests of the texture I had earlier created. This was a good time to do that in some places. Other spots needed to be painted this first time around and wiped later.

I came back to it the next day to look at it afresh. At this point, I started to make decisions about clarifying my composition. Where would be my point of interest? I had already chosen the upper left point when I put down the texture, so that is where I began defining contrasts and adding in the blue to make that area the most vivid. I wanted your eye to move around the painting, so I added in the linear movement (and then some shadowing effects under them to create depth). Some spots needed to be more neutral in color, some more intense, some softer, some more defined. When I reached a point where I liked the lights and darks, and the repetition of color and shape and texture, but didn't feel it was quite finished, I tried something I had never done before. I took a picture of the painting and opened it in Adobe Photoshop Elements. I created a duplicate of it and went to work darkening or lightening areas to see how I liked it. There is no right or wrong with abstracts, in my mind. I did want to get it to the point where I enjoyed the balance of all as-

pects. So I kept playing with the saturation and light until I felt it was strong. I even drew in some shapes to see if they enhanced the painting. The circular shape on the right was one I added in my photoshop rendition. I then made a photo and used it to make changes in the painting. I did not paint it exactly like the photo, but it gave me a point of reference.

When I felt that I had accomplished a vibrant, well-composed abstract, I stopped. I allowed it to dry thoroughly and then varnished it several times with a satin acrylic varnish.

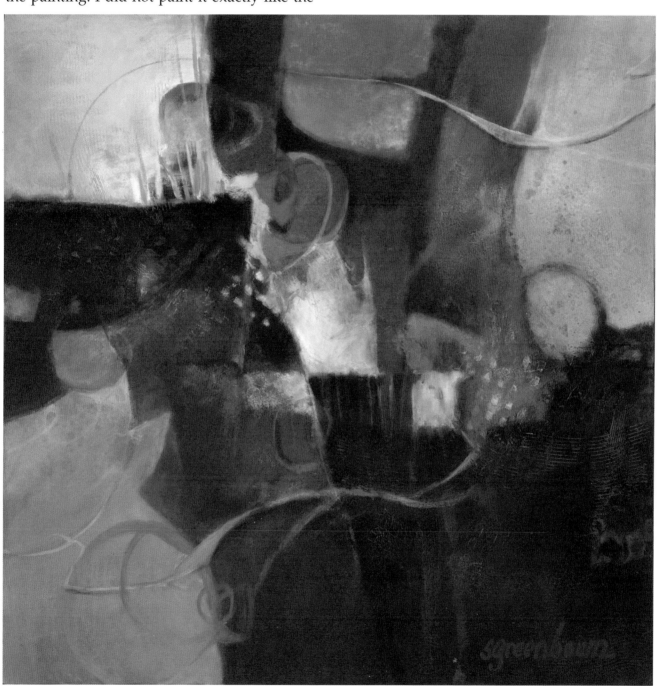

Autumnal • Susan Greenbaum, NWWS
Acrylic , 36" x 36" x 1.5"

Jan Groenemann

"Doors Bleeding Time" began in the same way as "I Am." I created the textured ground with papers, glue, modeling paste and by scraping and drawing into the final coats of Gesso.

I was at a place of transition as I began this painting, needing to make some important decisions, working from mixed feelings and even some confusion. Some years had passed between the painting of "I Am" and the painting I was then beginning. Though spheres/circles had become my trademark for several years I had since explored other themes as you can see if you visit my website (www.groenemann-studios.com). Yet, as I worked on this new painting the sphere specifically appeared again. I had a sense of having come "full circle."

I had painted "I Am" in my home studio where I also teach private classes. Since then I had become a resident artist with a studio at a local arts centre. I had also just completed a new painting studio at home that overlooks my Japanese Garden and was feeling drawn to leave the arts centre and paint again in solitude.

I began the layers of watercolor washes then added acrylic. Doors appeared in the sphere and a title came to me: "Doors Bleeding Time." I suddenly knew I was wasting time by delaying my move into the new studio. The decision was made as I worked on this painting. I wanted to achieve a luminosity in the piece that spoke of insight or enlightenment.

I made the move and once settled into my new space with my view of the garden, a creek and a Koi pond, I began to sand the surface of this new painting. I sanded and cleaned then began to apply layers of oil paint, some metallic, allowing each layer to dry and then sanding before applying the next. It was a time consuming process, sanding, cleaning, layering, drying then sanding again until I achieved what looked like an inner glow.

This became the new technique that I am using on the series I am working on at the present called "Doors."

This is a time consuming technique but not new in that it was used by the Masters. Combining this ancient technique with my textured ground, washes of watercolor then acrylic, and then used as I apply the oils I get a luminosity not before achieved.

Doors Bleeding Time • Jan Groenemann, MA, CLC
Mixed Media: Textured Ground; Watercolor; Acrylic; Oil

"I Am" is created on two canvases. I began by creating a textured ground with the canvases placed side by side to work as one composition. I used handmade papers and tissue. First I applied the tissue paper with a mixture of half Elmer's Glue and half water. I laid down this solution with a two inch brush then applied the tissue. I then worked more water/glue solution on top of the tissue, scrunching it, wrinkling it and shaping it to my liking. I did the same with various handmade papers, some with threads that I could also manipulate. I gave this time to dry then began applying modeling paste to create even deeper textures. I am thinking composition as I do this, allowing many years of exploration and study to initiatively combine to create a textured ground that is quite pleasing on its own.

I allowed this to dry thoroughly then applied three or more coats of Gesso, scratching into the Gesso with clay tools, combs, etc. as I applied it.

Once the finished and sealed textured ground was dried I began to apply washes of watercolor. I use Winsor & Newton professional watercolors. I allow myself to work from a deeply intuitive level. In this painting I hoped to capture my own essence. Once the layers of watercolor dried and I was sure I would not want more

watercolor on the canvas, I sprayed the surface with Krylon matte acrylic to fix the watercolor.

Next I began to work wet and lose with acrylic. When I intuitively felt ready, I then allowed this to dry thoroughly.

The next step was to draw out the large circular shapes using string and a pencil. I also, at this point, taped off the rectangular shapes with masking tape.

At this point I began to look carefully to see what this painting wanted to be. I began to paint again with acrylic forming the circles and rectangles, but, also, allowing the sense of landscape, a stone-like wall and some trees to appear. Each step allows me to see the next. In this painting bits from my Native American

heritage emerged: nature, feathers, designs. I was consciously open to capture myself in color, texture, pattern and symbol. I then removed the tape and softened the edges of the rectangular areas.

The last step in this painting was the application of color in oil. I love the washes only watercolor can give me and the intensity of color from acrylics, but oil gives the deepest earthy feel. Because it has to breathe it goes on last.

Once a painting is complete I need to live with it and let it speak to me before I either exhibit or sell it. "I Am" speaks to me of my connection with all things - with nature, with my heritage. It wasn't until this painting was complete and hanging in my living area that I saw the whale in it. According to Native American teachings The whale symbolizes ancient knowledge expressed through psychic or telepathic messages which we might call intuition. Whale as a Native American totem animal appearing in a painting in which I am attempting to express the fullness of who I am tells me to "listen to my intuition through the whale songs of my ancient ancestors and find and express my own unique cry or voice." Paying attention to my intuition and not second guessing it has come to be an important lesson in my life. It always leads me in the right direction.

I Am
Jan Groenemann, MA, CLC
Mixed Media: Textured Ground; Watercolor; Acrylics; Oil

Suzanne Jacquot

This painting was inspired by my surroundings and my favorite time of year. Spring bursts forth with colorful blossoms and pure clean light and sun. I lived on two well loved acres like a park and it was such a pleasure to sit out doors with my morning tea and enjoy the garden.

Starting with bright bold colors of spring flowers for my platette, I made large brush strokes of yellow, orange and violet to give a background that felt like a muted field of flowers. There were daffodils, poppies, both orange and red, lupine and other beautiful gloms that I wanted to suggest in this image.

After that layer dried, I began with circular brush strokes to give the feel of the flowers blowing gently in the morning breeze. They overlapped one another, so I, too, put colors on in layers upon layers to get the sense of depth and bunches.

I work back and forth from background to foreground, by blending colors for fields and circles for details The bold red was dahlia inspired marks. The blossom was so large it stood out and I wanted to honor it with more of a drawing like quality. I love drips and accidents because nothing is perfect so I often encourage them by putting extra pain on my brush or adding acrylic glazing liquid to the colors out of the tube. I also use fluid acrylics for the more watery feel. This more fluid acrylics makes it easier to make circles with my different sized brushes.

Once I finalize the blending of the circles into the background and add small finishing bits of color where needed, I put a top coat of gloss varnish to seal and protect the image.

Cacaphony of Spring Suzanne Jacquot Acrylic on canvas 36" x 48" x 1.5"

This painting, as with all my paintings, comes out of inspiration and desire to image with colors and form in a spontaneous manner.

Starting with a palette of colors, in this case, I put out chromium green, titanium white, green gold, magenta, cadmium yellow medium, ultramarine blue, blue violet, and prism violet. I first painted the canvas overall with shades of blue and violet mixed with white, done in a circular motion. Most all the brush strokes are circular in this painting.

After that layer dried, I began putting on large circles and let them dictate where they would fall. By changing colors often the brush gets combinations of colors which blends well as I painted the various circles. I again let the layer dry.

I repeat this process for several layers, putting different mixture of colors on each layer to give depth and flow. Once all the circles are put on the canvas, I then began to work violet into the circles to soften or mute various ones and then blended that color with magenta and worked it into the background. I used different sizes of brushes for different colors at different times to give the circles variety and definition. I put Cadmium yellow on last.

To finalize the blending of the circles into the background I went over the background with blues and white to make the background merge with the group of circles. Once the painting is finished, I put a top coat of gloss varnish to seal and protect the image.

Circles Go Round
Suzanne Jacquot
Acrylic on canvas
36" x 36" x 1.5"

Elaine Kahn

My work in this medium is always done on Cretecolor Colorfix pastel paper. I like to use this paper because it has a very coarse texture. It feels like sandpaper.

I start out by randomly placing a few brush strokes of white acrylic paint with a 3-4 inch brush. Next, I usually do something to soften the edges of the brush marks. This can be either by using a foam roller or a toilet paper roll over the surface. I sometimes sprinkle alcohol on the paint while it is still wet and roll toilet tissue over it to produce more texture.

When this stage has dried, I start to use charcoal in different widths (chunky/ willow), so that I can vary the size of my lines. I then start to make my marks intuitively, trying not to think too much about the process. The only think I try to keep in mind is that the space between the lines are not the same, the width of the lines are different, and the marks or lines themselves are interesting.

At this point I may go in with a Japanese calligraphy brush and some black ink to do more marking and splattering. I also may use white acrylic paint to do the same process if the painting calls for it.

Finishing touches include touching up areas with white acrylic and layering with charcoal powder to create another texture. The powder will adhere to the wet paint.

River Bed • Elaine Kahn
Mixed Media, 26 1\2" x 18 1\2"

Mary Lauren Karlton

Whenever I begin a painting, I start by setting forth an overall intention of where I'd like the painting to go, its overall design structure, and a general idea of the color palette. In this acrylic/multimedia painting, entitled Free Fall, my intention was to achieve a certain serenity and simplicity that evokes Asian minimalism punctuated by movement or an event frozen in time. My chosen design mode was the cruciform shape.

I started with a 30" by 22" sheet of 300-lb. Fabriano watercolor paper, which I like using for acrylics and multimedia because it doesn't curl and has a hefty feel. Before I started painting, I primed the paper with two or three coats of white acrylic gesso to make the surface stiffer and prevent paint from soaking through. For the basecoat, I chose a soft neutral tone—Titanium White combined with Raw Titanium White and a soft, pale gray (Titanium White mixed with a small dab of Lamp Black). With a palette knife, I spread some of these soft colors liberally on a sheet of waxed paper. Flipping the paint-laden wax paper over so that it was face down on my sheet of Fabriano, I ran a rubber printmaker's brayer across the back of the wax paper in different directions, moving the wax paper to different areas of the surface until I achieved a stucco-like effect. After each coat dried, I repeated the process several times. I ended by spreading pale yellow (Titanium White and Hansa Yellow) in patches using the same technique.

When I was satisfied with the results, I turned to various drawing tools—fine-pointed markers, pens, and sharp pencils—to draw the grid-like structure with a light touch. I sealed the drawings with a matte fixative spray and allowed it to dry over night. I found the contrast of the freeform background and the delicate geometric line drawings interesting, pleasing, and suggestive of the philosophy of Yin and Yang. My intention was to express the juxtaposition of form and formlessness, the opposition of manmade structures and the unarticulated matter of nature, and the inchoate and unborn contrasting with the rigidity of the old and outworn.

Once this was established, I injected a jolt of color, the red sparks igniting the quietude of the mysterious landscape. Here I introduced bits of handmade red-stained paper with small shreds of newspaper showing, gluing these into a sparse cascade that suggests the slow floating path of cinders in the wind. I finished the piece with a light coat of satin acrylic varnish.

Free Fall • Mary Lauren Karlton, ISAP
Acrylic, 30" x 22"

For as long as I can remember, I have had abiding appreciation and passion for impressionist music of French composer Claude Debussy with his dreamy, sensory, and lyrical passages. One day at my studio, while his music played in the background, I was inspired to create this acrylic multimedia piece called "Le Reve" ("the dream" in French).

A key step to developing this painting was creating a rich background with multiple layers of transparent acrylic glazes. I used Fabriano 300-lb watercolor paper for my surface, applying two to three coats of white acrylic gesso for added stiffness and to prevent porosity. I began by loosely covering the surface with a thin coat of Indian Yellow, moving my three-inch brush in different directions loosely to great an organic effect. After allowing the paint to dry completely, I followed the same process but this time used Iron Oxide Red. While the paint was still wet, I randomly sprayed the surface with rubbing alcohol, which created a lovely mottled effect. Again, I allowed this layer to dry and then did one more pass with Thalo Blue followed by another spray of alcohol. The end result was a sur-face that resembled the rich patina of oxidized bronze. I finished the surface with a light coat of acrylic gloss medium.

The next step involved applying the collage pieces (with acrylic medium and Modge-Podge used as adhesives). While assembling the pieces, I had in mind a Cubist-like arrangement, similar to the early collage compositions of Georges Braque and Picasso but with the bright, colorful hues of the Fauves, particularly Henri Matisse. I applied a selection of rice papers in various shades of blue, along with a delicate, lacy white—a pleasing complement to the warm background. And then I used handmade red-stained paper with newspaper bits to add punch and draw the viewer to the focal point—the white mask-like shape to the left that suggests the face of a dreamer. I added two shards of blue rice paper to create an unexpected chasm—underscoring the apparent separation between the realms of reverie and reality—when, in fact, as the painting asserts, these realms often overlap and merge. When I was satisfied with the piece, I sealed it with several coats of acrylic gloss medium for a lovely sheen.

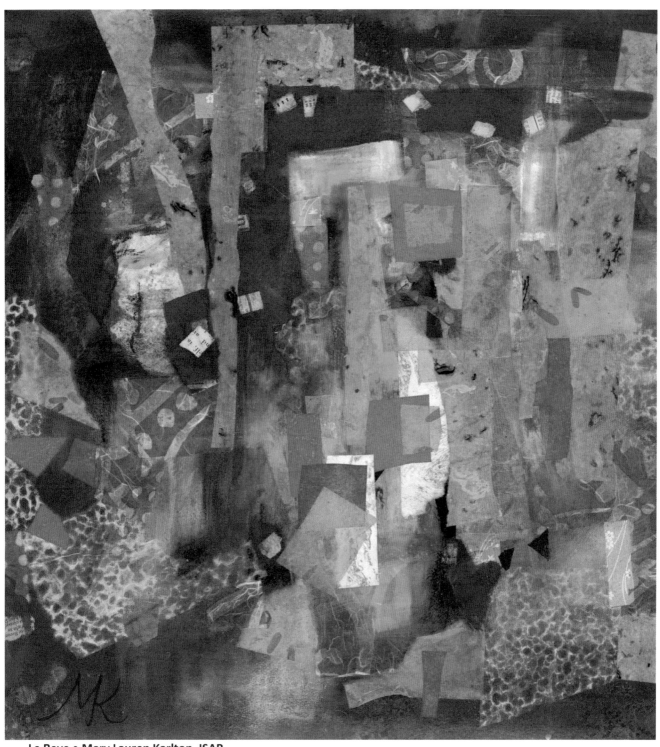

Le Reve • Mary Lauren Karlton, ISAP
Mixed media / collage, 21" x 19"

Anett Kilén Kennedy

When I started to work on this painting I had something totally different in mind, which is usually how it goes. You might wonder what I originally set out to do, but this I cannot even remember. For me the act of painting is a process where the most important thing is to experiment and discover the undiscovered. It is like I am looking for a certain kind of energy or feeling that is hard to describe. I just know intuitively if it is working or not.

Sometimes I have certain feelings in mind that I want to transmit, and other times I am not quite sure where I am going. If I feel that I am starting to paint aimlessly for too long, I might decide to leave the painting for a while, which is exactly what happened to this canvas.

For about two years I looked at it without feeling any new direction for the piece. Every time I looked at it, I knew that there was something I liked about it, but could not seem to finish it. I finally decided that it was not going to happen, and just started to cover parts of it with a yellow that I kind of knew it needed as there was too much purple in it to create balance. This did not cut it and I was about to throw the whole canvas out the window.

I usually use large brushes, as it gives me more freedom to experiment and helps me to resist from what I call decoration, meaning trying to make something beautiful. I am not looking for something that is perfect but rather a feeling. In fact I feel limited if I am looking for the beautiful. It is the same as if somebody asks me to paint something with a lot of red in it. Then I want to paint something blue instead. I need the freedom. I get in the same kind of trouble if somebody tells me half way

that they like it. Then I feel this instant urge to change it. The freedom of creation is the most important for me in the process.

Then one night I was working on another painting, and all of a sudden thought that three of the colors on the palette would be great on top of the old canvas. At that point I do not know how many layers it was covered with already. I had a feeling in mind, and it was about pregnancy, destiny, soul mates, caring, new life and childhood. I painted very fast, and all of a sudden it was just there. Done.

Caring • Anett Kilén Kennedy
Oil on Linen, 100 cm x 70 cm

This painting is, as all my other paintings, a result of a lot of experimenting and layers on layers. I usually start out with thick layers of paint that I later remove by pouring on turpentine. In this particular painting I had been experimenting with ground coffee into the paint. The painting got thicker and thicker and I go nowhere. Only more and more frustrated.

When I create a painting, I search for an inexpressible place, between dream and reality, which hopefully, ultimately heals and leaves the viewer with a fresh way of seeing Home Base. The reason for this is that I believe a painting can be just as calming and exciting, interesting and dynamic, as nature. In this particular case I did not feel close to this aspiration and thought the whole process was wasted as the coffee ground was stuck in places where I absolutely could not make any sense of it. So I put it to rest for a long time.

I kept looking at it from time to time. It resisted covering with new layers because I liked the colors and just could not make myself paint the whole thing over. This lasted until one day I saw a pencil drawing by Pablo Picasso which was only a few black lines indicating the eyes, the nose and the mouth of a face.

I decided to use it as an inspiration, wetted my canvas with medium, loaded my brush with burnt sienna, turned up the music and went for it. The face just appeared in a few seconds. I decided that it was done. Coup de grace.

Picture of Life • Anett Kilén Kennedy
Oil on Linen, 50 cm x 60 cm

Maureen E. Kerstein

I like to study nature as I travel and enjoy the constantly changing world around us. My goal is to capture as many images in my mind as I can. I love to take the time to closely examine the way water moves and how different a stream is from the ocean. I draw in my mind the shapes and movements of nature and her parts. As I paint I am totally immersed in the process. I need this state of mind to create and this makes painting a valuable therapy that I wish all could experience. I enjoy trying new color combinations and mixtures of painting mediums and I am always trying to discover something new when I paint.

I'm in love with the water and the beauty of the ocean and the lakes and the rivers. I love to gaze into the water and to see what there is to see. Searching for shells and rocks and shore birds and sea life is my joy in life. I am at peace at the water's edge. Winds and open air take away any cares of the day by providing calming breezes. The open air and expansive views allow easy breathing. The sounds of the water, the birds and nature are capturing and soothing. When I paint the water and the coastal land I can experience again these memories. I try to paint the way the water moves over land. My techniques are similar to laying the paper on the beach and letting the water mix with the paint and adding shells to impress their beautiful shapes in places they choose. I do little but enjoy the process and guide the colors and water adding and subtracting as the painting requests. In the end the painting is as unique as each shell is on the beach or as the shore of an ocean change each day as the waves roll in.

I usually prepare by cleaning and organizing my work space, organizing my paints and brushes, and preparing my boards for at least 3 paintings. I like to work on 3-5 paintings at a time as each painting needs time to dry, and I have learned that stopping at the right time is just as important as knowing when to keep painting. Over weeks of time I return to each painting with fresh eyes to evaluate and decide what the painting needs, where it is going, or if it is completed.

I add and subtract elements of nature that will affect the path and final outcome of my painting. I simulate weather conditions as I add heat and cold, mild breezes to heavy winds, and falling mist to pouring rain. Everything that happens naturally outdoors I try to re-create in my studio. Through adding and subtracting these elements of nature I am rewarded by various textures that cannot be created in any other way. The paper I work on, Yupo, is a very smooth synthetic paper that allows the paint to sit on top and dry on the surface, giving the paint the added advantage of increased intensity and strength. The paint and water flow on the smooth surface much the way a skater glides on the ice. Painting in this way is an adventure and although I am the painter, I invite the painting to lead the journey.

Painting with nature as my assistant results in the magnificent benefit that each painting is created with so many variables that it is easy to find something new and unique each time I paint. As it is in nature, the excitement and challenge never ends.

Breathe • Maureen E. Kerstein, GWS
Watercolor, 40" x 26"

I like to study nature as I travel and enjoy the constantly changing world around us. My goal is to capture as many images in my mind as I can. I love to take the time to closely examine the way water moves and how different a stream is from the ocean. I draw in my mind the shapes and movements of nature and her parts. As I paint I am totally immersed in the process. I need this state of mind to create and this makes painting a valuable therapy that I wish all could experience. I enjoy trying new color combinations and mixtures of painting mediums and I am always trying to discover something new when I paint.

I'm in love with the water and the beauty of the ocean and the lakes and the rivers. I love to gaze into the water and to see what there is to see. Searching for shells and rocks and shore birds and sea life is my joy in life. I am at peace at the water's edge. Winds and open air take away any cares of the day by providing calming breezes. The open air and expansive views allow easy breathing. The sounds of the water, the birds and nature are capturing and soothing. When I paint the water and the coastal land I can experience again these memories. I try to paint the way the water moves over land. My techniques are similar to laying the paper on the beach and letting the water mix with the paint and adding shells to impress their beautiful shapes in places they choose. I do little but enjoy the process and guide the colors and water adding and subtracting as the painting requests. In the end the painting is as unique as each shell is on the beach or as the shore of an ocean change each day as the waves roll in.

I usually prepare by cleaning and organizing my work space, organizing my paints and brushes, and preparing my boards for at least 3 paintings. I like to work on 3-5 paintings at a time as each painting needs time to dry, and I have learned that stopping at the right time is just as important as knowing when to keep painting. Over weeks of time I return to each painting with fresh eyes to evaluate and decide what the painting needs, where it is going, or if it is completed.

I add and subtract elements of nature that will affect the path and final outcome of my painting. I simulate weather conditions as I add heat and cold, mild breezes to heavy winds, and falling mist to pouring rain. Everything that happens naturally outdoors I try to re-create in my studio. Through adding and subtracting these elements of nature I am rewarded by various textures that cannot be created in any other way. The paper I work on, Yupo, is a very smooth synthetic paper that allows the paint to sit on top and dry on the surface, giving the paint the added advantage of increased intensity and strength. The paint and water flow on the smooth surface much the way a skater glides on the ice. Painting in this way is an adventure and although I am the painter, I invite the painting to lead the journey.

Painting with nature as my assistant results in the magnificent benefit that each painting is created with so many variables that it is easy to find something new and unique each time I paint. As it is in nature, the excitement and challenge never ends.

Seaside • Maureen E. Kerstein, GWS
Watercolor, 40" x 26"

Pat Wheelis Kochan

I began this painting by making my own stamp of an arch and doorway with steps. This was to be the theme, which I built the whole painting around.

Beginning with the top half of the paper and using acrylic on 140 lb. paper, I laid in the stamp in the upper left hand corner with yellow and gold acrylic paint. I then began to repeat the arch shape in yellow in larger and medium shapes throughout the painting. Between each shape I repeated yellow layers several times where the darks are now. I used every yellow and gold I had in my paint box. This created the structure for the existing shapes.

I left the large arch and the areas of purple, white. If I had made everything yellow, then the purples would not be pure; they would be grayed down. I proceeded to stamp other stamps, which I made to give line and texture to the piece. Once the yellows were built up thickly in the planned dark areas of brown, I layered reds which turned some areas orange and the white areas turned mauve or pink. I built up the red layers and then added blue layers of paint which turned these areas dark brown, red brown, and purple.

Once the top half was finished, I began to mix grays with the yellow and purple to establish interesting shapes and also giving a mirrored image to some areas, especially the verticals. The whole painting is yellow and purple which complement each other made grays with both colors.

That gives the painting unity and harmony. This painting with its bright colors, make me feel happy.

Arches
Pat Wheelis
Kochan,
WHS, WFWS,
SWS
Acrylic
22" x 30"

96

The under painting is abstract shapes in watercolor on cold press watercolor board. I glued aluminum foil into the shape of a scroll. I crunched it and melded it into various shapes; being very careful to leave the hole in the middle looking through to the original watercolor under painting. After it dried, I layered various yellow reds, and orange and burnt umber for the darks acrylic paint. I added modeling paste to make transition from foil to paper with a palette knife. Then painted warm colors to denote gold leaf effect.

I love this piece because it is an opaque scroll against the transparent watercolor under painting. If you looked at my previous painting, you will see my same shapes repeated; the archways, the circles and rectangles.

I burnished the foil with ochers, raw sienna and quinacridone burnt orange and gold. I used browns and brought blues over some of the gold to give a metal greenish look.

**Copper Image
Pat Wheelis Kochan,
WHS, WFWS, SWS
Watercolor, acrylic, foil
collage on watercolor
board
30" x 40"**

Ruth Kolker

"Merged" represents my fascination with making art, developing a theme and transforming it. The assemblage of recycled materials assist in creating a dialogue in my monotypes. How the materials are layered and arranged is critical to the composition. Pattern, texture, shape, line and color are woven together to create a personalized architectural environment. The arrangement and style exemplify the energy between the geometric shapes and the natural elements.

The technique of collage often plays a role in establishing a theme. First I make a drawing. According to the light and dark shapes in the drawing, I begin to cut out shapes from paper, netting and raffia that correspond to the space divisions in the drawing. Creating patterns through low relief effects can be achieved by the manipulation of paper and found objects. Anything with a slightly raised surface can create an interesting line even a slender thread. I build a relief plate from a 4 ply matt board that has been cut into a rectangle.

My beginning image reflects the theme of the drawing. I treat the plate and my recycled paper pieces with polymer medium. Once the plate and my cut up collage pieces are dry I go into a printmaking studio and begin my work. Using brayers I coat my plate with even layers of oil-based printmaking inks. I ink each piece of paper individually and then I place them on my inked plate. My plate is placed on the bed of the etching press.

I dampen my paper and center it over the plate and run it through the press. Once the monotype has dried, I often choose to paint over the composition with acrylic paint to enhance the theme or embellish it by starting a slightly different theme. The paint at first acts as a resist. To me it is like unearthing some hidden image.

I work on more than one painting at a time. I can respond to a specific moment at hand with an unconscious awareness. The paint is layered. My goal is to create a strong visual texture. The painting process is spontaneous and physical. I try to unearth each image without getting mired down in conscious details. I don't want the results to be predictable. Vocabulary will appear and repeat over time.

Merged • Ruth Kolker
Mixed-media painting on rice paper, 32" x 24"

"October" represents my fascination with making art, developing a theme and transforming it. The assemblage of recycled materials assist in creating a dialogue in my monotypes. How the materials are layered and arranged is critical to the composition. Pattern, texture, shape, line and color are woven together to create a personalized architectural environment. The arrangement and style exemplify the energy between the geometric shapes and the natural elements.

The technique of collage often plays a role in establishing a theme. First I make a drawing. According to the light and dark shapes in the drawing, I begin to cut out shapes from paper, netting and raffia that correspond to the space divisions in the drawing. Creating patterns through low relief effects can be achieved by the manipulation of paper and found objects. Anything with a slightly raised surface can create an interesting line even a slender thread. I build a relief plate from a 4 ply matt board that has been cut into a rectangle.

My beginning image reflects the theme of the drawing. I treat the plate and my recycled paper pieces with polymer medium. Once the plate and my cut up collage pieces are dry I go into a printmaking studio and begin my work. Using brayers I coat my plate with even layers of oil-based printmaking inks. I ink each piece of paper individually and then I place them on my inked plate. My plate is placed on the bed of the etching press.

I dampen my paper and center it over the plate and run it through the press. Once the monotype has dried, I often choose to paint over the composition with acrylic paint to enhance the theme or embellish it by starting a slightly different theme. The paint at first acts as a resist. To me it is like unearthing some hidden image.

I work on more than one painting at a time. I can respond to a specific moment at hand with an unconscious awareness. The paint is layered. My goal is to create a strong visual texture. The painting process is spontaneous and physical. I try to unearth each image without getting mired down in conscious details. I don't want the results to be predictable. Vocabulary will appear and repeat over time.

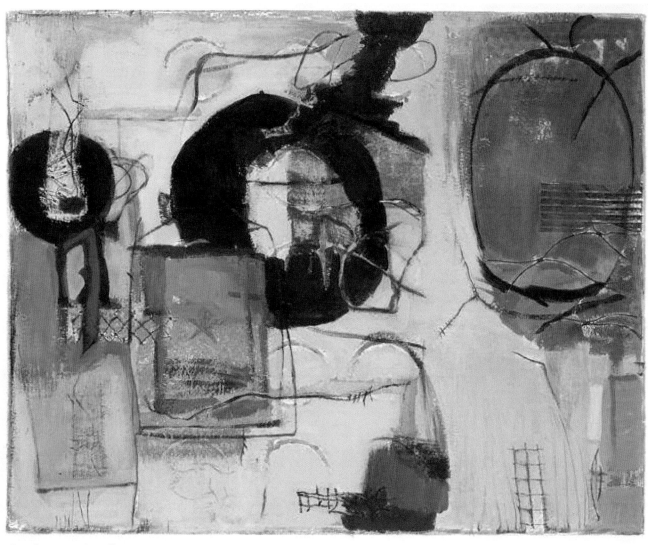

October • Ruth Kolker
Mixed-media painting on BFK Rives paper, 30" x 26"

Pat Lambrecht-Hould

Working with abstract is the most challenging painting that I have ever done. In my 40 year painting career, many art forms have peaked my interest but nothing holds it like the abstraction.

I have an enormous passion for color, line and texture. Much of my work is based on collage, gold, copper and silver leaf. I use Golden Fluid Acrylic Paints and any textured surface I can create.

All of my work starts with a charcoal drawing on canvas. I love the feel of charcoal and it is easy adjusted if the shapes don't come together. I think of my paintings as visual mathematics...shapes within shapes, sections divided by curves and lines. Think of it as designing a house, you would never decorate it before you designed it. The structure of your painting is your blueprint.

When my charcoal drawing is done I then begin to think about my color story. To me color is a passionate reactive adventure. I try to emulate much of nature's brilliance with my use of color. With Slice of Light, it started with the reds...the passion color!

If you establish cool and warm reds, and situate them next to a variety of grays, the reds will have a very loud voice. Choosing a color story is often supplied by collage papers but with this particular painting I was looking more for texture. I applied heavy gel media on the canvas using it to apply my collage papers and creating texture at the same time. After the gel dried I used charcoal to create and off center curvilinear design for my hot glue application. This is a very permanent step, it is almost impossible to remove the hot glue after is dries. In some areas I let the glue self level, in others I placed parchment paper over the hot glue to flatten out the surface and create a different effect.

With this particular painting I used gold and silver leafing over all of the collage paper and textured areas. I love the way the reds give lumination over the gold leaf, it creates a reflected light source. I apply a glaze of pure color over the leafing, buffing off excess paint with Hake brush. It is a layered fusion of acrylic glazing over the leafing. This process is what creates the high color glow. In the gray areas my low lights over the gold leafing are done in the same manner but I use a combination of Golden Metallic Glaze and white. The line work progressing along with the painting.

The abstract painting journey can be long, but it is never without surprises, rewards and pure joy!

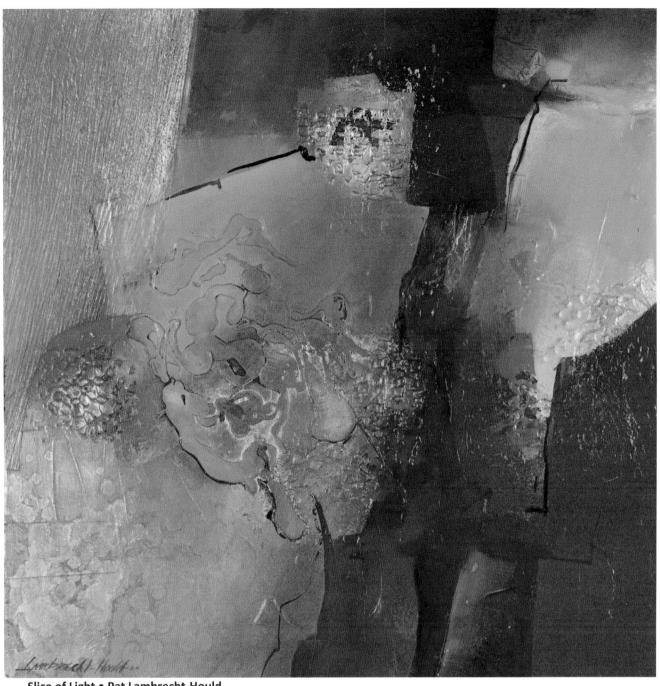

Slice of Light • Pat Lambrecht-Hould
Mixed media / collage, Size: 30" x 30"

edie Maney

"Blues I" was the first of a pair (Blues I and II) of commissioned pieces done for a client through an art gallery. The client wanted a very blue format. The painting was created on Fredrix Heavy Duty Professional 12 oz. cotton duck canvas. The sides are gallery wrapped and 1 ½ inch thickness. The canvas was prep rimed but I usually add two additional coats of gesso. After the gesso dried, I applied a heavy gel medium with a palate knife in a random fashion rotating the canvas.

When starting this painting, I used naples yellow, quinacrdome gold, and raw umber. Golden Fluid Acrylics were used in this painting. I used both a 2 inch flat brush and a series round brushes to paint in a chaotic fashion. I then divided my canvas in three vertical sections visually, and began applying shades of blue: ultramarine blue, cobalt blue and cerulean blue chromium. I used palette knives, erasers, plastic scrapers (credit card) to scratch and reconfigure shapes. I also blotted with Kleenex to add interest.

It is important to evaluate the composition and design in non-objective or abstract paintings. I reviewed the shapes and colors to be certain there is variation. I worked yellow into the blue and vice versa to bring softness to the edges and overlap the colors. I added planned splashes throughout the piece. When is a painting finished? To me, it is when I feel the piece is complete and that another shape or color will not improve the artwork.

I used satin varnish to seal the painting. Painting around the edges with black gesso gave the piece a nice, flat finished look. Completed, this is a bold and commanding painting.

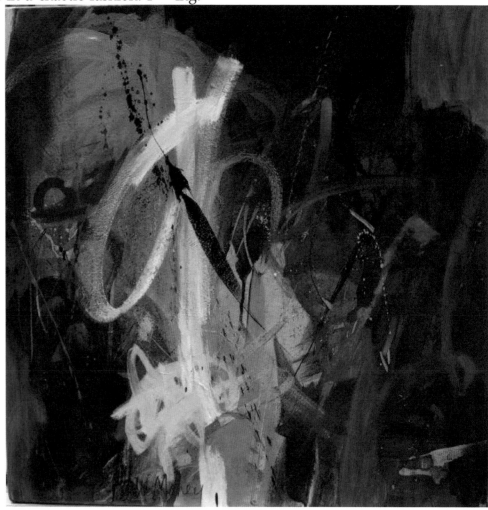

Blues I
edie Maney, TnWS
Acrylic, 24" x 24"

"Green Tide" was created on a Fredrix Heavy Duty Professional canvas. It is 12 oz. cotton duck, gallery wrapped. The canvas has been primed with acid free titanium white gesso. I usually apply two more coats of gesso and then apply a coat of heavy gel medium. Using a palette knife, I spread the medium in a casual manner over the canvas.

When I began this painting, I had my acrylic colors (Golden Fluid Acrylics) on the palette and started in a chaotic manner using a 2" brush to spread the paint in a random fashion. I covered the canvas with blues, yellows, and raw umber and rotated the canvas to develop irregular patterns. The colors blended to create secondary colors. I then moved to the top to create the horizontal shape. By mixing raw umber and ultramarine blue, I created a rich dark shade for the top portion.

Next, I painted the blue green shape all over. Using composition and design principles, I painted the vertical shapes on the left using reds and wiped over it for the blue to come through. I started painting mostly red and some yellow into the dark shape at the top. Red and yellow was also applied to the lower left of the canvas. I used easers, a palette knife, and plastic scrapers to rework shapes and lines into the surface to give additional definition. You can see the dark lines throughout the painting. It took several reddish coats to cover the dark shape leaving some of the dark.

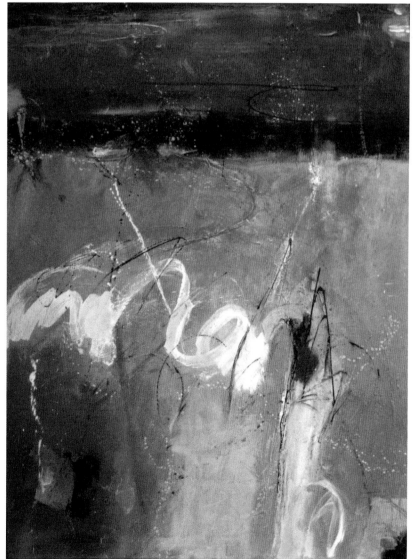

The final review was to evaluate the color, shapes, lines, and values to determine if there is enough variety to five interest to the artwork. I felt it needed more movement and value so used both a 1" and round brush to put in the cream shape making a light, irregular pattern. Then, I began thinking about the focal point. Placing a small reddish dark shape in the cream form accomplished this goal. I painted black gesso around the sides and satin varnish over the painting. My desire is to invite the viewer to become lost in my paintings.

Green Tide
edie Maney
Acrylic
48" x 36"

Jinnie May

This painting is painted on watercolor paper (Arches 140 lb. Rough) covering a failed watercolor of representational subject matter. The paper was prepared with two coats of tinted (beige) gesso and allowed to dry. I started with a square format 22" x 22". I used acrylic paint for 100% of this painting.

Rosy-Fingered Dawn began with larges shapes of red, black and vanilla colored acrylic paint from 2 oz. bottled paint found in craft stores (Folk Art or Apple Barrel manufacturers). After studying the painting for several hours and deciding it just was not working I went back in covering up old areas and add-ing new areas. When I felt comfortable with an area I left it alone and continued adding different colors. As you can see most of the red and black were covered up with a wonderful green-gold, a light olive and a rosy pinks. Knowing that I needed some cool colors to add balance I added the blues and purples being careful not to make the shapes the same sizes.

When I was happy with the over-all design and the shape of the major shapes I finished by connecting areas with acrylic paint and a liner attempting to pull the painting together.

I could have go on and on adding and subtracting willy-nilly forever but felt like I had a successful painting at this point and decided to leave it alone.

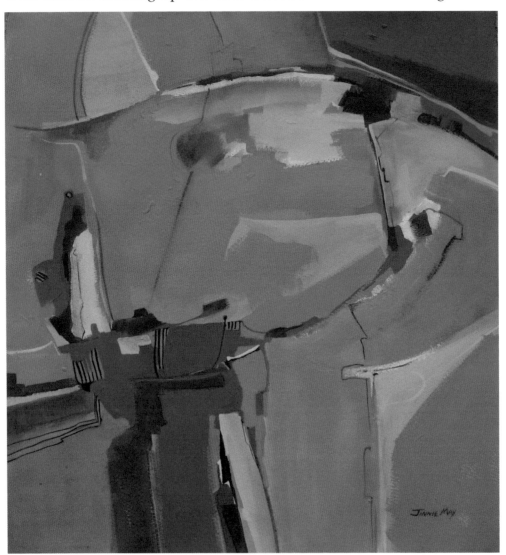

Rosy-fingered Dawn
Jinnie May
Acrylic
22" x 22"

My medium of choice is watercolor and I try to paint every day. Since I don't turn out masterpieces every day (wishful thinking) I have a lot of used paper (Arches 140 pound ROUGH) in my inventory. I also primarily paint in a casual realism style not abstractly. However to recharge my inspiration and get out of that all too familiar creative block I turn to mixed media ,failed watercolor paintings and have fun with abstracts. Don't get me wrong abstracts are not easy and in most cases it is more difficult for me to pull off a successful abstract than a representational painting but they are GREAT fun.

I start with a failed watercolor (dry) painting, tint white gesso with acrylic paint and give the paper a coat or two of the tinted mixture. Sometimes I use house paint that I have lying around and do several of these sheets at one time.

For ideas I cut a 2" x 4" opening in a 5" x 7" piece of plain paper. I'll take old magazines, ones with lots of pictures and I'll scoot all around the pictures looking for a place to jump start my abstract. I try to keep in mind that I will need the same elements of design that I need for my realistic paintings (even more so). I may get several of" 2" x 4"ideas from one magazine. I use these as my creative starts.

Next I may pour acrylic or watercolor inks, or use regular watercolor or acrylic paint sort of following the design I've selected. The colors I use are spontaneous.

Generally I don't use anything to stamp (bubble wrap) or imprint as I tend to prefer abstracts that don't have visible signs of gimmickry. Of course this can all change during my painting process.

This particular painting took on an Asian feel (probably the colors) but it actually is a garden scene with the sun in the upper right and flowers on the bottom left. The Forecast which is the title is for a sunny day. Who knew? I used Acrylic paints (both tube and bottle), watercolor and water-soluble wax pastels (Caran D'Ache) and the black is Indian ink applied with the stopper lid. I'm left-handed and often use my right hand when drawing or painting to get a not-so-perfect look as I did in this painting. This painting is 22"x22", a square format which also appeals to me. I framed it with a five inch off-white mat and a Florentine Silver metal frame. This painting is in a private collection.

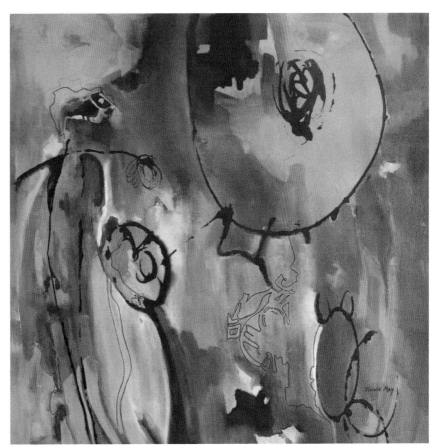

The Forecast • Jinnie May
Mixed Media, 22" x 22"

Joyce McCarten

This painting was created after a trip I made in 2001 to visit missionary friends who live on the edge of the desert in Niger, West Africa. I wanted to do a body of work about that trip, but I did not want to do the usual paintings of Africans in the marketplaces, outside their huts sitting on mats or riding camels or donkeys. I spent time with the Wodabe-Fulani people. They are nomads living in the desert that is drying up and will soon be unable to provide grass for their sheep and goats. They are beautiful people with eccentric ways of dressing for celebrations, but that is not what impressed me. It was the land that took my breath away. This painting is a "sensation" painting. It is abstract and has all the subtle values seen in an actual dust storm that I witnessed while visiting the missionary hospital in the desert.

First, I chose the square format because of the grid-like villages of mud houses that I witnessed while driving to the desert. The houses were square and the village format was in a grid. I am very attuned to shapes, and a large square was very symbolic to me. It represents safety and simplicity.

The painting has three layers of oil paint. I used alkyd resin paints that mix with oil paints for my first layers. The alkyds dry overnight and permit me to continue on with the same ideas and energy the very next day. You can mix alkyds with oil but once you use oil only, you can no longer put alkyds over the oils. So the first layer of paint was patches, shapes and lines of thinned alkyds in ochre, raw umber and a red earth color. These shapes and lines were applied with a brush.

The second layer, applied the next day, was a mixture of oil and alkyd. The alkyds will increase the drying times, but the oil paint is more sensuous and intense. I used a Holbein warm grey oil paint with a raw umber alkyd and worked with a palette knife, to move the paint around to merge shapes and find new subtle value changes.

The third layer was applied in the late afternoon before the paint dried. I continued to add patches of warm grey and raw umber but also used some Sennelier Pale Ochre (one of my favorite colors) and Sennelier Naples Yellow. I continued to scrape with the palette knife in order to merge shapes and distinguish values, and some of the lines from the original layer began to show through. When earlier layers begin to show through, I know that I am beginning to get somewhere. By that time, I have let go of any preconceived notions of what this painting will look like. That is the "surrender moment" when the painting begins to have a life of its own. I reinforced some lines from the first layer, added some pale yellow markings with an R & F oil stick and stepped back. The painting had become an abstraction of the colors' opacity and suffocating yellow dust that I watched swirl around the desert from the hospital view. This was exactly what I wanted to say in this painting! I put myself in the hands of the right side of my brain and I trusted it to make a painting that was more than my left brain could imagine. It's always a good feeling when that trust leads you to the painting you really want.

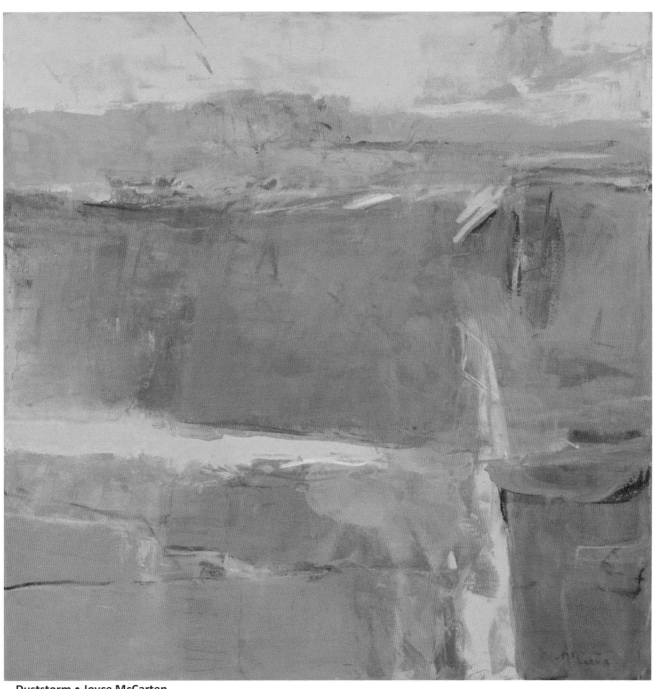

Duststorm • Joyce McCarten
Oil on canvas, 36" x 36"

This is a small, square-shaped painting and one would think it would be easily assembled. The truth is that in a small space, every paint stroke, every piece of media and color choice must be very intentional. This painting took me over a month to reconcile. The oil paint makes a beautiful surface, but every effort to change or add something must dry before another step can be taken.

I had no idea about what this painting should be except that I knew I wanted earth colors with brilliant yellow. I was making it as part of a body of work of mixed media abstract paintings. I had many treasured papers to use for collage and several pieces of metal from my late husband's garage paraphernalia. There is also a structure that is part of my abstract vocabulary, and I will often start with that structure.

For "Sproing", I applied a thin wash of raw umber (alkyd) and divided the surface into an uneven grid pattern with darker and thicker raw umber (alkyd) lines. Though I made structural divisions on the panel, I reminded myself that these would not necessarily be the structure in the end. It is important to remember that everything can be changed if it is not "working".

The next step was to create some surface tension on the panel. As I was applying white (alkyd) with a palette knife, I saw the piece of paper with the orange squares and applied that to the upper corner. It was a fragile piece of paper and it repeated the shape of the panel itself.

Because it was fragile, it would not have gone on smoothly over a rough surface. This was an early decision on my part and one I usually do not like to make. It dictates a certain structure too early, but I did it and I was pleased.

After the white alkyd paint dried, the layers were all trial and error. Sometimes the colors were too dull. Sometimes I tried other papers but they weren't right. I would apply colors and then wipe them off with a cloth or paper towel. I was reluctant to use metal pieces too early, but I did play with those metal strips on the bottom right of the panel. I turned the painting on all four sides to think about how it was meant to go. Somewhere along the way, I began to play with the piece of heavy wire that is looped. Eventually, the metal pieces were glued on when the oil paint was dry to the touch and I glued them with "Yes" glue.

So, in this small painting, I had all the elements of art making in play: structure, line, color and value, surface tension, shape and scale. At the end, I picked up a blue R&F oil stick and used it over that dark umber division. It felt right to me and did not seem too structured or tight in spite of its divisions. The metal loop was definitely the surprise. I only had one metal loop and I used it. I wish I had more.

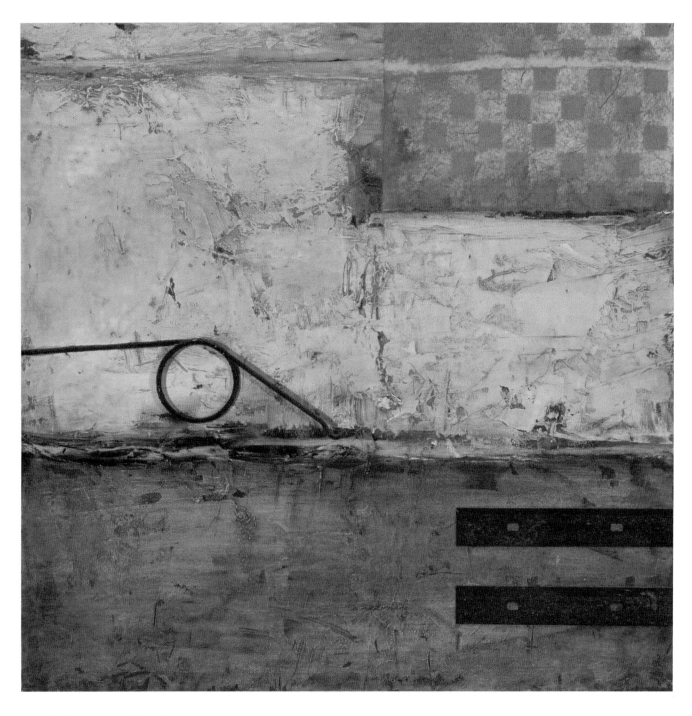

Sproing • Joyce McCarten
Oil and Mixed Media on board, 12" x 12"

Linda Benton McCloskey

I typically challenge myself to paint "out of my comfort zone". On this particular challenge I decided to use a color that I normally do not use...yellow, which in the past I never used as a background but only as a highlight.

I started this painting with brushing heavy bodied gesso on the entire canvas surface, letting some of my brush strokes show. After the gesso was completely dry, using a 1-1/2" and a 1" brush, I gesturally painted black lines almost over the entire canvas. I also used a round brush to get more variety of strokes in both width and shape. I let this dry completely before my next step. This step will show in layers that follow giving the painting "history". My next step was to partially obscure the black lines with white paint.

Leaving some white areas and with a 2" brush I started by painting the entire surface with a limited palette starting with heavy body yellows of various shades, such as naples yellow, cadmium yellow light and medium, and aurleolin. I also used unbleached titanium for a range of color and only slightly blended the shades. After the canvas as almost dry, but not completely, I pulled out a jar of blue black paint (indigo) and started brushing spontaneously with a 1" brush two areas of that color – one bigger than the other. Since my canvas was not completely dry, the blue touched some of the damp yellow areas and those small areas turned a beautiful olive green, others remained a deep indigo. I then added white to the blue black for a lighter tint of that shade and painted that lighter tint on both the left and right side connecting the two, one side having a larger area.

With black paint, I brushed circles of different sizes down both sides of the canvas. On top of these circles, I highlighted and obscured them with the lighter tint of blue and also with white.

To finish the piece, I used a brighter shade of yellow and brushed this color between the two sides and across the top. This seemed to really give harmony to the piece.

**August Series #1 • Linda Benton McCloskey, PWS, BWS, ISEA-NF
Acrylic on Canvas, 48" x 36"**

Sometimes when I overwork a painting I don't get the results that I want. That's what happened with "Lady Luck". My paper was Strathmore, 500 Series, Bristol, Vellum Finish, 3-ply, which has become my favorite type of paper to paint on since it really does take the "punishment" that I seem to give it.

Originally this was another painting that consisted of shades of green with various other colors. I overworked it and disliked the outcome. That's when I decided to take my "head out of the picture" and just start painting with my gut and with an "I don't care" attitude. I covered the entire green surface with bright red fluid paint. While still very wet, I dripped and spritzed alcohol over parts of the painting. And, again, while wet I took my brayer and used the edge to make circular and straight lines over the entire area. A beautiful thing happened. Green started showing through the alcohol areas and also where I took by brayer to make lines – those lines also revealed the green paint.

With watered down gesso, I painted in some of the shapes that were formed by my brayer. Before the gessoed areas dried, I sprayed water and scraped those areas with a credit card and a

"color shaper". I also blotted some of the white shapes with tissue. After the painting dried, I glazed the red areas with lighter and darker colors of red. I then added black in the middle, in the circular area, and also in some of the shapes above and below the circle to give the eye a path. I again sprinkled alcohol in the black circular area and the red was revealed from below. After the black dried, I glazed the circular area partially with red and scraped white into it. Later after my initial finish, I added more white areas where needed.

Lady Luck
Linda Benton McCloskey, PWS,
BWS, ISEA-NF
Mixed Media, 30" x 22"

Lois McDonald

"Energized" was yet another great journey! The journey started with an idea, as usual, revealing itself around 2 o'clock in the morning. The circle idea came first so I painted a sheet of Unryu paper with various shades of orange, red and warm yellow. Once that was dry, I adhered the large circle in the "sweet spot" of a 48" x 60" "The Edge" box canvas.

Energized • Lois McDonald, CASA, SAWG. Acrylic, 48" x 60"

When that dried, I tied a string to a pencil and attached the opposite end to a pushpin that I stuck into the middle of the circle. I drew in circles at various widths from each other to keep the design more interesting. I started painting the various circles with blues of different hues: phthalo, cobalt, and anthraquinone. I added white to some; others came straight out of the bottles of Golden fluid acrylics.

As I was mixing one of the colors that had white added to it, I decided to stretch it out a bit by adding Golden GAC 100 specialty acrylic polymer to the mixture. Viola…I got that marbling effect which was a wonderful surprise!!!! When that happened, I decided to carry that surprise to other places in the piece not only to balance the happening but to make the whole more interesting.

The idea for the cobalt turquoise occurred because I also wanted to bring in some greens and it was a good transition from the blues. I toned down some of the strong colors by the addition of a gray value in several places in the piece. Notice that every color used leads your eye around the whole painting.

Because of the energy of color that came from my circle, I then decided to add the orange-red rays for a more interesting design and then put the frosting on the cake with the golden shots of lightening that surround the piece. When doing that, I painted that double bolt of lightning on the left side so I could bring in the Jenkins green, also mixed with the GAC 100.

I then added the other three orbs, cut from the same paper as the focal point circle, being careful of size and placement. Several coats of Liquitex varnish finished the work.

Isn't it wonderful that, even after a lifetime of painting, one can continue to learn as an artist? The GAC marbling effect was yet another cog in this never-ending journey.

Do you dream? I will often wake up at 2 o'clock in the morning with an idea. It nurtures and grows: thoughts of how to go about it, what papers to use, what mediums to play with, and, of course there's the color. That's how this "Meditation" series began and continues.

I painted Unryu papers with Golden fluid acrylics and cut the bough shapes from those gold papers. I cut boulder shapes from textured Mulberry paper. I decided on a 30" x 40" Creative Mark canvas and pasted down the land with other textured Mulberry paper. I let that dry and painted in the red oxide sky followed by the green hills.

The land mass was painted with color and shape to give me an idea of where I wanted to plant the tree trunks. With that accomplished, I decided to get out the FW acrylic inks and paint in the water. (Sometimes this area will be underground so the colors are earth tones.)

With the canvas in a flat position, varied inks are dropped randomly in that area and a spray bottle of water is used to meld and blend the colors, being careful to avoid getting fussy. While all of this is soupy, I put papers on top and around the sides of the canvas. The papers vary such as plastic wrap, the inside packaging from dry cereals, sandwich wrap and/or wax paper. Each type of paper leaves its own kind of texture as the paint sets and starts to dry. When the design looks interesting and is fairly set, I remove the papers and let it dry.

I added the cut boulders while keeping design in mind, gluing down each one with gel medium. I added the hand painted golden boughs of the trees and the mixed green papers in the landscape. Then I decided to paint in the row of rocks in the landscape area for yet another layer in this strata piece.

I looked for the horizontal line areas in the water, and darkened and covered some of the light areas that would take away from the feeling of water. The boulders were then shaded with various earth tones and the tall grasses were cut and put in the landscape shoreline.

Finally, the design was enhanced by the vertical red oxide in the water and washes of that color throughout the piece. With a few layers of varnish, my dream idea, Rockin' Rocks, was complete!

Rockin' Rocks
Lois McDonald,
CASA, SAWG
Acrylic
30" x 40"

Jason Mejer

For this piece, I chose a 300 lb. watercolor paper for increased durability and to prevent buckling. I filled a large sink with lukewarm water and soaked the paper for twenty minutes, then let it drip diagonally from all four corners before laying it flat on a wooden table. While the paper was still damp, I began to lay down washes of yellow, red and purple. I tried to allow a few areas of the cool color to burst into the warmer ones.

I painted one side of a wooden block to use as a stamp of the letter "M", and the number "8" was produced using a sponge which was allowed to sit while drying on the damp paper. The top center crackle effect was created by laying

Plexiglas on top of the yellow passage. This remained in place until the paper was dry.

A few areas on the image were spritzed with a spray bottle of water. Most of the detailed areas were done on dry paper, such as the sections of pointillism and the wet-into-dry shapes and lines. The diagonal shape on the top left of the image incorporated watercolor crayons and water-based pencils.

8M
Jason Mejer,
MFA
Watercolor
30" x 22.5"

116

I dripped a light layer of white glue on the back of a sheet of 140 lb. watercolor paper and pressed it onto a lightweight drawing paper on a wall (you can only see evidence of this by the red shape coming from the back on the top left of the piece). Then I stapled it to my studio wall before applying one coat of gesso. After the gesso dried, I applied some areas of wet–into-wet watercolor such as the blue staining on the top left; not letting it drip too much was easy since I had only used a thin layer of primer.

I also worked acrylic paint into areas such as the large dark circle. While the piece was still on the wall, I glued the large yellow shape down (a torn acrylic painting and the smaller right hand corner piece from a watercolor painting). I then worked in the dry areas with Prismacolor colored pencils, some of which were water-based. When I cut and tore the work off the wall, I laid it flat. I placed the bucket I had used for primer on the top left and sprayed around it with water, creating the white circle. I weighted the piece down with a board for a few hours then made a few finishing strokes and washes, allowing the underpainting in some areas to show through.

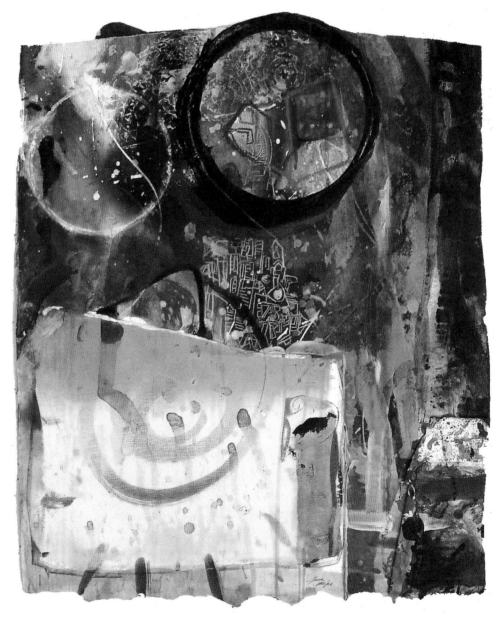

Repelling Heracles
Jason Mejer, MFA
Mixed Media
on Paper
30" x 22.5"

Robert Lee Mejer

Since the mid-sixties I have used collage (papier colle) as a method of generating ideas for my paintings, much as an artist uses the sketchbook. I like the idea of layering space. These collages, part of my "Inscape" series, are made from a palette of found magazine images, textures, color, and so on. The scale is kept small (6" x 4") so that I can generate many images from which to select for future paintings or retain as works of art in-and-of themselves. Problems of composition, color possibilities, and shape are worked out at this stage so that I can devote more time to the painting process and tweaking the design. I chose "Take PC #26" because of the challenge it presented to me regarding transparency, space, edges, geometry, composition and working with neutral colors.

I use a 9" x 12" Strathmore 140lb Acid Free Watercolor Cold Press or Bienfang Bristol 100lb Acid Free paper as support for my collage. For gluing down the elements of the collage I use a 4 FL.oz bottle of Ross-No Wrinkle-Acid Free Rubber Cement. I find this to be ideal for cutting and pasting and it is easy to remove excess glue. I scan or take a digital shot of my collage, which I print out for painting reference before I apply a permanent protective Gloss Coating using Krylon Crystal Clear Non-Yellowing Acrylic.

This painting, developed from my collage, was done on a full sheet (30" x 22.5") of acid free, cold pressed 300 lb. Saunders Waterford Watercolor Paper from St. Cuthbert's Mill, England. Because it is a heavy paper I find no need to do a stretch.

Instead, I align and square the paper and push-pin it to a piece of 32" x 24" Homosote Board. This allows for much flexibility when working on the painting or viewing it from a distance for evaluation.

For enlarging my image I work by sight and ruler measurements. I lightly draw the image with a 2B pencil. If corrections need to be made I use a Staedtler Mars plastic eraser, which does little damage to the paper. The collage for the painting is proportionally expanded five times in order to approximately fit the size of the watercolor paper. I do enough drawing for my design layout, which provides a foundation for color and surface treatment.

I mostly use Daniel Smith Extra Fine Tube Watercolors along with permanent colors by Grumbacher, Winsor and Newton and M. Graham. These colors are arranged from light to dark and warm to cool around the John Pike 24-well Plastic Palette which provides a generous color mixing area, including the lid. I work with a Double Bias-Double Primary Color wheel when mixing and choosing colors for my painting.

After my design is laid out, I plan where my white areas will be or where I need clear color later in the painting process. These areas are masked by using various sized, low tack tapes like Loparex Easy Mask Painting-Tape, Scotch Drafting Tape or Contact Self-Adhesive Clear Vinyl. Physically applying paint to a surface is inherently satisfying to me and connects me to my humanness. I mix my colors on the palette with a 1" flat natural hair brush and apply the paint very loosely for the largest areas of my underpainting where other layers will be applied later in increments to the dry surface. For linear and smaller areas later in the process, paint is applied with a Winsor & Newton #4 Artist's Sable brush. For me, color contrast is important.

Like the various opposites in life, I love working with visual opposites, which creates "liveliness" in the work.

My basic procedure for painting a watercolor involves the following process: from background to foreground; from out-of-focus to focus; from large to small shapes; from shapes to line; from painted to scratched line; from stencil to stamped areas of pattern; from light to dark; from soft to hard edge; from lost to found edge; from warm to cool colors; non-texture to texture; from low color saturation to high saturation; from transparent to semi-opaque; and all the time I am thinking of design with detail added last.

My background experience in drawing, painting and printmaking provides me with a rich vocabulary of techniques from which to choose for realizing my image. The painting informs me of the direction I need to take during this dialogue in the painting process. Periodically, during the painting process, and after several days of not painting, the painting is hung on the wall for viewing with "fresh eyes."

When I am finally satisfied with the painting and my goals are met, I take a digital shot of the work before I frame the piece under glass.

It is my hope that the painting "resonates" with the viewer, as it did with me, in attempting this challenge to capture the spirit of the collage and provide theater for the eyes.

I am reminded of this statement, during a gallery talk about his work in New York, made by painter/printmaker Michael Mazur: "Every medium has surface and surface is the message of the medium. . . Surface carries the work of art and not the subject."

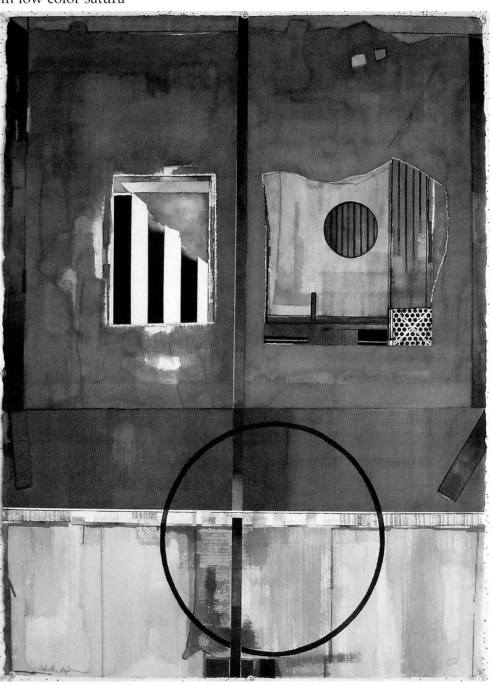

Take PC#26 • Robert Lee Mejer-MFA, NWS, WHS, ISEA-NF, TWSA; Watercolor 30" x 22.5"

119

I am an abstract intimist involved with painting situations and not things. My work is about "felt remembrances" frozen in time. I am attracted to the infinite possibilities of the medium and techniques of watercolor and its interaction with paper. I find the unique layering process and the fluidity of color to be seductive and rich in nuance.

The impetus for this watercolor image came from an earlier water-based monotype press-printed from collaged elements assembled on a plexiglass plate. I did not consider the print successful but felt that the image-idea was strong enough to pursue in watercolor. Collage plays an important part in all of my work; its physicality, its illusion, and its spatial dominance are all attractive to me. With watercolor I try to push the realm of illusion without resorting to the physical use of collage. The painting is but a fingerprint of the spirit of this search.

The intent of the monotype image was to marry the Cubist space-collage idea of the flatness of the picture plane with the Impressionist concern for light and color, the Surrealist approach of using unconscious and automatic techniques and the Abstract Expressionists emphasis on the elements and principles of design and fidelity to the materials. By shifting planes and using gestural and controlled linear elements, I captured the sense of the push-pull via color and the interplay of inside-outside space.

The painting was done on a full sheet (30" x 22.5") of acid free, cold pressed 300 lb. Saunders Waterford Watercolor Paper from St. Cuthbert's Mill England.

Because it is a heavy paper, I find no need to do a stretch. Instead, I align and square the paper and push-pin it to a piece of 32" x 24" Homosote Board.

For enlarging my image I work by sight and ruler measurements. I lightly draw the image with a 2B pencil. If corrections need to be made I use a Staedtler Mars plastic eraser, which does little damage to the paper. I do enough drawing for my design layout which provides a foundation for color and surface treatment.

I mostly use Daniel Smith Extra Fine Tube Watercolors along with permanent colors by Grumbacher, Winsor Newton and M. Graham. I work with a Double Bias-Double Primary Color wheel when mixing and choosing colors for my painting.

After my design is laid out, I plan where my white areas will be or where I need clear color later in the painting process. These areas are masked by using various sized, low tack tapes like Loparex Easy Mask Painting-Tape, Scotch Drafting Tape or Contact Self-Adhesive Clear Vinyl. I mix my colors on the palette with a Grumbacher 1" flat natural hair brush and apply the paint very loosely for the largest areas of my underpainting where other layers will be applied, in flat washes, later in increments, to the dry surface. For the linear elements I use a Dick Blick Golden Taklon #10 round brush.

My basic procedure for painting a watercolor involves the following process of working: from background to foreground; from out-of-focus to focus; from large to small shapes; from shapes to line; from painted to scratched line; from stencil to stamped areas of pattern; from light to dark; from dry brush to wash; from sanded to adding salt; from soft to hard edge; from lost to found edge; from warm to cool colors; non-texture to texture; from low color saturation to high saturation; from transparent to semi-opaque; and all the time I am thinking of design with detail added last.

As for watercolor materials and techniques, I try to present the beauty found in the material while remaining "true to the material" and pushing its boundaries.

My background experience in drawing,

painting and printmaking provides me with a rich vocabulary of techniques from which to choose for realizing my image. The painting informs me of the direction I need to take during this dialogue in the painting process. Periodically, during the painting process, and several days of not painting, the painting is hung on the wall for viewing with "fresh eyes."

The image is meant to be visually experienced by the viewer, who is challenged to think again about the nature of watercolor, image and space ---to "converse" visually with the piece.

When I am finally satisfied with the painting and my goals are met, I take a digital shot of the work before I frame the piece under glass. I use Adobe Photoshop for documenting my images.

I use a visual language (painting) rather than a verbal language to express a moment in time which represents to me my humanness. My only hope is that the viewers trust their instincts and make a visual connection that cannot be expressed in words but is experienced also, as part of being human.

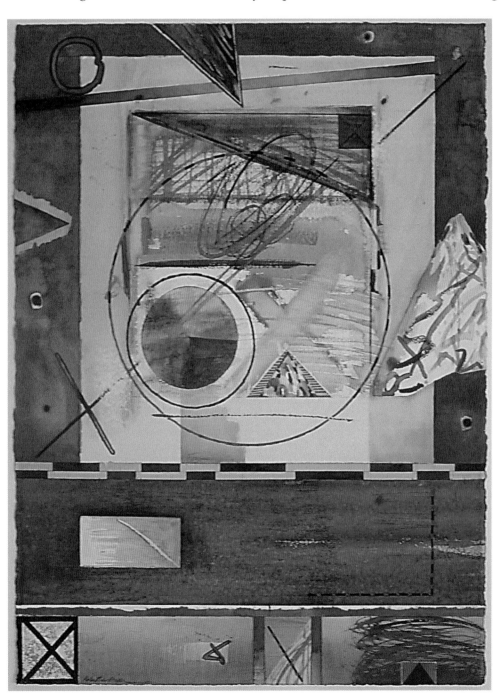

Variant: Zig-Zag
Robert Lee Mejer-MFA,
NWS, WHS, ISEA-NF, TWSA
Watercolor
30" x 22.5"

Shirley Eley Nachtrieb

This painting was done in much the same way as "Natural Elements #2", also found in this E-book. I used Golden fluid acrylics Quinacridone Nickel Azo Gold, Phthalo Turquoise, and Primary Magenta for my pigments, and Saran Wrap, cotton gauze, wax paper and Thai unryu for my textural elements. Here, however, I had a preconceived idea that I wanted a high horizon line in the major design format. I planned the approach so that the white saved by the Saran Wrap would be at the top of the painting. The colors are mainly purple and gold which are complements on the color wheel thereby giving the painting a very striking presence.

The wax paper left behind the great rock shapes. The Saran Wrap gave me a light road shape which I later exaggerated with white gesso. Trees were added with a liner brush and a mixture of Quinacridone Nickel Azo Gold and violet mixed with Primary Magenta plus Phthalo Turquoise. The gold spray paint showed up well. I added back some of the gauze texture which was the linear movement, using matte medium as my adhesive.

This 7" x 7" painting was then matted and framed in a 12" x 12" black oak frame. I painted a series of twenty of these. I have found it very helpful to paint in a series of 3-20 paintings when I am trying something new. It is very educational.

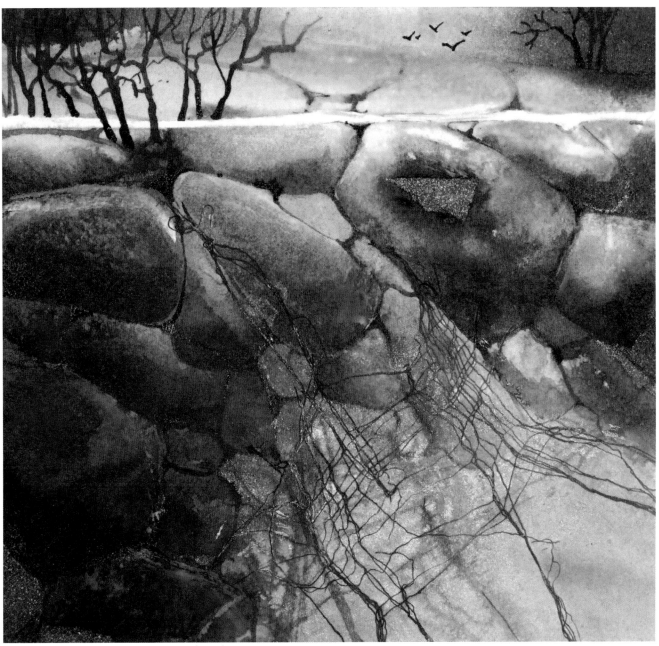

High Road #3 • Shirley Eley Nachtrieb, MOWS, ISEA, SLMM
Mixed media, 7" x 7"

I began this project by first painting a textural substrate on 140 lb. cold pressed Arches watercolor paper, using Golden fluid acrylics, Saran Wrap, wax paper, rice paper and woven cotton gauze and marbled paper. A simple triad of Golden colors was used: Quinacridone Alizarin, Phthalo Turquoise and Quinacridone Nickel Azo Gold. My design format was aerial perspective.

Water was brushed onto both sides of the paper and a dilute wash of the gold was lightly painted on. Saran Wrap was then used to trap some of the gold color and some of the white of the paper. Saran Wrap was used to save the whites. When more texture is wanted this element is stretched before it is placed on the paper.

The second textural element used for texture was woven cotton gauze. This was cut into the desired sizes and pulled slightly to get a distorted shape (like a spider web), then placed on the wet paper near the Saran Wrap. I misted the gauze with water to anchor it to the surface then added a second layer of gold paint on the surface.

The third textural element used for texture was wax paper. This left a pattern of rock shapes on the surface. The wax paper was torn in a variety of sizes depending on the overall pattern desired. I painted a third layer of color over the papers. This was Turquoise, a second color. It mixed with some of the gold paint and created a green.

The fourth textural element was Thai unryu rice paper in white. This absorbed the wet paint and can be recycled back into the painting during the collage process. As the rice paper absorbed the color, it became the darkest area of the painting. Thicker paint will make this an even darker value. The color I used was a violet made with the Quinacridone Nickel Azo Gold and Quinacridone Crimson.

The painting was then taken outdoors and lightly sprayed with a metallic gold spray paint. This unifies the painting. The painting rested for about an hour inside, then the textural elements were removed. If left outdoors, the painting will dry too fast. You could tell when the papers were ready because they wanted to stick to the surface. (When trying this for the first time, you may want to check on the papers about every half hour. If left on too long they may be permanently attached). The Saran Wrap and wax paper are discarded; the rice papers and gauze are saved for later collage work.

The finishing touches were added once the paper had dried. A watercolor pencil was used to draw in the rock shapes. These were then painted around and shaded. More linear movement was added using a small liner brush. Collage papers were added back in smaller pieces. Dark marbled papers were adhered to the surface with matte medium near the focal point. I put the painting on an easel and came back to it the next day with a fresh eye to determine if it was finished.

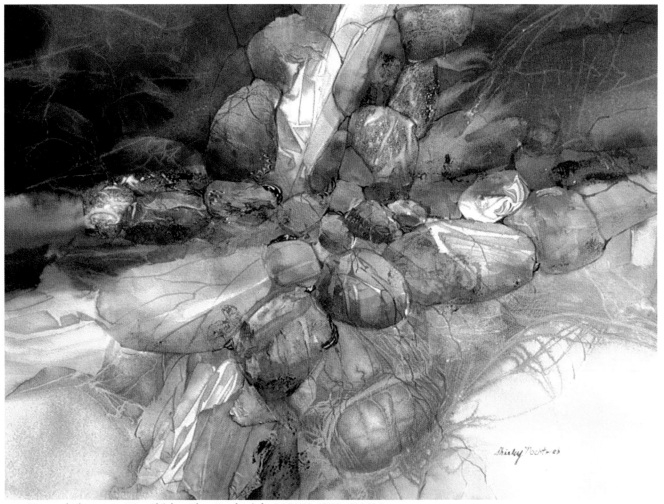

Natural Elements #2 • Shirley Eley Nachtrieb, MOWS, ISEA, SLMM
Mixed media, 22" x 30"

Aleta Pippin

My new series of paintings are about energy and motion, freedom of movement, and color interpretation of the music I'm listening to.

Enjoying My Freedom is the first painting in this new series, an acrylic on canvas. The canvas is a 12 oz. cotton duck on heavy-duty stretcher bars. In this new series I'm returning to the use of paintbrushes; I have not used brushes in over ten years. The brushes are from the hardware store, big floppy brushes and short bristle brushes. I like these as they accomplish my purpose. When necessary, they're easily tossed into the trash without the frustration of tossing a $30 brush away.

The paintings in this new series are hung on a wall in my studio, rather than using an easel. First I hang a large plastic drop cloth to cover and protect the wall from splatters. Then I place three rows of screws along the wall in a level line, one row higher than the next. The screw heads are exposed about 1.5 inches out of the wall. I hang the canvas up on these screws. By placing the rows at various elevations, I'm able to move the canvas up and down in order to reach the top.

Music is key in this process; it must have movement. Who doesn't remember the scene in Shall We Dance with Richard Gere and Jennifer Lopez when they were dancing

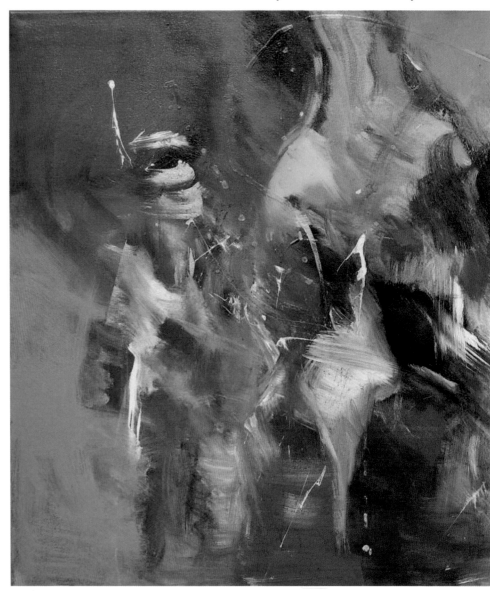

alone in the studio? I was so taken with the music, I looked it up to discover the Gotan Project and the song – Santa Maria (Del Buen Ayre). That song and others on that album have the movement that works for this style of painting.

Enjoying My Freedom is a painting done with music, speed and emotion. It is about movement and feeling, a translation of the music. The colors are loosely and rapidly applied in time to the music. Judgment is muted, a benefit of painting quickly and to music; it's easier to turn off your left brain. If you've

mastered the technique of painting and have painted long enough to understand the principles of design, values, etc., then painting in this manner can be very gratifying.

After selecting the music, choosing the color palette is critical. Color has a vibration, triggers emotions, has a physiological impact on us. It can evoke feelings of joy, introspection, melancholy – just as music does. I am a colorist and the color palette I select is intuitive. For painting these high key and emotional paintings, I prefer Golden acrylics.

After setting everything up, buckets of water, open paint, brushes ready, music playing – I use charcoal to quickly mark up the white of the canvas. It loosens me up and signals the start of the process. Then moving quickly in tune with the music, I begin applying paint. Brushes move at a fast pace, other tools (from the hardware store) are incorporated, fingers dig into the thick juicy paint to throw it onto the canvas – all seems to be chaos, then the image appears, more paint is added, more marks are made, more energy is projected until suddenly, the painting is complete.

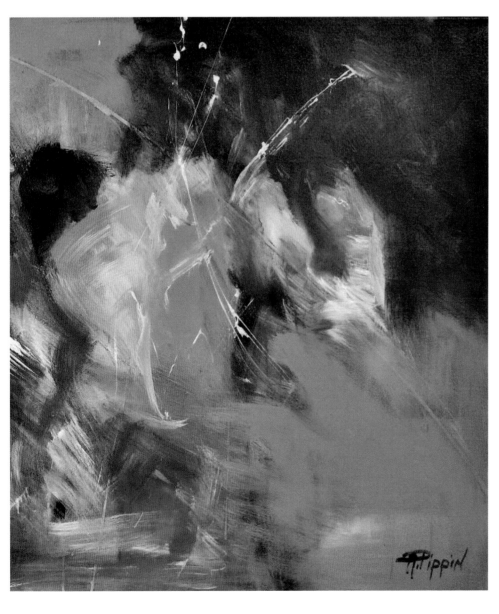

Enjoying My Freedom
Aleta Pippin
Mixed media, acrylic on canvas,
36" x 60"

I started this painting on Yupo paper. Yupo is a polypropylene paper made in Japan. I like it because it doesn't absorb the color like typical watercolor paper. As a result, the color sets on the surface of the paper and the color dries in extremely vibrant tones. Yupo paper can be purchased in rolls from Daniel Smith stores or online, or in sheets at most art supply stores.

Next, I selected the colors I know work well together. I used Golden fluid acrylics for this piece as I knew that I would be pouring the paint and Golden fluid acrylics have a high pigment content even when diluted. The colors used in this piece are primary cyan, naphthol red light, bronze or gold, quinacridone azo gold, titan buff and interference blue. In a plastic container, I mixed each color individually, diluting it with a little water and Golden pouring medium #2. This medium has to be specially ordered from Golden. When dry, it gives the feel of encaustic, a little brighter but with a dimension I haven't achieved with other mediums.

The drawback to using pouring medium #2 is that the paint has a cloudy appearance while you're painting. For some this is a hindrance but for me it provides a bit of a surprise after it dries. This particular painting was poured. I laid the Yupo paper on the floor and moved around it, pouring the various colors. After a few pours, I picked up a corner of the paper and shifted it to move the paint, sometimes folding it back into itself. I continued pouring the paint and moving and lifting the paper until I liked the result. This is a time to be a little conservative as you aren't completely controlling the flow of the paint and some gorgeous passages may continue to flow, completely changing the appearance.

Once I achieved the desired effect, I let it dry and returned the next day to an extraordinary image. Because the paint is a little cloudy when you begin, it is amazing to see the clear, vibrant color of the completed piece. When it was completely dry, I mounted the paper on an Ampersand panel using white glue. I finished this painting with EX 74, an Envirotex epoxy resin. I like this particular brand of resin as it has a high quality, is very clear, and has a UV protector in it.

Prior to pouring the resin, I taped the edge of the panel with blue painters tape (orange) and allowed the resin to run off the edge. The resin is a mixture of two components thoroughly stirred and poured onto the painting. Once poured, I have to release the bubbles as they form. I do this with a propane torch. In my studio, I have an "epoxy room", where the paintings are laid flat and I can leave them. I feel comfortable that when I return most of the dust particles floating in the studio won't have reached the surface.

The next day after the epoxy resin coat had dried, I viewed the painting to determine whether the pour ended up as smooth and glasslike as I desired. To my dismay, there were places along the edge that were rough, so I did another resin pour and actually ended up doing five or six pours, sanding down in between some when the resin became very thick. This is not uncommon as the resin is a bit uncontrollable.

Once I determined that the resin surface was finished, I pulled off the tape and sanded any areas along the edge where the resin crept under the tape. After I got the edge smooth, I painted it with black acrylic paint.

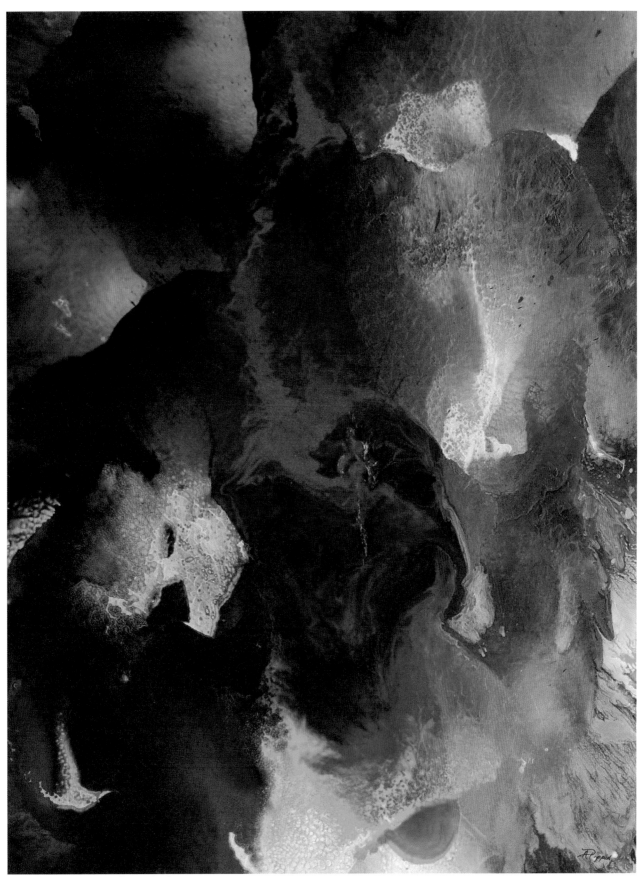

Floating Free • Aleta Pippin
Mixed media, acrylic on Yupo paper mounted on panel with epoxy resin surface, 48" x 36" x 2"

Karen K. Rosasco

Connections started as a demo for a layering project in one of my week-long watermedia workshops. Many of my paintings start out this way using a variety of layers to create a rich surface. I usually work on three at one time in the same color scheme, allowing time for each layer to dry, and I can keep using the same limited color palette.

I covered a full sheet of 300 lb. cold pressed watercolor paper with diluted gloss medium. This solution is made by filling recycled small plastic margarine or hummus tubs with about one inch of medium. I then place about 1/4 inch of water on top and gently stir. You do not want to add air to the mixture as it will cause bubbles while drying. When this layer was dry, I divided the paper in five stripes of unequal widths using several analogous colors from the warm temperature side of the color wheel. Many paintings suffer from a lack of unity by not having a temperature dominance. By using colors close together on the wheel, you solve the problem at the beginning of the project.

Applying the stripes one at a time with fluid acrylics, I was careful to keep the edges soft for smooth transitions to the next shape. While the paint was still wet, I pressed objects such as bubble wrap, food wrap and nonskid carpet pads in the large areas of color to create interest. When the stripes were dry I stenciled in numbers and letters, and pressed more textured objects covered in darker paint over some of the lighter stripes to keep the edges soft.

The next step was the painting of a large opaque shape of gray-tinted gesso placed centrally over at least three of the initial stripes. I left "holes" in the gesso near the focal point area where the underneath layer showed through. Once again, I was careful to keep the edges of the gesso shape soft and textured. I even used my fingernails to scratch through the wet paint.

Since the gesso shape was large and plain, I divided it up with black and gray geometric pieces and arranged a line of visually connected but irregularly shaped darks. The final excitement was the application of three pure red areas.

To tie it all together I used paint, colored pencils and graphite pencils to create lines overlapping the shapes and also stenciled on more faint numbers and letters. By using some circular line work over the mostly rectangular shapes, I created more interest. The result is a complex, but unified, completely unique work of art.

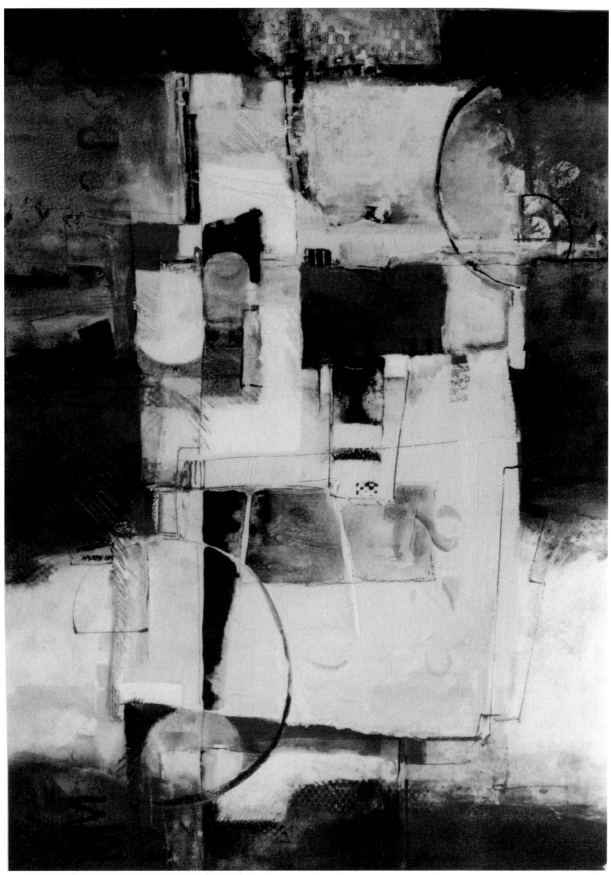

Connections • Karen K. Rosasco, CNYWS
Mixed media, 30" x 22"

"Steadfast" was created on a piece of 10" x 10" masonite primed with gesso, which you can make yourself or buy as gesso board from the major art supply companies. I applied heavy gel medium with a large palette knife in various directions trying not to make it smooth but to create an interesting pattern. While the gel medium was still wet I collaged in pieces of torn sheet music and a rectangle of paper I had covered with powdered charcoal. I make the latter in large sheets (which I either use as collage or paint on directly) by spooning the charcoal on the paper and then splashing the sheet with water. After it dries I shake off the excess charcoal, spray with fixative and seal with watered down gloss medium, not gel medium!

I think limiting the color palette in your art gives a unified look with little effort and helps you make a more successful painting without a struggle. For this piece I will use only yellow, green, black and white.

I let the piece dry overnight and then gave it a coat of Quinacridone Nickel Azo Gold fluid acrylic paint except for a few areas on the sheet music and charcoal paper. While the paint was still wet I sprinkled rubbing alcohol on the surface to create the circular textures.

After drying I began the next layer using black fluid acrylic paint carefully applied in two different sizes of irregular shapes.

When that dried I used a green fluid acrylic paint mixed with black and then with gesso to make two more irregular shapes but still kept the golden layer as a unifying pathway through the piece.

While the green paint was still wet I scratched in lines with my finger nails to tie the shapes together. The final touches were several slender vertical areas of black on the yellow layer to cross over the horizontal layers of the sheet music for more unification. I also put in several small rectangles of the green mixed with gesso over the black area on the top and right hand side.

This exciting work maintained its freshness and sparkle even after five layers. I gave it a final layer of watered down gloss medium to protect the surface and put it in a wood frame without any glass.

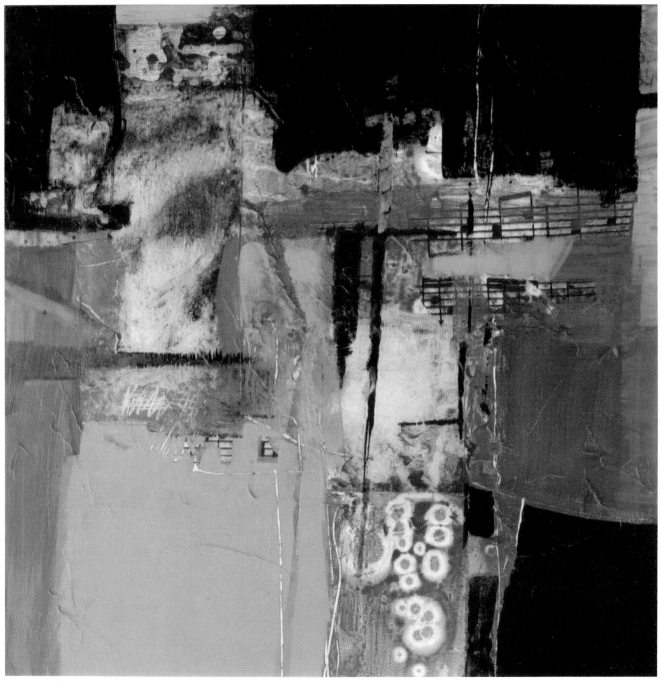

Steadfast • Karen K Rosasco
Acrylic and Collage, 10" x 10"

Jane Segrest

Land Plan – Fall is one in a series of four paintings that I created for a museum show that emphasized environmental subject matter. The series was based on land patterns as seen from the air.

I began this painting by toning the stretched canvas with yellow acrylic paint. During the painting process, I will paint over this color and leave parts of it showing to carry it through the painting.

Next, using my own photographs, I draw patterns of land images on the canvas with white chalk. Chalk allows me to work out my design. Things that I think about at this point are size and direction of shapes, a variety of shapes, and how to connect these shapes to other paintings in this series. While painting, the chalk lines are easy to change and are mainly used as directional tools.

Using acrylic paint, I lay out the colors that I will use. For this painting, I selected colors that represented fall - yellow, orange, red, green, purple, brown, white and black. Most of these colors will be used in other paintings in this series but in different amounts and intensity.

Texture is also important. Corrugated cardboard, Saran Wrap, bubble wrap and paint are used to entertain within the shapes.

I started this painting with yellow paint at the top and worked down. Some areas were painted solid colors while other areas had a variety of colors and textures. Each area was painted with consideration of the space next to it. I finished one area before going to the next. When I had completely covered the canvas, I spent time just looking to see what needed adjusting. At this point, I can change a color completely, adjust sizes and shapes, add lines and create lost and found edges. Only when I am satisfied with the painting will I sign my name.

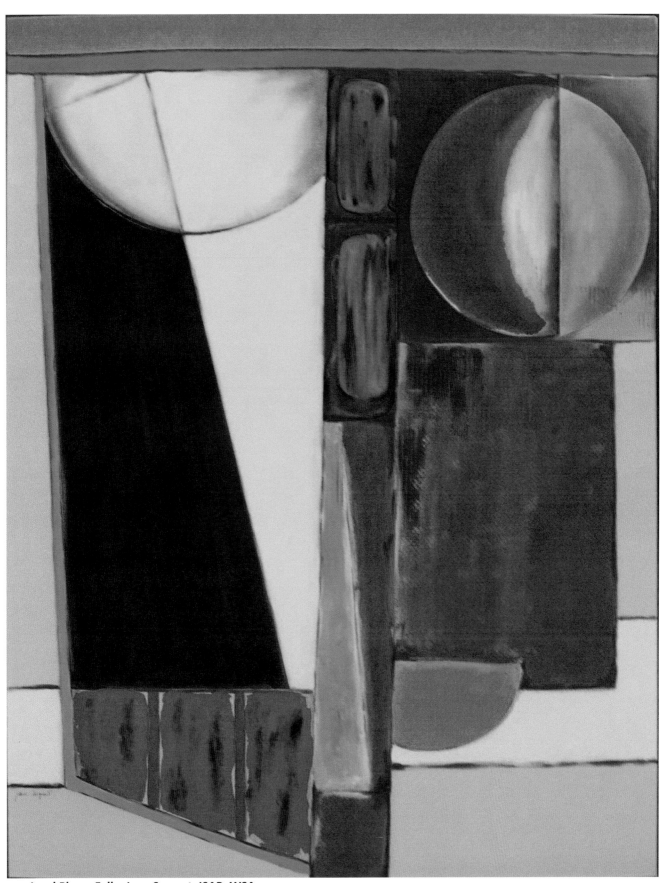

Land Plan – Fall • Jane Segrest, ISAP, WSA
Acrylic, 48" x 36"

Mary Beth Shaw

This piece started with collage elements, specifically architectural drawings that I glued to my canvas using gel medium. You can get a really nice flat, bubble-free look by spritzing the collage paper with water on both sides before you glue it down. At the time I made this piece, I was working on a series about compartments and that was my initial inspiration.

After the collage components were added, I created texture using acrylic texture mediums and stencils. Some of the texture was also created by 'raking' through the medium with a found object that has become a favorite texture tool.

I used soft pastel for some of the initial layers of color, 'fixing' them on the canvas with matte medium so they would adhere. I really like to leave some of the pastel areas somewhat granular, and allow other portions of the pastel to create a paint (of sorts) as it mixes with the medium.

As I moved deeper into the painting, my painting process turned to 'wet in wet' and became very spontaneous, involving the use of a spray bottle and a hair dryer to direct the flow of the paint. I alternated between acrylic paints, airbrush paints and acrylic ink to create my layers. The top greenish box is an example of where the dripping ink created a resist with the paint. I love it when that little bit of magic happens!

I frequently turn the canvas as I am working and work from all four directions. After working on this piece for a number of days, I happened to notice that a house had appeared in the lower left. This was a happy accident that helped me determine my final orientation for the painting.

Even though I work in fairly broad strokes early on, my final steps are actually quite detailed. I get really close to the piece adding press-on lettering and doing the graphite work. I then move back and forth from the painting to determine where I will add fluid acrylics to 'pop' certain areas as needed. Once I have deemed the painting as done, it is varnished with a glossy finish.

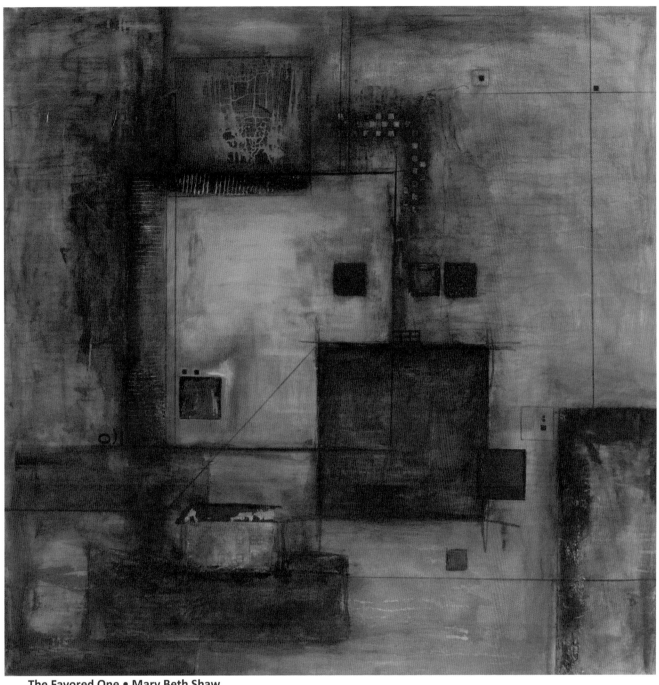

The Favored One • Mary Beth Shaw
Acrylic, Collage, Pastel & Graphite on canvas, 40" x 40"

Jan Sitts

My description for the composition of this painting is as follows: I

used two wooden panels that I had built for me. I applied three coats of Gesso, after I sanded the panels thoroughly.

After all was dry, I chose heavy Gel medium and applied it in heavy thick coats throughout the composition. The composition was spontaneous, and I did not know what was going to develop, I just know I wanted a beautiful ocean, after all the difficulty that was made by the oil spills in the south.

I used heavy gel and a mixture of beads, to create a "bead gel" which is my little secret! I then picked acrylic paint in many colors and layered the paint one over the other. When dry, I might add a little gel or gel/ bead and repeat the process. I do not paint by any "rules" or in any order.

I paint what feels good to me at the moment. I am strictly a spontaneous painter, but always have the elements and principles of design within my reach. I like to make statements about the world today and try to make it a better place to live thru my art.

My philosophy is take off the bad...and put on the good... in my painting. I like to see the essence of beauty in an abstract painting and let the viewer relate to how the world might be a better place, by viewing the beauty of landscape.

Rethinking Oceans • Jan Sitts
Mixed Media, 36" x 48"

Patsy Smith

This is painted on a 4 ply "Untempered Masonite" board. I had given a board three coats of gesso and sanded between each coat for a very smooth finish. It was bone dry when I started painting.

I had cut out of stencil plastic a large circle which I moved around the surface until I felt like it was in a good position. With paint of some of my favorite colors I painted around the circle to designate and emphasize it. I then painted some fluid colored shapes to create some lift and brace against the wheel. That has a way of making it feel secure.

I enhanced the supports by pressing in some of my favorite stamps that I had created with the rubber stamping block. At the same time I pressed the material of my paint rag for more texture. Then I let the paint thoroughly dry.

I studied the empty circle to decide how I was going to design it to fit with the surrounding so it would work together as a whole part of the work. I tried some areas but did not like what was happening. So I wiped out the paint with a dampened rag. That is when I decided to radiate from center to outer edges with color and texture repeated from the shapes around the circle.

I begin to cut up the circle to make it more interesting. Again I let it dry.

When I started again, I glazed over the textures with deep colors or light tints to change the feel and enhance the design. The texture remains in a deepened state. The darks were strengthened to make the composition strong.

In the end I had a painting of something reminiscent of my sundial in the yard.

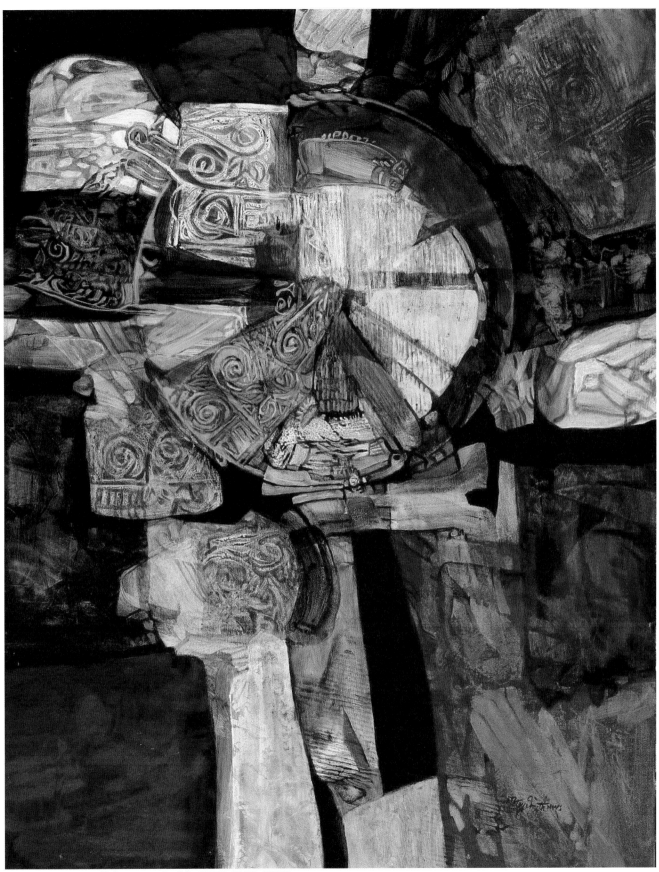

Amazing Sundial • Patsy Smith, NWS, KWS, NWO
36" x 28"

Working on my idea of a playing card was a fun experiment in design and color.

I poured liquid acrylic paint on the surface of my museum board which I have pre-sealed with matt medium. Let Dry. Most of the rest of the painting I paint with full body acrylics.

My colors consist of cool passages of greens and blues. This will be my dominant color. It set the mood of the over all tints and shades I work with in this piece. In the area where I wish to have my area of interest I pour in yellow and reds. Then with a dry rag I press out areas of paint to make a luminous glow of lighter color. This wiping has a neat way of mixing some of the colors.

While drying I study the possibilities for structures within the surface. It is like being a child and searching clouds for forms of people or animals. I turn the paper to find the different ways I a might work with the design. To my amazement, in one direction my surface reveals two faces.

I lightly sketch on the faces to fit the colors I want to keep. I proceed to enhance these shapes by painting darks to clarify lights and shadows. Carefully I began to develop some facial features by adding lights to the noses where the strongest light sits. The eyes are added that fit my idea of the look I want.

The faces I have created remind me of royalty, hence I decided to they are a king and queen. This is when I add a scepter and heart.

It was fun that they were in reverse on the paper. I bring forth the faces with darks and light bring the shapes to the surface boldly. With light washes I chisel out the shapes of the heads with crowns loosely to preserve the creative magic.

This painting is whimsical. It was a complete a joy to paint.

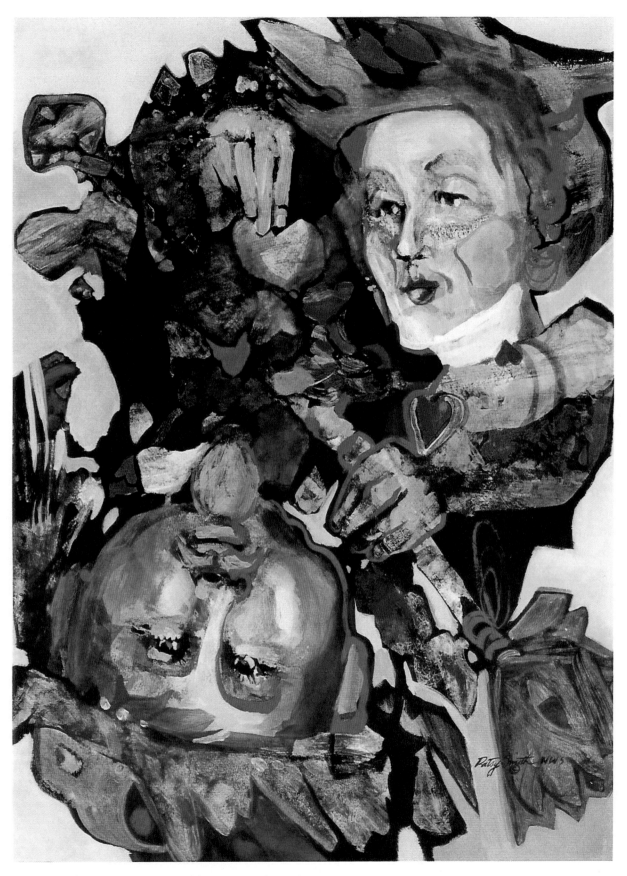

Royal Enchantment • Patsy Smith, NWS, KWS, NWO
30" x 22"

Margaret Stermer-Cox

My work begins with drawing. Working from life, memory or imagination, the initial drawing process gets my creative juices flowing. Often I work in a series, seeing how I can develop an idea in multiple ways. The designs that speak to me are selected for transfer to watercolor paper for painting.

The development of Groovy Kitty was typical; I began with a drawing. This was one of several studies inspired by a photograph I took of my aunt's cat. Using graphite pencil, each drawing started with a simple gesture or shape. I push, pull, smudge, lift, and redraw the shapes and tones. I engaged the drawing until an abstract design I liked emerged.

With Groovy Kitty I thought I would experiment with a "frame within frame" format. I started drawing and building tone, watching for interesting shapes. I drew spiral shapes near my center of interest for a touch of humor. I repeated stripes to allude to a tabby cat and to add visual interest. I intuitively started developing a value plan. I decided I would use analogous value shapes within a larger alternating light and dark scheme. Once I had a design I liked, I copied the outline onto tracing paper for transfer.

Sometimes I do small color studies of de-signs, as with this painting. I transferred the design to a 5 x 7 size. I chose a palette consisting of prussian blue, perinone orange, quinacridone burnt orange and quinacridone violet. My intention was to have a few pure color shapes and contrasting muted colors, with orange being dominant. The palette was chosen specifically for the rich muted tones I desired to create. I wanted the mood of a relaxed cat just hanging out, being groovy.

My painting process for Groovy Kitty and many of my paintings consists of layered watercolor washes. Painting from shape to shape, I overlap, under-lap or restate shapes. The layering allows me to "mix" colors on paper. I am careful to ensure each layer is dry before starting a new layer. During the entire process, I watch the color and value relationships develop. The painting is done when all is in balance.

My painting process is not as "step-by-step" as it might seem. I allow myself the opportunity to edit, evaluate, change and develop the design. Even when I get into final painting mode, I make adjustments. But the drawing and color studies are at the core of my creative working process.

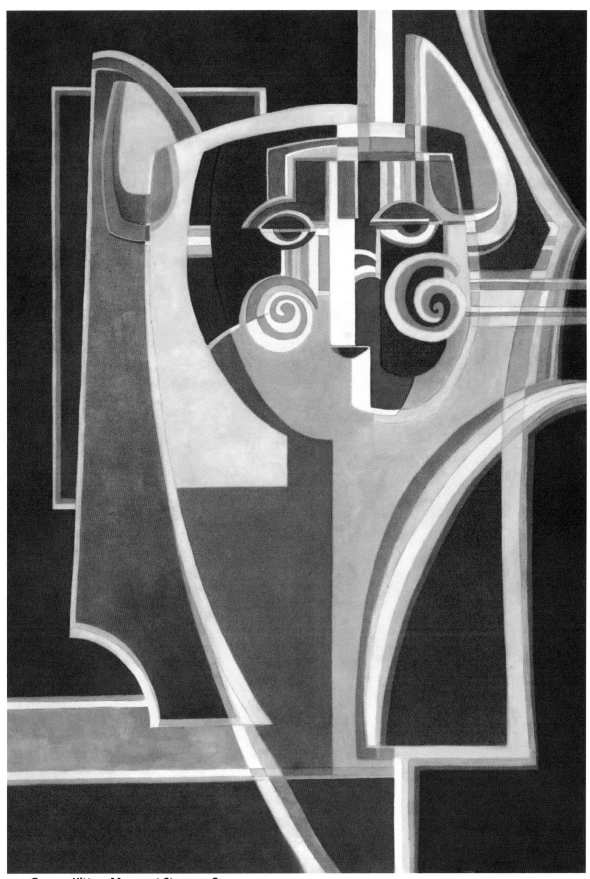

Groovy Kitty • Margaret Stermer-Cox
Watercolor, 21" x 15"

Debora L. Stewart

Undergrowth came about after a great deal of frustration on my part. I had been searching for a way to add some darker tones to my work in an effort to create more emotional intensity. I took two older works and washed them off in the sink. Then I restarted by adding some intuitive marks with water- based black oil paints. This appeared to be a breakthrough for me as I began to achieve more of what I was searching for.

So after these experiments I took a full sheet of gray Wallis sanded pastel paper and laid down some lines and areas of the water-based oil paint. I let this dry and flattened the paper by weighting it down with some books. I chose more neutral colors for this piece. I used many earth-based pastel colors such as blue-green earth, sienna ochres, creams and grays. I primarily use Unison pastels in my work as I love the color selections and consistency of these pastels. I worked the darker areas first with the sienna, dark ultramarine blues and ochres. I responded to the lines that I had spontaneously laid down and used them as a basis for the composition. After the darker areas I focused on the lighter area and added some blue-green earth pastels. For this piece I tended to use the end of the pastel and this makes the lines and movement more evident in the piece. Therefore it has a sense of movement to it.

After I had quickly put in these main color areas I began to add some complimentary and pure colors to add more of an emphasis and energy to certain areas. One of the things that I do while I work is turn the piece in different directions as I work. I think this helps me to see what parts are off balance and need more work. I look in the mirror at the piece to see it from a different perspective and I also photograph the work in progress. This is a part of my working process and is very important to developing a finished work.

I also like to balance out a piece by repeating a color in an opposite part of the work I have used the ochre color in two corners. It keeps the piece stable and centered. Another thing that I tend to do is wash off a part of the painting that I do not like. I did this in the upper right hand corner of the pastel. This area was blue-green earth and I did not like it, so I took a foam brush with some water and washed this section off. I dried it with paper towels and then laid down the ochre instead. To finish I added the lightest of the areas.

After my pastels are finished I glue them with an archival glue to an archival backing. I leave a border around the work and often sign my name on the border instead of the painting. I always struggle with where to sign my name as I do not like to take away from the painting with my name. This painting took second place in the abstract/nonobjective category, Pastel 100 Competition, Pastel Journal Magazine.

Undergrowth • Debora L. Stewart
Soft pastel on sanded paper, 24" x 18"

Sue St. John

I began "By The Seashore" by wetting the watercolor paper with a sponge and water. Texture was created by placing strips of plastic wrap from the top of the paper down to the lower half of the paper and curving it to the right edge of the paper. This device pulls the viewer into the picture.

In the lower section of the paper, I placed torn 100% cotton gauze on the wet paper. I pulled, stretched and tore the gauze so it would not appear to look like gauze in the finished painting. This texture helped convey the idea of the underwater theme.

Starting with a limited palette of Payne's grey and raw sienna, I used a spray mister of Payne's grey on the paper while it was still wet. Certain areas were textured by splattering and misting to produce an unusual surface especially in the lower half of the painting. I also misted a little raw sienna in places. I added touches of vermillion red mixed with orange in the lower half of the painting. The warm reds provide a little cheerful relief. I also added small touches of black in this same area. I tried to save some whites of the paper. The top of the painting was left with no texture and very light Payne's grey color.

Once this dried, the plastic wrap and gauze were removed, leaving a textured imprint of the gauze and areas that formed sea shell shapes.

As a finishing touch, I used a Wite-Out pen and added more small whites in the area where the plastic wrap had been. This is a simple way to add whites back into any painting. I also used colored pencils to enhance certain areas. The challenge of "By The Seashore" was to create the underwater effect.

By The Seashore • Sue St. John, AWS, KWS
Watercolor, 30" x 20"

Toys In The Attic was executed in a deliberately childlike style. The painting also utilizes rich color choices that add interest, contrast, and dimension. Rich color provided an unusual quality similar to an aged wooden attic.

I began the painting with warm reds. The warm reds also provide a little cheerful relief. I used a number of reds for the background, but primarily vermillion watercolor. Further texture was created by placing plastic wrap on the entire wet painting which I pulled to create line and direction in some areas. I let the paint dry, and then pulled away the plastic wrap.

After drying, I studied the background for a while. I then began to develop the concept of antique toys. Using a small piece of white chalk, I sketched the toys. This subject seems to offer a glimpse into my childhood relying on memories of some of my toys.

With my chalk sketch leading me, I used a light red and some yellows including yellow ochre to paint the old toys. I placed plastic wrap and crumbled wax paper down into the wet paint as I painted each area. I also let the colors mingle. The plastic wrap and wax paper add texture to the toys and help convey the idea of aging. Enhancement with colored pencils also helped convey the aging look.

In the process of working on this painting, I concentrated on making the wood walls in the attic look worn. On the right side, I used some burnt umber on the wood areas to age it. This sets off the piece nicely and adds to the oldness of the wood.

In this painting, I used damp pieces of "Mr. Clean Magic Eraser" to rub on different areas to partially remove the paint. Of particular note, this was used on the dolls face and feet and areas on the wood post on the right. Wherever I wanted it to look aged, I used this simple technique.

Finishing touches include using colored pencils, Only in the last stages does the painting come together. When I began this painting, my intention was to create an old but interesting surface and I think I achieved this.

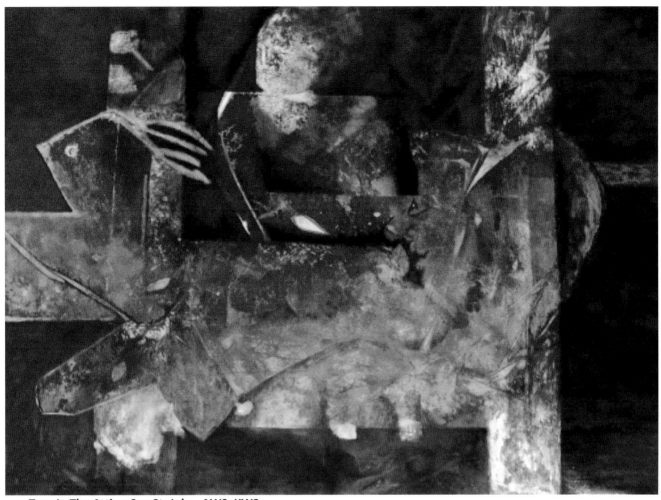

Toys In The Attic • Sue St. John. AWS, KWS
Watercolor, 22" x 30"

Susan Swinand

Before I begin I usually tape the paper down to a board on all sides, to keep the water from getting underneath the sheet. I use a lot of water, so I always paint with the board flat, but often I need to tip the board to spread a wash evenly. D'Arches 300lb. rough is my favorite paper. I use mostly Windsor Newton paints.

Ninety percent of the time, I don't have any idea of what I am going to paint, so I just start spreading puddles of color, wet-into-wet, over the whole sheet. I try to get variety of value, temperature and chromatic intensity into the color mingles to create compositional pattern and interest. Sometimes I will save, or paint around, a few small white shapes as I lay down this first wash. Watercolor is usually thin veils of color without body or texture. One of my goals has been to make the medium more physical and substantial. While this first wash is still wet, I work into it to create pattern and texture. I might take clean water on my fingers and shake them over the damp sheet to create random bursts in the wash or I might splatter in colors. Sometimes I lay sheets of tracing paper or plastic wrap into the heavy mingles of color, waiting patiently and allowing them to dry. Capillary action between the papers creates patterns that are fairly uncontrollable. But they suggest shapes and compositions to me that I would otherwise not have imagined. It is a great way for me to 'get something going' in the painting. At this stage I am very loose and free with the water, and don't worry about the final outcome too much.

After this first heavy wash dries and I remove any papers I have used to create areas of pattern, I look at the shapes and try to find my composition. The objective now is to create some kind of order in the chaos. I paint over the parts I don't like or wash them out and repaint them. When I wash out, I use clean water and soft, flat, short haired brushes, that don't mar the paper. I work the brush from side to side, gently lifting out the part I don't want. I turn the board so the sharp chiseled edge of the brush creates a clean crisp edge as I lift. Then I blot gently with soft paper. Lifting is an important part of watercolor painting for me. Without it I can't make changes and am locked in to my first efforts without room for discovery.

Little by little I find the shapes, mostly by painting darker washes around or behind them. This method of painting the darks around the lights is a negative way of creating shapes and I find it more intuitive and surprising than drawing in shapes consciously. As the composition becomes clearer, I glaze some of the shapes to make the colors richer and to balance the design. I may add more pattern if needed for interest. Sometimes I use dry, abrasive marks made with colored pencils to add line and a different kind of surface or pattern. If I need an opaque white, I use it.

Symbiotic Forms, II • Susan Swinand, AWS
Watercolor, 30" x 22.5"

The painting, Unknown Frequency, II, started with a ready-made, gessoed canvas that had quite a slick, plastic surface that I didn't like very much. I fought against that surface from the start, trying to build up real texture with thick paint, scratches and collage. I also heightened the illusions of texture by washing layers of wet color over rough surfaces. A thin, white, milky wash was brushed vigorously over the rough black bottom area creating bubbles in the wash. The liquid then settled into the depressions of the black paint exaggerating the relief. Paint thinned with a lot of medium and applied with hard, swift strokes of a big, stiff brush left powerful gestures across the top of the painting, giving a feeling of raw energy and movement like natural forces.

I liked that the piece had a sort of 'barren landscape' feel. I thought the use of the measuring tape, although at first chosen for formal reasons (color, interest, pattern, etc), added to a sense of scientific experimentation. I felt the shapes and textures took on a military significance as well. The stark contrast of the hard-edged, gold squares, and the other precise geometric shapes played off in an interesting way against all the very loose, organic surface textures.

When I glued the black and white strip down the left side, with acrylic medium, I was really excited, because I felt it gave the whole painting energy and tension.

The perfect circle around the white triangle on the horizon is made by puncturing the canvas with an awl. The other little circle is a metal washer sewn on with wire and reminds me of a target with cross hairs. I wanted the surface of the painting to be an actual, physical reality. The big heavy rectangles in the sky are mat board, collaged on with acrylic medium and then painted over with a gray sky wash. Suspended overhead, they have a kind of foreboding immanence. Their smooth flat surface and mechanical shape raised off the surface, gives them a lot of impact against the rough, broken field.

All form in the universe is created by energy acting on matter. So I put my energy into my materials, stand back, then make analytical and emotional choices in response to what is taking place on the canvas. . In the end the painting stands as a symbol, a physical embodiment of my ideas, values, emotions and intentions. I believe that painting is an intuitive process of trial and error, that hopefully leads to the discovery of significant visual form.

Unknown Frequency, II • Susan Swinand, AWS
Acrylic on canvas with collage, found objects, 24" x 24"

Lorraine Ulen

Balance began as a doodle on an envelope in one of those moments where too many things are begging for little pieces of me and my time. It's my statement about how we often expect ourselves to "do it all, do it gracefully, and do it with a smile". But no matter how calm and balanced we strive to make things appear in our lives, there is always some disturbance in the background, and despite beliefs to the contrary, it's universal.

I wanted lots of action in the background in this piece to contrast the relative calm appearance of the jester. I felt that I could best achieve this with heavy texture. I began by applying a thick layer of soft gel medium to a full sheet of 140 lb Arches watercolor paper. I used an old credit card to move the gel around and spread it across the paper using sweeping motions, being sure to leave a few areas uncovered to create interest. When I was happy with the coverage, I pressed an old checkerboard stencil into the gel in several areas. I then used a large paint brush to swipe into the gel, leaving brush strokes in some places and knocking back texture in others. When I was completely satisfied with the gel layer, I left it to dry for several days.

I used mostly fluid acrylics to paint the background. I began by applying the paint slightly thinned with water, allowing it to slightly dry, then spraying it with alcohol and using a rag to rub some of the color back to the gel layer. I worked back and forth between the blue shades and the rust color, allowing one to dry before switching to the other. When I was happy with a particular layer or effect, I would apply a thin barrier coat of soft gel over the entire piece and let it dry completely before proceeding with the next layer. I highlighted heavily textured areas by allowing paint to settle into the nooks and grooves and completely dry before scrubbing back.

I continued on layer after layer until I had achieved a stormy, slightly ethereal backdrop with areas of orderliness peeking through. I then applied another coat of soft gel as a protective coat.

When the background was dry, I sketched the jester and other items with a watercolor pencil in a shade similar to his jump suit. I use watercolor pencils as they will melt into the paint when it's applied without making it appear dirty like graphite can sometimes do. I again used mostly fluid acrylics with a few heavy-bodied acrylics where necessary. I find that I prefer the coverage of heavy-body white, black and earth tones like siennas and umbers. I then painted the jester, cairns, clocks and hourglasses as the last stage of the work. It took several layers to complete this part of the piece, adding a little more detail and depth with each subsequent layer. I finished the piece with a 1:1 mixture of gloss varnish and matte varnish for a satin glow.

Balance
Lorraine Ulen, ISAP
Acrylic
30" x 15"

Tempus Fugit (Time Flees) represents the passage of time, the passing of loved ones, the passing down of treasures. While we can hold the timepieces of our predecessors in our hands, the time marked by them slips through our fingers in the same way it has slipped through their fingers. Time is the sum of all the parts of our lives, what we glean from history and the optimism we have for what lies ahead. This piece pays homage to time lost and is a reminder to make the most of the days we have, to live in the moment.

As with most of my paintings, I began with a detailed scale drawing in a 9" x 12" sketchbook. I made several drawings before I was satisfied with all the elements of the design. I then lightly transferred my drawing to a full sheet of 300 lb Arches watercolor paper using a graphite pencil and a grid method for accuracy. Next, I treated the paper with soft gel medium applied with a brush in a random fashion, leaving brushstrokes and a few areas of blank paper here and there for interest. Once the gel was dry, I began building my background using transparent fluid acrylics. Because of the thin, transparent nature of these paints, the application is very similar to the methods used with watercolors: preserve white areas and build color with thin layers. Wherever possible, I painted around the areas where the most detail would appear later.

My goal was to draw the viewer's eye to the main focal point - the largest watch face - using both value and color. I began by applying the lightest and brightest colors in the focal area and gradually building toward darker, richer colors as I moved toward the edges of the paper. I was careful to only use one color at a time unless I specifically wanted two colors to mingle together. I started with the yellows and golds, then progressed to the reds, violets and blues. Once I had a light color pattern established, I let the piece dry thoroughly overnight.

The next step was to add a second layer of soft gel medium, applying it thinly and somewhat smoothly in the areas where I would later add detail, and more heavily in the larger background areas away from the center of interest. At this point, I began playing with textures, using the brush to make circular patterns in some areas of the gel and sweeping toward the focal point, leaving heavy brush strokes in other areas. I allowed it to dry thoroughly for a couple of days. It was important to let this heavier layer dry completely, not only because of the thickness of the layer but also because of the scrubbing technique I would use in the subsequent layers. If the gel wasn't completely dry at this stage, it would be very easy to scrub a "hole" in the textured area.

Continuing with the background I applied additional layers of paint, again starting with the lighter colors and working outward toward deeper hues at the edges. Before each layer completely dried, I sprayed alcohol on some of the heavily textured areas and used a rag to rub back some of the color. This exposed the texture layer as well as the layers of color below and gave the background a feeling of depth. When I was completely satisfied with the background, I applied a barrier coat of thinned gel medium over the entire piece to protect it as I finished the work.

The fine detail areas were the last stage of the painting. With my sketchbook, photos I had taken and the actual pieces themselves as reference, I painted the watches and other elements. It took several layers to complete this stage, adding more detail and depth with each layer. The end result provided the contrast between realism and abstract that I desired.

Tempus Fugit • Lorraine Ulen, ISAP
Acrylic, 30" x 22"

Julie Weaverling

I started this painting by painting the surface and sides with several layers of black acrylic paint with a 1 inch flat brush. Next, I made a thick mixture of white acrylic paint and gel matte medium. This was applied in a thick layer to create texture with a painting knife. The paint was applied on the top surface but not completely to the edge, allowing some of the black paint to still be seen.

Next, I painted the surface with acrylic washes in numerous layers as they would be absorbed into the matte surface. I was thinking of water. Colors of blue, white, yellow and brown were used and were applied with vari-ous small brushes including flat, Filbert, and round.

I then used a charcoal stick to create lines both vertically and horizontally and crossing one another, to give the idea of a barrier to the inner surface. To add depth to the lines, each one was then painted with at least 3 of the colors used in the painting, using a thin brush. Lastly, I used white to highlight areas. When the painting was dry, I applied a thin coat of matte varnish.

Nest I Cage
Julie Weaverling
Acrylic &
Charcoal
12" x 12"

As an experimental painter, I am often interested in trying new things. Ideas are always flowing and sometimes a picture very vividly appears in my mind. I have often used a horizon line, either high or low, in my paintings. Usually these were in abstract paintings that had something concrete in the subject matter, like the ocean.

In this case, I was interested in texture and mood. I was also interested in my layering and further use of gold leaf. I started with laying a heavy base coat of white mixed with gel medium. This was basically to start achieving a level of texture. A large 2 inch brush was used and the paint was put down randomly. While the paint was still wet, I pressed on a piece of a large plastic grid (purchased at Home Depot as a sheet then broken into varying sizes). I knew I would have a horizon orientation and wanted the imprint to cross the horizon. I left the grid for about 15 minutes to get an imprint with depth. I then carefully removed the grid. After about 10 more minutes when the paint was more dry but not completely, I made some deep scratch marks with two sizes of nails being careful not to scratch all the way through the paint to the canvas. Next, I abstractly painted with the blues and oranges until I was happy with the overall look.

Next, I painted the gold leaf adhesive over the entire surface and let it dry about 20 minutes. I then applied gold leaf to the entire surface. Next, I burnished the entire surface with the edge of a credit card to bring out all the texture. I then again scratched through the gold leaf with the nails to reveal part of the paint underneath the gold leaf.

I then painted the entire surface with washes of the acrylic fluid paints, using blues, oranges and raw umber, with a 1

inch Filbert brush. The paint was mixed with a small amount of water and numerous thin layers were applied.

Then the horizon line was drawn and everything below the line was painted with a thin layer of a mixture of burnt and raw umber. The paint was mixed with a medium varnish to increase the flow and transparency. I wanted the bottom dark but still wanted the undercolors to come through. Above the horizon line I finished by using acrylic fluid paint with just my fingers to really focus and highlight specific areas. The painting was finished with a thin coat of varnish.

Traditions • Julie Weaverling
Acrylic, 24" x 36"

161

Marti White

Basket Fragments began with a piece of paste paper I had made that had the feeling of woven strips. Collage artists collect papers of all kinds and also create their own textured papers, so I am never without an array of materials from which to choose.

Beginning with the paste paper I chose several neutral-toned heavily textured papers and one indigo paper, with bits of natural materials imbedded in it. I cut various shapes of the paste paper along lines in the pattern, varying shapes, sizes and orientation of the strips. I also cut into the edges to give more interest to my shapes and allow what I put behind to show through.

Next I began to tear large shapes of the other papers, moving them around until I had an overall design that pleased me, using all the papers that I had chosen. Then the gluing process began. Using Golden soft gel medium and working in small areas, I began to adhere the papers to the canvas in layers. Collaging on canvas has some challenges. Soft gel is easier to control and allows fewer bubbles to form. I use a brayer and a large plaster spatula from the back side of the canvas to work out any bubbles, and then wipe off any excess gel I squeeze out from the top surface.

Once this has dried (about 24 hours), I begin to glaze the surface using Golden fluid acrylics. The colors used in this painting were quinacridone azo gold, quinacridone burnt orange, indian yellow and titan buff. The glazing process takes place in many layers, applying and wiping back, applying another color and wiping back and in some cases, lifting even more using 90% alcohol (from the pharmacy).

When this piece was nearing completion, I realized I needed some light values to develop my center of interest. These last touches of indian yellow and titan buff along with a few tiny dots of all the colors right in the center of the converging shapes did the trick.

On a canvas piece, I finish the surface with several thin coats of Minwax polychrome water-based varnish in clear satin, brushing in one direction across the painting, allowing that to dry and then turning the painting 90 degrees and adding another coat, building up until I have a uniform surface. I prefer a soft bristle brush for this process.

Basket Fragments • Marti White, CASA, ISAP
Mixed Media/Collage, 24" x 20"

The artist always has a few canvases around that just didn't work – even after numerous attempts to save them. Spirals has about four paintings beneath the final result.

I was playing with transfer techniques and one of them called for painting a piece of paper and an image from a magazine or copied photograph both with fluid acrylic and then placing both painted surfaces together, burnishing it and allowing it to dry about 24 hours. Then you wet the back of the image piece and rub off the paper and you get a transferred print.

The broken circle in the "eye" of this painting and the labyrinth in the upper right are both transfers. The half circle is actually an aerial view of a city laid out in a circle which I cut from a magazine. I used 140 lb. Arches watercolor paper to print on and Golden titan buff fluid acrylic on both surfaces.

This piece was set in first using Golden soft gel acrylic medium. Several textured neutral colored papers were torn and added to the surface with soft gel, using a brayer and a spatula from the back side of the canvas to work out any bubbles. Any excess gel medium that is squeezed out is wiped off the front.

Several different color schemes were attempted – one was a muted green and a peach with yellows and titan buff. This was abandoned and mostly lifted out. A third spiral was added in the lower right and later papered over. The crescent moon shape and the attachment of all the spiral shapes with line and color finally accomplished a pleasing design.

The colors used in Spirals were Golden fluid acrylics quinacridone azo gold, indian yellow, ultramarine violet, quinacridone burnt orange and titan buff.

Many glazes and lots of alcohol scrubbing were necessary to get to where I wanted to be. The final result has a richness of texture and a depth of color that I would never have been able to plan.

This is a good example of how an abstract painting evolves for me. Too much planning almost always results in a stilted, contrived look that I don't like. Trusting my intuition is usually more successful, always keeping in mind the basic rules of good design.

Spirals • Marti White, CASA, ISAP
Mixed Media/Collage, 30" x 24"

Colleen Wiessmann

I started this particular painting with a theme in mind. So I actually named the finished product before I started. I do this sometimes to capture the emotions and feeling that I want the finished painting to have. This helps me keep the main idea in focus.

Keeping that concept in mind, I then apply a random texture with a gloss medium and molding paste. When texturing a canvas it is important to use a sturdy or reinforced frame, since the texture can add significant weight to the painting. I do this process to most of my paintings and they must be left overnight in order to dry sufficiently.

I then begin the painting by applying fluid acrylics, creating numerous layers of color. I paint some areas out, and then reapply new color to some areas, until I feel satisfied with the message. I then apply charcoal to the raised areas of texture; this provides a depth of vision and a vibrant contrast. Next comes a layer of satin medium to prevent the charcoal from running when additional color is applied.

Now I begin "writing" along the sides of the canvas. This archaic writing is intentionally illegible but is meant to enhance the theme and allow the viewer room for interpretation. I then add a few random shapes to help accent the focal point. In this case, naming the picture first enabled me to express my feelings and help direct what I hoped the viewer would feel.

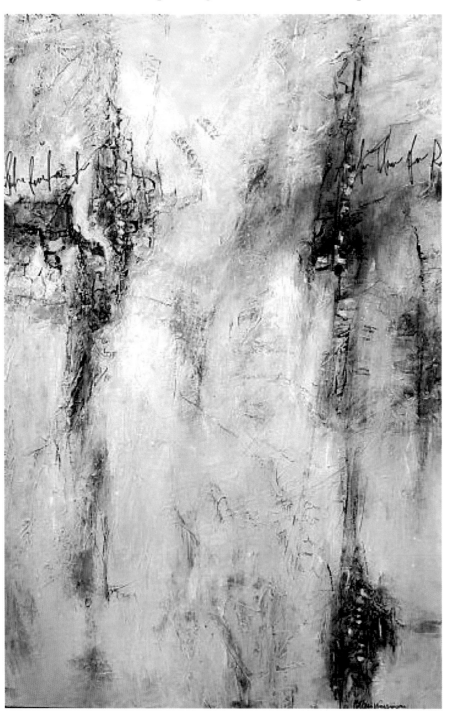

Echoed Messages • Colleen Wiessmann
Mixed Media, 30" x 40"

I began this painting by first sculpting texture on the blank canvas. I love the added effect that texture gives to a painting. For my texture I use gel mediums and molding pastes, in random patterns. When texturing, it is important to use reinforced or sturdy frames, since the molding adds significant weight to the work. The canvas must be left overnight to ensure complete drying of the texture.

Normally I do not have a predetermined final appearance for my work. In this case I began painting with fluid acrylics. I utilize numerous layers of transparent color, many of which will peak through on the final painting. Quinacridone nickel oxide gold is painted on first, and then sprayed with alcohol and left to dry. I then continue with an array of colors overlapping each other.

When I am content with this "final" background, I then proceed to apply torn collage paper in random shapes. Some of these papers have been previously painted by me, others are manufactured paper with interesting textures. In Rejuvenation I utilized gold paper which provides the iridescent look.

I then look for an interesting shape to utilize as a focal point. I continue painting and adding layers of paper until I have the desired appearance. This sometimes takes many layers. I also look for movement and shape to flow towards the final focal point.

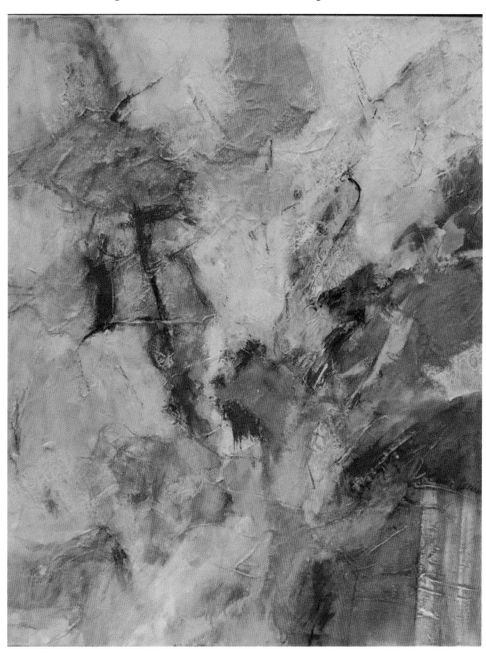

Rejuvenation • Colleen Wiessmann
Mixed Media, 24" x 30"

Jerry Wray

This painting is one in my series called "The Altar Series". By using Christian and archetypal symbols, I hope to express my love for God and His love for His creation: the whole universe from before mankind to the present day and forever.

The basic design, outlined in wax, which is common to all paintings in "The Altar Series", started as a small sketch in crayon on a piece of watercolor paper. When several colors of watercolor were poured on the wet paper, the crayon design stood out. I didn't think much of it at the time, but when three of my artistic children wanted one of these tiny sketches, I thought, "There must be something here that I have missed." Having studied Carl Jung's Man and His Symbols for some time, it occurred to me that this square represented the Earth, and the circles represented God above and below the Earth. Upon enlarging the size of the paper, I thought of adding even more symbols.

To paint this piece, I first picked an absorbent paper, Lanaquerelle, which would work well with the dyes. Then, I used a hot waxer to draw on the basic composition. Then I took three to five Dylon cold water dyes and sprinkled them, dry, on the paper, as if they were salt and pepper. Next, I misted the dyes, and they burst into color, running together and making new colors as well. This is always the fun part, it's like fireworks on the 4th of July. I try not to use too many colors, though, because when they run together it just looks muddy.

After the paper dries, I rinse it with running water to remove excess dye powder, and then I put dye set on it and let it dry again.

The paper is now ready to accept my "embroidery". I use gouache and watercolor crayons to add symbols and figures to the painting to express my theme for the piece. At this stage, I still try to use a limited palette that goes with the dyes I used, to maintain unity. Gouache is a thick, opaque watercolor liquid, which I use to paint the symbols in whatever color is appropriate to the painting. The crayons are just dried gouache in a crayon form, so I use them in a similar way to draw details. In Dream Catcher, you see a figure that grew out of the original "X" that was in the first drawings. There are also some Indian symbols which I researched for this piece, as well as Christian symbols which appear in most of "The Altar Series" pieces.

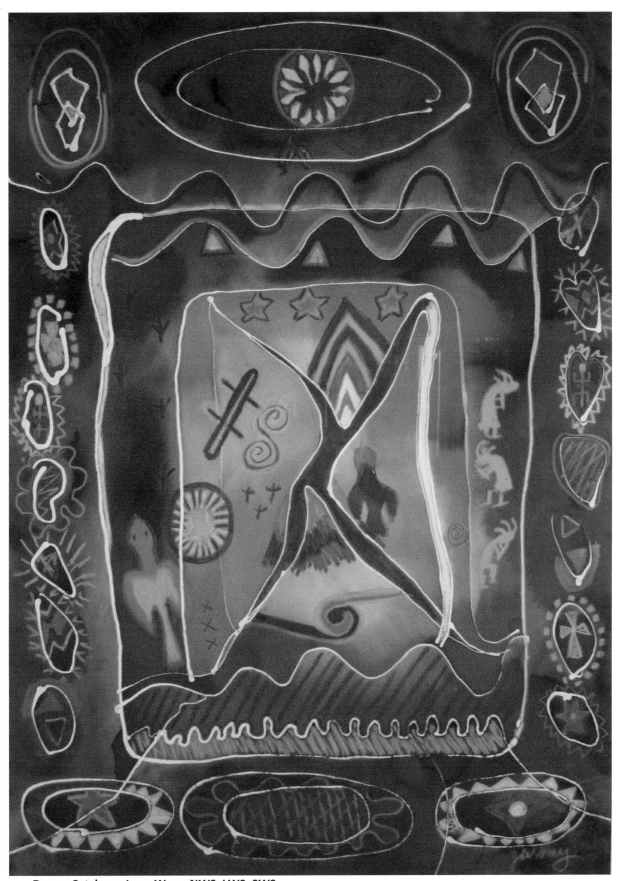

Dream Catcher • Jerry Wray, NWS, LWS, SWS
Wax, Cold Water Dyes, Gouache, Caran d'Ache Watercolor Crayons, 30" x 22"

This painting is one in "The Praise Series". The idea of pouring paint on unstretched canvas or paper positioned at a 45 degree came to me when I saw Paul Jenkins' paintings in New York in the 1980's.

First, I stapled the paper to two sticks about 36 inches long, then I placed the sticks at a 45 degree angle in the bathtub that I had built in my studio so I could pour paint when the weather is too bad to work outside. Usually I do pourings outside, in part because the process is very messy.

After placing the paper in the tub, I mixed my paint using short plastic cups. I squeeze about 1/4 inch of Golden liquid acrylic paint or about 1.5 inches of tube acrylic paint in the cup. Then I pour a mixture of half matte medium and half water into the cup and stir. This mixture makes about 1/2 cup of liquid. Usually I use three to five colors in a painting.

After thoroughly stirring the paint, I take another cup and pour some of each of the colors into a separate cup. This makes what is called the "mother color" because it has some of each of the other colors to be used mixed together in it. Then I pour a little of the mother color back into each of the colors to be used. Using this method, any color will go with any color.

Now it's time to pour. Using an upward circular gesture, I pour the paint on the paper and let it run to the bottom of the page. I repeat this gesture with the same color two or three times across the page.

Next I use another color on top of the one I first poured. Sometimes I use a mister spray bottle, to make the paint more transparent and to make it run faster.

I did this for the pink in this painting. I either pour the next color right away or wait until the paper dries a little bit, depending on how wet the paper is and if I want the next color to stand out or meld with the previous color.

This type of painting is sometimes called "process painting" because the painter decides as she paints what to do next according to what is happening on the paper.

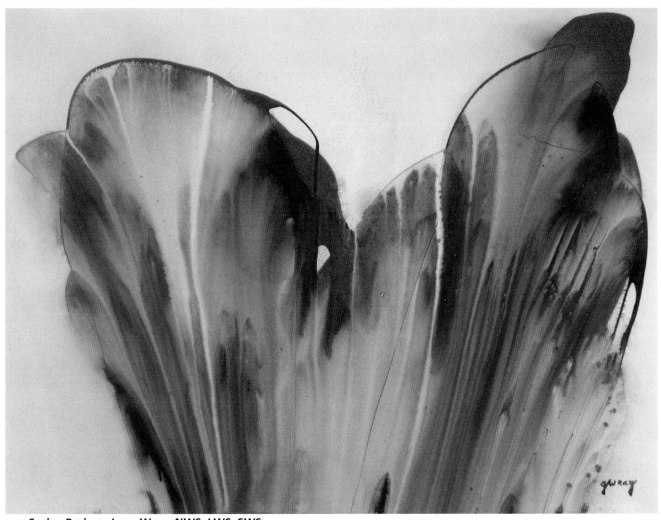

Spring Praise • Jerry Wray, NWS, LWS, SWS
Acrylic, 22" x 30"

Nita Yancey

Crossroads was painted on Strathmore Aquarius II paper. The paper was prepared for the painting process by covering it with gloss medium and letting it dry thoroughly. This allows you to be able to go back and scrub down to the white, using alcohol, after you have painted if you feel you need to get some white back in the painting. I usually put the gloss medium on two or three sheets of paper while I am doing this so these will be ready to work on later.

I was painting with a group of friends when the person next to me was ready to stop for the day and offered leftover acrylic paint to anyone who wanted it. This is where the prepared paper comes in handy.

Using a 2 inch brayer I began by rolling the brayer through the paint that was left, then rolling it on the prepared paper. This was repeated until all the free paint was used. Be sure to roll the brayer first in one direction, then another, not overlapping too much, so you don't cause the paint to get muddy. Always think in terms of design. Let this dry thoroughly. Now you have something to work with on another day.

I mixed one of the colors which was on the paper with some gesso to make it opaque. Using a ruler, I painted some straight lines and filled in between them with the opaque paint. Then I switched to another color of paint, and did the same thing.

Using the watercolor technique of putting a very small bit of color in a brush loaded with water, I applied this as it faded out from the design in the middle of the paper. This finished this painting.

What a fun way to use leftover paint, always coming up with a different color scheme and design.

Waste not, want not!

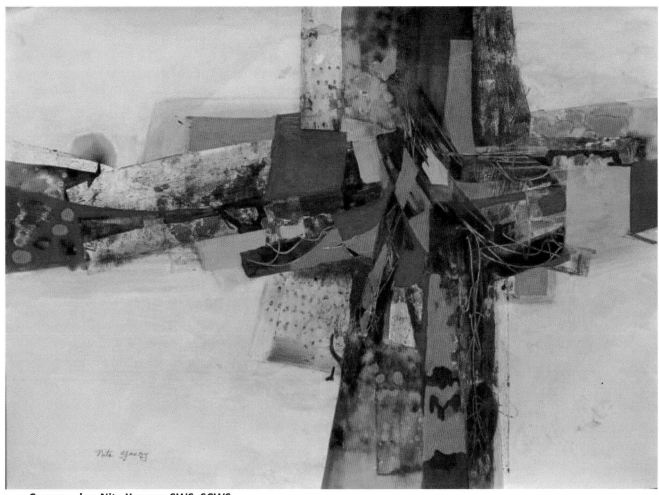

Crossroads • Nita Yancey, SWS, SCWS
Acrylic, 30" x 22"

Barbara Zaring

Pull of the Moon began as an acrylic and ended up as an oil painting. You can combine the unique qualities of each if you remember that you can put oil paint over acrylic, but not acrylic over oil. It is a delightful way to work and can be highly experimental, as long as you finish all the acrylic ideas before you begin to paint in oil.

The painting was done on a prestretched canvas with edges wrapped around 1 ½ inch stretcher bars. I like the firm, yet giving surface. I gessoed the surface several times and sanded lightly in between the coats. I applied an area of ¼ inch Golden crackle paste to the middle, let it dry, and sanded it slightly. I sprayed it with water and painted with burnt umber light and bone black heavily diluted with water. The paint seeped into and accentuated the cracks. I sanded the surface lightly again exposing the subtle cracking effect. This was covered with a layer of mixed 2:1 water to gloss medium to seal the porous nature of that material. I added a layer of very pale gray to the rest of the painting and dragged an old brush across it while it was still wet. It created an almost marble effect.

From this point on Iused my oils, beginning with opaque gray shades of varying warms and cools applied with a palette knife, plus brilliant reds and oranges in a few spots. I emphasized the two "moon" shapes with different mixtures of whites, both titanium and zinc. I added sap green and a dark mixture of ultramarine and prussian blues. I spent weeks subtly changing the colors. Playing with the warms/ cools and opaque/transparencies established a push/pull movement that I liked. I knew that I wanted to develop a glow from behind and achieved it by many layers of transparent glazes of yellows, reds and violets, mostly Holbein transparent oils greatly diluted with Winsor & Newton Liquin original.

At one point, I took a picture and played with it in Adobe Photoshop to see if I could get more of the effects I wanted. I frequently do this as it helps to see the image in a different scale and setting. Nearing completion, I mixed up several rose-colored glazes and applied them at the edges of the gray masses. Using the side edge of my palette knife I laid some paint on in short lines, adding impasto to the work. I think Pull of the Moon expresses mystery and is refreshing to view. I did a final varnish of a mix of Winsor & Newton gloss and matt varnishes.

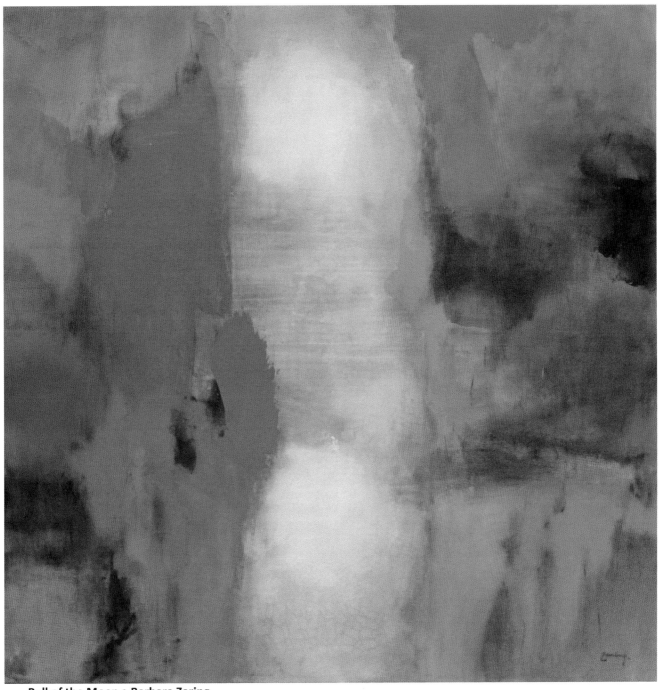

Pull of the Moon • Barbara Zaring
Acrylic/ Oil on canvas, 30" x 30"

This painting began with a bang. I put the canvas on the floor, sprayed it with water and poured paint rather randomly over the surface. I was using a prestretched canvas on 1 ½ inch stretcher bars with wrapped edges which gave me a firm surface that was easy to manipulate. Earlier I had prepared several colors: yellow, blue, yellow-orange and violet, all heavily diluted to a pouring consistency with my frequently used mixture of 2 parts matte to 3 parts gloss medium and also "water" which contains 1/10 flow release to tap water. The colors were all Golden fluid acrylic paints. I used wide squeegees to move the paint around to achieve an interesting pattern. After this dried, I added the more intense violet in a long drip. The next day I made two batches of translucent white using zinc white and varying amounts of my acrylic medium mix. I tried them on a dry painted swatch to make sure that they were not too opaque. Once again I sprayed the surface with water before pouring the white paints and moved them in diagonals on both the right and left sides of the painting, leaving the center section untouched.

At this point I changed direction completely and began painting with oil paint. It is very important to remember that you can paint with oil over acrylic, but not acrylic over oil. I use this method of employing both mediums because I can achieve effects in acrylic that I can't in oil and vice versa.

Using sable brights and soft Japanese hake brushes, I applied glazing in subtle colors using Winsor & Newton Liquin Original. It dries quickly and leaves a hard surface with a slight sheen. I have a wide selection of transparent oils. Some are called transparent oils by their companies and others you just have to learn about, such as ultramarine blue, aureolin yellow, alizarin crimson, viridian etc. Over several days I applied many layers of this transparent paint until the piece started to "sing".

Later on I added some opaque colors such as the dots that move across the surface. The overall effect was of cascading veils. Once I was pleased with the color, the balance of forms, composition and feel of the painting, I took a photo, put it in Adobe Photoshop and played around to see if it could be improved. I discovered a few new ideas and with a couple of quick flourishes, the painting was finished. I covered it with a mixture of gloss and matte Winsor & Newton varnish.

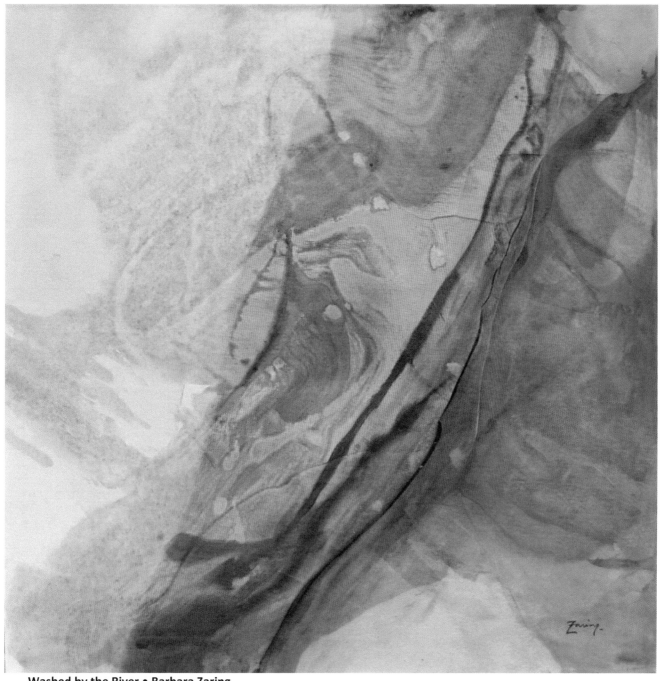

Washed by the River • Barbara Zaring
Acrylic/ Oil on canvas, 30" x 30"

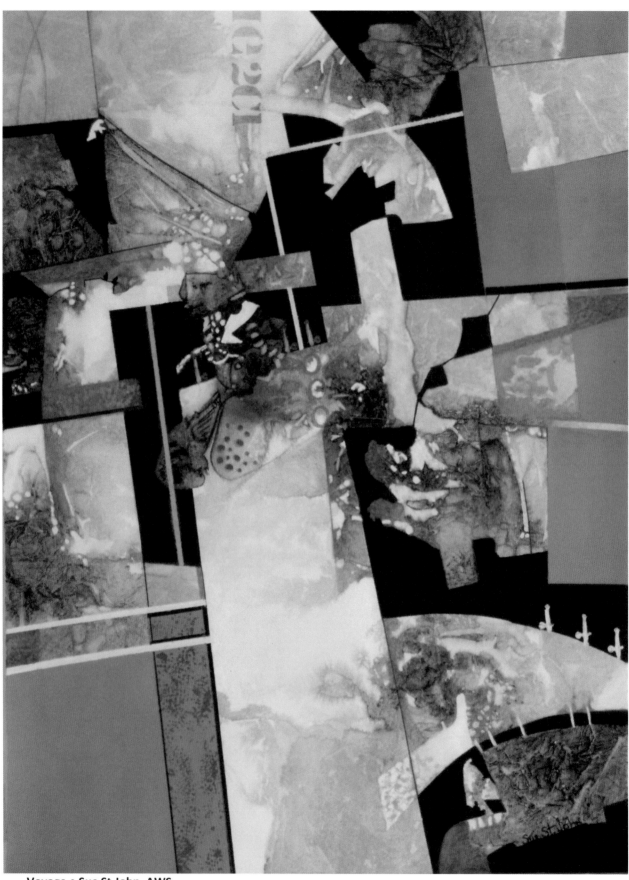

Voyage • Sue St.John, AWS
Mixed media, 30"x 22"

DIRECTORY OF ARTISTS

Patricia Baldwin
290 E. Loudon Ave.
Lexington, Ky 40505
Pbsartist@gmail.com
www.pbsartist.com

Jane Bazinet
Boca Raton, FL
bazinetjane@yahoo.com
www.JaneBazinet.com

Mary Ann Beckwith AWS, NWS, ISEA
49107 North Royce Road
Hancock, MI 49930
Mabeckwith@mtu.edu
www.maryannbeckwith.org

Sue Bishop
Georgetown, TX 78633
info@suebishop.com
www.SueBishop.com

Joan Blackburn
Pensacola, FL
JoanBlackburn313@msn.com
www.JoanBlackburn.com

Pam Brekas
Gardnerville, NV 89460
pambrekas@gmail.com
www.PamBrekas.com

Sally Clark
Savannah, GA 31411
Tasclark2@aol.com
www.SallyClark.net

Patricia Cole-Ferullo
140 Pacolet Street
Tryon, NC 28782

patdomferul@windstream.net
www.theartistindex.com

Phyllis Coniglio
184 N. Atlanta Ave.
Massapequa, NY 11758
mirrordoor@aol.com
www.PhyllisConiglio.com

Carol Cooper
Rogers, AR 72756
Cwcooper@cox.net
http://faculty.nwacc.edu/ccooper

Lauren Daddona, PWCS, BWS
Collegeville, PA 19426
Lkdart@comcast.net
www.Laurendaddona.com

Martha Deming, TWSA
9757 James Road
Remsen, NY 13438
Mmdatmeadowtop@frontiernet.net
www.marthademing.com

Marilynn Derwenskus
1902 N. Holsted Unit 1
Chicago, IL 60614
info@derwenskusart.com

Joan Dorrill, ISAP
St.Augustine, FL 32080
JoDoArt@bellsouth.net
www.JoanDorrillArt.com

Glenda K. Drennen, IWS, WHS
LaMars, IA 51031
Barley@lemarscomm.net
www.glendadrennen.com

Jo Ann Durham, SLMM, ISEA-NF
Fort Worth, TX 76116
Joandurham.com
Joannart35@charter.net

Michael Edman
N. Topsail Beach, NC
edmanmichael@yahoo.com
EdmanFineArt.com

Sharon M. Eley
Chillicothe, OH 45601
Sharoneley08@yahoo.com

Cheryl Fausel, FWS, SW
Cape Coral, FL 33914
Cherartist@aol.com

Elizabeth Fluehr
Omaha, NE 68154
Fluehr1@yahoo.com
www.artzone.webs.com

Carol Frye, NWS,ISEA-NF,ISAP, FWS
President FWS 2013
5173 Cambry Lane
Lakeland, FL 33805
Cfrye4art@msn.com
www.carolfrye.com

Joyce Gabiou, NCS
Jacksonville, FL 32225
jgabiou@yahoo.com
www.joycegabiou.com

Susan G. Greenbaum, NWWS
Luvn2paint@aol.com
www.sgreenbaumart.com

Jan Groenemann, MA, CLC
St. Peters, MO 63376
Hokseda@charter.net
www.groenemannstudios.com

Suzanne Jacquot
Sebastopol, CA 95473
ljsjacquot@gmail.com
www.SuzanneJacquotArt.com

Elaine Kahn
ElaineKahn@me.com
www.ElaineKahn.com

Mary Lauren Karlton (MK)
303 Potrero St.
Suite 2B
Santa Cruz, CA 95060
mkarlton@earthlink.net
www.MaryKarlton.com

Anett Kilén Kennedy
Oslo, Norway
anett2112@gmail.com
www.AnettKilenKennedy.com

Maureen Kerstein
Kennesaw, GA
Artbymaureen@gmail.com
www.SeaScapesArtGallery.com

Pat Wheelis Kochan
patkart@aol.com
www.artisansstudio.com
www.onceuponatimeindallas.com

Ruth Kolker
St.Louis, MO 63141
Ruthy.kolker@gmail.com
www.ruthkolker.com

Pat Lambrecht-Hould
Lakeside, Mt. 59922
plh@centurytel.net
www.artistswork.com

edie Maney, TNWS
309 Harpeth Ridge Dr.
Nashville, TN 37221
ediemaney@icloud.com
www.ediemaneyart.com

Jinnie May
Randolph, NJ 07869
Jinnielou@aol.com
JinnieMay.com

Joyce McCarten
Falls Church, VA 22044
jmccarten@cox.net
www.joycemccarten.com

Linda Benton McCloskey
Harrisburg, PA
mccloskeyart@comcast.net
www.LindaBentonMcCloskey.com

Lois L McDonald
9420 E Summer Trail
Tucson, AZ 85749
loismcdonald@q.com
www.LoisMcDonaldArt.com

Jason Mejer

Robert Lee Mejer, MFA, ISEA-NF, WHS,
NWS, TWSA
Art Department/Quincy University
Quincy, IL 62301
Mejerbob@quincy.edu
www.quincy.edu

Shirley Eley Nachtrieb, MOWS, ISEA, SLMM
908 Ruth Drive
St, Charles, MO 63301-1164
Shirley@nachtrieb.com
www.nachtrieb.com

Aleta Pippin
Sante Fe, NM 87501
aleta@aletapippin.com
www.AletaPippin.com

Karen Rosasco, CNYWS, Oakroom Artist
Kkrosasco@aol.com
www.karenrosasco.com

Jane Segrest
Bonifay, FL 32425
info@janesegrest.com
www.JaneSegrest.com

Mary Beth Shaw
Wildwood, MO
Mbshaw77@gmail.com
www.mbshaw.com
www.mbshaw.blogspot.com
www.stencilgirlproducts.blogspot.com

Jan Sitts
Sedona, AZ 86336
Jan@jansitts.com
Jansitts.com

Patsy Smith, NWS, KWS, NWO
61 South Lakeview Rd.
Brady, NE 69123
Love2create@msn.com
www.patsysmithart.com

Sue St.John, AWS, KWS
5379 Carnoustie Circle
Avon, IN 46123
Info@suestjohn.com
www.suestjohn.com
317-386-8020

Margaret Stermer-Cox, NWWS,MTWS
margaret@stermer-cox.com
blog: http://stermer-cox.com
www.DancingClouds.com

Debora L. Stewart
Iowa
deboralstewart@gmail.com
www.DeboraLStewart.com

Susan Swinand, AWS
Shrewsbury, MA 01545
Susan@swinand.com
www.swinand.com

Lorraine Ulen
1948 Soule Road
Clearwater, FL 33759
lorraine@lorraine-ulen.com
www.Lorraine-Ulen.com

Julie Weaverling
julie@julieweaverling.com
www.JulieWeaverling.com

Marti White
11370 Camino del Sahuaro
Tucson, AZ 85749
martiaz@simplybits.net
www.ArtByMartiWhite.com

Colleen Wiessmann
Johns Island, SC 29455
ColleenWiessmann@yahoo.com
Colleen Wiessmann.com
Jerry Wray
Shreveport, LA 71106
Jerrywray@bellsouth.net
www.JerryWray.com

Nita Yancey
Columbia, SC 29210
JandJYancey@aol.com
www.NitaYancey.com

Barbara Zaring
Taos, NM 87571
barbarazaring@gmail.com
www.BarbaraZaring.com

About the Author

Sue St.John has been painting for more than forty years. Like many Midwest artists, she began with painting rural landscapes, barns and flowers in oil. Having lived for several years in the beautiful hills of Brown County Indiana, this was natural.

Over the years Sue began working more in watercolors and moving toward more abstract paintings. She found the challenge of watercolors and abstracts to be a wonderful outlet for her creative talents. She loves abstract art where color flows freely giving the effect of stained-glass colors.

"We who create are very blessed to put something into this world that is totally and uniquely us," she says. "It completes the circle to be able to share it."

Sue is a Signature Member of the American Watercolor Society and a Signature Artists Member of the Kentucky Watercolor Society.

Dedication

This book is dedicated to my family whose unfailing love and support provides me a soft place to land.

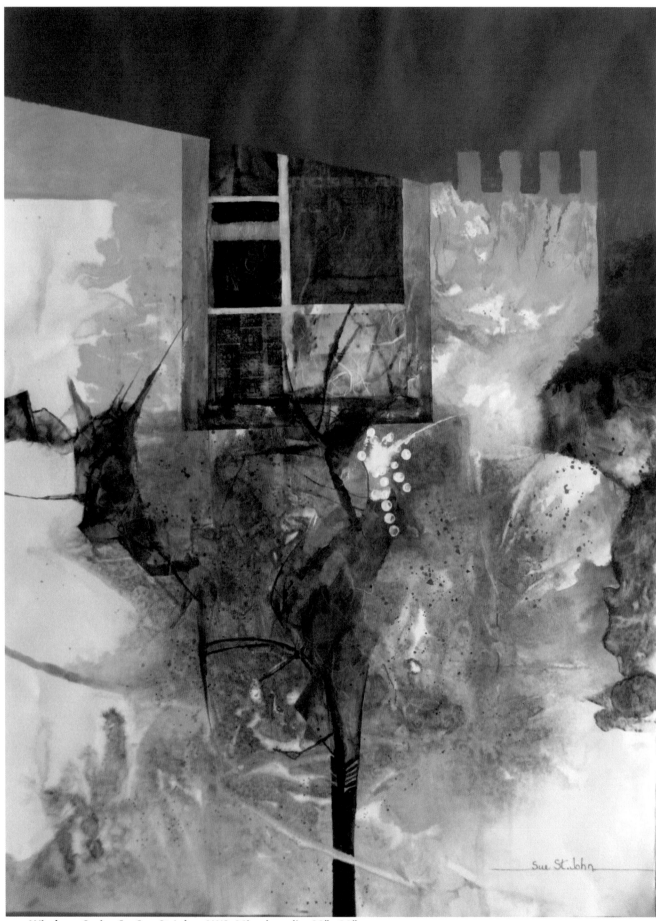

Windows Series 6 • Sue St.John, AWS. Mixed media, 30"x 22"

Printed in Great Britain
by Amazon